Visualizing Muscles

JOHN CODY, M.D.

Visualizing Muscles

A New Ecorché Approach

to Surface Anatomy

Photographs by David Riffel

Model: Michael R. Miller

Assistant Artist: David Breault

Photographic Consultant: Jack Jackson

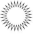

University Press of Kansas

© 1990 by the University Press of Kansas

All rights reserved

Published by the University Press of Kansas (Lawrence, Kansas 66045), which was organized by the Kansas Board of Regents and is operated and funded by Emporia State University, Fort Hays State University, Kansas State University, Pittsburg State University, the University of Kansas, and Wichita State University

Library of Congress Cataloging-in-Publication Data
Cody, John, 1925–
 Visualizing muscles : a new écorché approach to surface anatomy / John Cody ; photographs by David Riffel.
 p. cm.
 ISBN 0-7006-0425-1 (cloth : alk. paper) —
 ISBN 0-7006-0426-X (pbk. : alk. paper)
 1. Muscles—Anatomy—Atlases. 2. Anatomy, Surgical and topographical—Atlases. I. Title.
 [DNLM: 1. Models, Anatomic. 2. Muscles—anatomy & histology. WE 500 C671v]
 QM151.C83 1990
 611'.73—dc20
 DNLM/DLC
 for Library of Congress 90-50112
 CIP

British Library Cataloguing in Publication Data is available.

Printed in the United States of America
10 9 8 7 6 5 4 3 2 1

The paper used in this publication meets the minimum requirements of the American National Standard for Permanence of Paper for Printed Library Materials z39.48-1984.

For my dear friend

RANICE W. CROSBY,

Medical Art's "mother of all"

Contents

Preface

To demonstrate anatomy by painting muscles on a model's skin seemed obvious and simple enough when I first thought of it. So obvious and simple, in fact, that I wondered why no one else apparently had ever attempted it. It was only after becoming fully involved in the process that I began to appreciate the serious difficulties it presented.

At first it appeared that I had everything necessary for bringing the project to a rapid and successful conclusion. As a physician and former medical illustrator, I had the requisite anatomical knowledge. I had dissected, not one, but two cadavers—the first as a medical illustration student in the Department of Art as Applied to Medicine at the Johns Hopkins Medical School. Later, as a medical student at the University of Arkansas for Medical Science, I registered for gross anatomy again and dissected my second cadaver. Not only did I know the muscles well; I had drawn and painted them on many occasions. I could not see how painting them on a model's skin could be much more difficult than depicting them on paper or drawing board.

Moreover, I had found an invaluable collaborator in Michael Miller, a former college gymnast who was teaching and practicing X-ray technology at the local university and hospitals. Mike's trim body made him a more than acceptable subject. But it was his medical savvy that enabled him to comprehend the goals of the project in a way not to be expected of the average model. Mike had worked for me before, on *Atlas of Foreshortening*, and was eager to do so again. The process of being painted from stem to stern did not daunt him in the least. He did not know what he was in for. But, then, neither did I.

I also had available several experienced professional photographers who were intrigued by the challenge and interested in collaborating with me. One was Jack Jackson, director of photographic services at Fort Hays State University, who did some of the preliminary work on this book, though he was unable to continue to the end. Another was David Riffel, from Kansas City, an excellent commercial photographer who took Jack's place. Thus I had knowledge and skill, an ideal model, and capable photographers. Foreseeing no problems, I set to work.

I consulted various theater people adept at altering the appearance of actors by means of powders, pencils, paints, and costumes. It was at this point I had my first

doubts. I discovered that there is almost nothing that cannot be done to faces. But when I told these professionals that I wanted to paint a person from head to foot, they all had misgivings, saying that stage make-up was not tough enough. I realized I would have to experiment and improvise.

Art supply catalogs are full of paints, inks, pencils, markers, sprays, and so on—for use on every surface but skin. A primary consideration, of course, was that whatever I used had to be nontoxic. I bought markers designed for children. The manufacturers had flavored them, knowing they would end up in little mouths. The cinnamon-flavored was reddish, the chocolate a deep brown, and the licorice a warm black—just right for muscle fibers. At a theatrical supply company, I bought liquid make-up, "creme liners," fluid eyeliners, scented instant watercolor, "velvet sticks," translucent powder, and an assortment of brushes, daubers, and spreaders, things I had not even heard of.

For the base coat and underpainting, I settled on "Stein's Liquid Make-Up," a mixture of water, isopropyl alcohol, iron oxides, and other pigments. The color "Hawaiian" mixed with "Red" produced a perfect raw-meat color. Painted in narrow stripes, it would undoubtedly give the desired impression of fibers and bundles of fibers. For tendons and aponeuroses, I had pearly velvet sticks, salvelike stuff I would apply with a small brush. For finer detail, I had the markers, and for the occasional dark accent, the eyeliner. It seemed easy enough. But as soon as I essayed a trial run, problems abounded.

Problem one: The painting process required an appalling amount of time. From the first brush stroke until the last muscle was finished took some ten to twelve hours. Only then was the model ready to be photographed—a matter of several hours more! *Attempted solution:* I engaged an assistant artist, David Breault, to help speed things up. The result was that we became more perfectionistic. It *still* took ten hours.

Problem two: The paint would not go on properly over the "peach fuzz" that covered Mike's legs and arms. It caked up, blobbed, and refused to look linear as muscle fibers should. *Solution:* Mike's wife, Jill, took razor and depilatories to her husband and made him smooth as marble.

Problem three: The paint was extraordinarily fragile. It smudged, blurred, flaked, and wiped off if anything touched it. *Solution:* Mike had to endure endless standing without leaning on anything to rest himself and ease his weight. He had to balance squarely, hour after hour, on the soles of his feet.

Problem four: As researcher Shirley Domer of the University of Kansas has shown, a dry, nude, inactive man feels cold and needs covering when the temperature dips below 83 degrees. Mike was far from dry, because he was constantly being brushed with a dilute alcohol solution that evaporated quickly, leaving him blue and shiver-

ing. *Solution:* We compromised on an incredibly high temperature that made everyone miserable—not quite warm enough for the motionless model and like a sauna for the active painters.

Problem five: Dave and I, hands dripping with paint and smeary from wielding velvet sticks, could not riffle through expensive anatomy books hunting for diagrams. *Solution:* I made huge copies of all necessary diagrams—about thirty—using Conté crayons on newsprint and tacked them up on the studio walls where they were visible as we worked.

Problem six: Fourteen to sixteen hours is an unreasonably long time to tell a model he cannot use the men's room because the seat would obliterate his hamstrings and gluteal muscles. *Solution:* Mike went on a liquid diet the day before the session, and the next morning, he endured a hefty soap-suds enema.

Problem seven: For the unpainted comparison photographs, I wanted a faint sheen on the model's skin, the kind one sees on marble statues. But the body oils and lotions I tried were too reflective and gave a greased-pig look. *Solution:* Mennen's "Baby Magic" lotion, applied liberally and then wiped off as thoroughly as possible with paper towels, left just the right patina.

It was necessary to repeat the exhausting process five times. One of our efforts was nullified by my attempt to render the simulated muscles less vulnerable to smudging by covering them with magnesium carbonate, a method suggested by the theatrical supplies people. But this pinkish powder lightened the raw-meat color to a state of anemia and obliterated all the details David Breault and I had so laboriously contrived. Even after the painting process had reached a satisfactory level, we still had to undergo the entire ordeal a couple of times more, because of certain not altogether successful experiments in lighting, lenses, backgrounds, and so on. After David Riffel arrived on the scene, the photographic aspect reached perfection.

On May 12, 1989, Mike, starved, prepped, and game as always, appeared at the store we were using as our latest studio and endured the painting of cold iron-oxide muscles on him for the last time. In the absence of Dave Breault, I had to do all the painting myself. As I sweated away, I vowed that if anything went wrong this time, I would not go through the routine again. When I finally set aside my brushes and stepped back to have a look at the living écorché, I was impressed and satisfied. Short of major surgery, nobody could have looked more thoroughly flayed than Mike. He said he even felt that way. Dead tired, shaved where he had never shaved before, hosed out, "sponge-bathed" with alcohol to the point of hypothermia, every muscle dissected out and aglow—he might have stepped from the pages of Vesalius. And, to everyone's relief, the photographs taken that day turned out to be everything one could wish. Perhaps sometime, somewhere, an anatomist, photographer, and athlete

Figure 1.
Our model at the end of the painting process. The body contains three kinds of muscle tissue: smooth (in the gut), cardiac (heart), and striated (skeletal). The striations are apparent here for every muscle depicted, marking them all unmistakably as skeletal muscles. This means that they are attached at one or both extremities to bone.

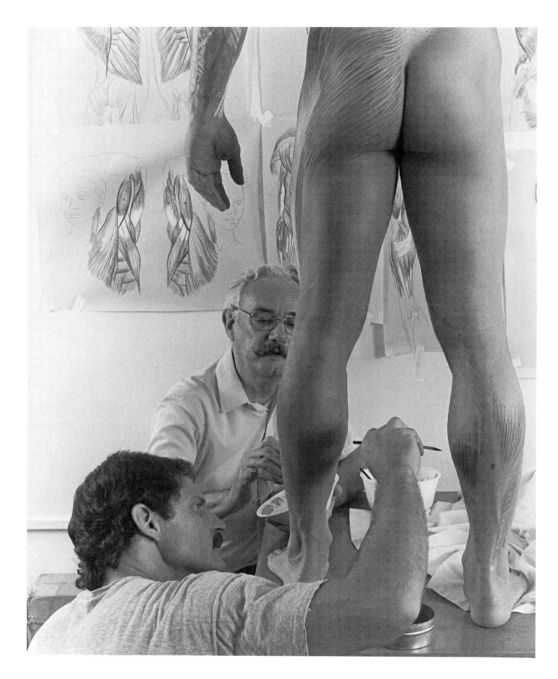

will try something like this again. They cannot say, however, that they have not been warned!

There are a number of people who have given me significant help in this project. I want to thank Monie Applegate and Pete Felten for their kindness in providing "studios" for taking the photographs. My warm thanks also to my son-in-law Skip Russell, for helping me pick the word processor on which the book was written and for

his patience in teaching me how to use it. I am grateful to Dr. Stephen Shapiro of the Drama Department of Fort Hays State University, for sharing with me his expertise in stage make-up, and to Dr. Irvin H. Mattick, for the use of his anatomy books. And, finally, I want to thank newlywed Jill Miller for her good-natured acceptance of the long hours this project kept her husband away from home.

Introduction

The original title of this book, *Live Ecorché*, was dropped because the word "écorché" drew a blank with everyone the author and publisher tried it on. Yet every artist, art student, and medical student, from the time of the Renaissance until the demise of nineteenth-century academism, knew what an écorché was. Today, probably not one artist in a hundred, or one physician in a thousand, has ever heard the word. But with the current ferment in the art world, and the resurgence of interest in naturalistic painting (as exemplified by the amazing recent popularity of wildlife art), together with the renewed emphasis in medicine on seeing the patient whole, things are changing. The écorché seems due for a revival.

An écorché is a flayed figure, a three-dimensional representation of the human body, usually made of plaster, with the envelope of skin and fat removed. Its intent is to depict the surface muscles globally, with precise anatomical correctness. So central to medical and artistic practices were they regarded that écorchés may be seen as a "trademark" in the backgrounds of portraits of artists and surgeons painted throughout several centuries. The figure is usually shown in action, one leg before the other, one arm raised over the head. They were invariably carefully constructed and beautifully proportioned. For surgeons, écorchés were reminders of what they had dissected and guides to what they would be operating on. Artists used them as a standard to check the anatomical accuracy of their life drawings. Muscular structures in even the most robust and thin-skinned patients and models are never observable in their complete outlines. Rather, they are revealed only here and there by the most subtle curves, ridges, swellings, and hollows that succeed each other in what may appear to be an arbitrary and incomprehensible distribution. The écorché rendered the underlying structures clearly apparent. It helped to provide a framework for medical strategies and enabled artists to organize and integrate their lights and darks.

Concern in the art schools for objective exactitude disappeared in the early decades of the twentieth century. With the emergence of cubism, abstract expressionism, minimalism, op and pop art, and other forms of visually nonrealistic painting and sculpture, life drawing and the study of anatomy were relegated to positions of negligible importance. In some art schools, these subjects disappeared from the curriculum altogether. It is impossible, I believe, to purchase a recently made écorché in this

country. Catalog companies for art supplies, such as Daniel Smith in Seattle, list only jointed wooden mannequins—a large ovoid bead for the torso, a smaller one for the pelvis, two elongated beads for the arms and legs, and so on—but no anatomically accurate model as was available to artists and physicians during the previous three or four centuries.

Still published, however, are nineteenth-century art anatomies containing some of the visual information once obtainable from the écorché. The usual practice is to show a photograph of a nude illuminated by a raking light designed to cast shadows and throw surface features into high relief. On the facing page, there is usually a pen-and-ink diagram corresponding to the photograph. The diagram shows the muscles in a manner resembling that used in constructing an écorché. The structures in the diagram are labeled with their anatomical names, and sometimes the various rounds and hollows on the photographed model are similarly labeled. The reader must examine the photograph and diagram and integrate the information from both into a mental composite—not an easy task. Anatomical textbooks such as Gray's, Morris's, and Cunningham's, designed for medical students and physicians, present the material in virtually the same manner, albeit in more detail. It is interesting that many of the plates in these books date from the last century, and even when the actual drawings do not, they are nevertheless reproduced by methods developed at that time.

Having given up as hopeless my search for a classical écorché, I asked myself if there might not be a new and better way of presenting anatomical information, specifically one that would not require so extended an imaginative leap. Why not, I thought, cause a living model to look as though his skin had been stripped off and then photograph him in multiple poses? Having at one time, as a medical illustrator, drawn on paper, canvas, vellum, and even walls, I thought: Why not skin? In this way, the kernel for this "live écorché" atlas first popped into existence and germinated.

After almost three years of experimentation, a method emerged whereby muscles, tendons, and fascial sheaths could be painted directly on the model's body. The materials were found to impart not only lifelike color to these structures, but, like the skin itself, they had a surprising plasticity, lending themselves to three-dimensional expansion and contraction. This meant that the painted *trapezius* muscle, for example, would contract or expand as the skin, and the actual muscle under the skin, contracted or expanded. In this way, the painted musculature, tied to the movement of the skin, would alter in shape to fit the pose and, with reasonable accuracy, reflect the changing shape of the real muscles. This elasticity of both skin and paint is amply illustrated by our photographs.

It was evident that photographs of the model "flayed" should be paired with photo-

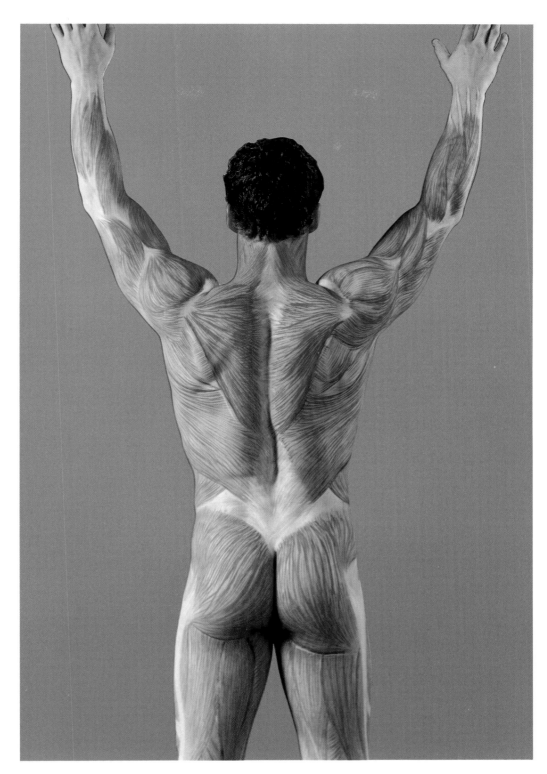

Our model at the
end of the painting
process. The body
contains three kinds
of muscle tissue:
smooth (in the gut),
cardiac (heart), and
striated (skeletal).
The striations are
apparent here for
every muscle
depicted, marking
them all
unmistakably as
skeletal muscles.
This means that
they are attached
at one or both
extremities to bone.

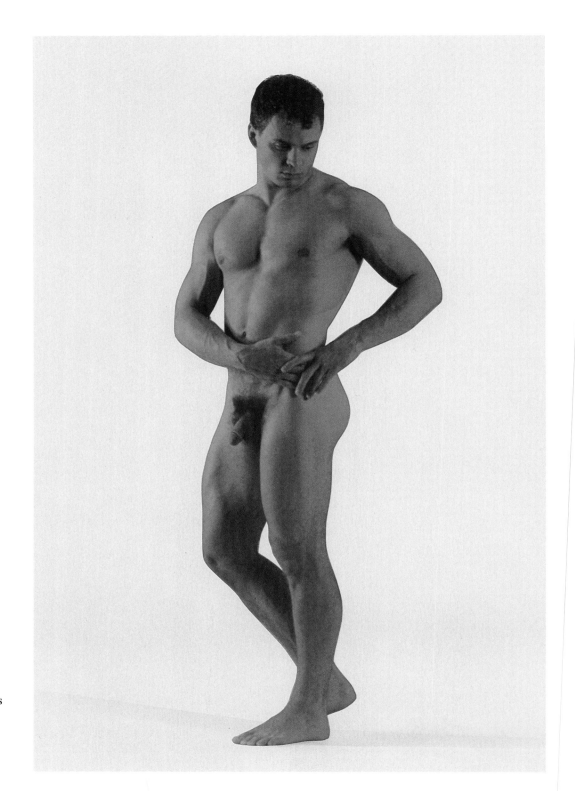

How many muscles can you identify from their surface depressions and elevations?

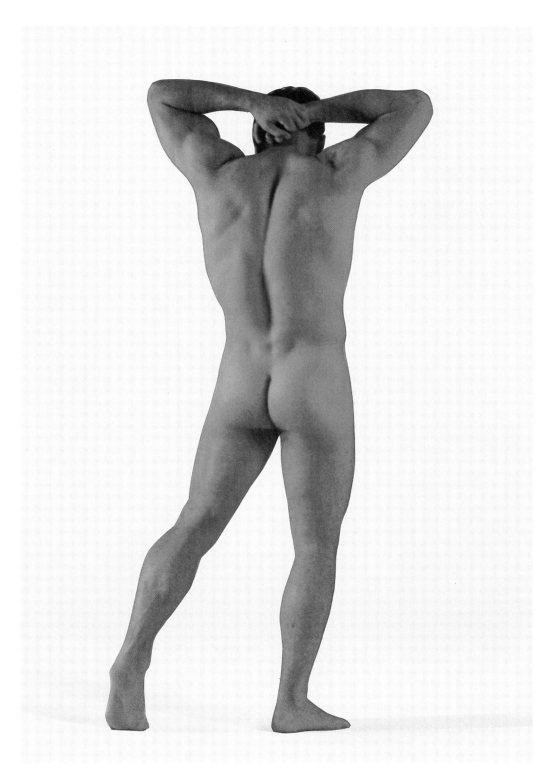

The ridges, grooves, and bulges of the back are among the most difficult to identify anatomically, as they alter in appearance with every movement. For example, what causes the conspicuous indentations here on either side of the upper back?

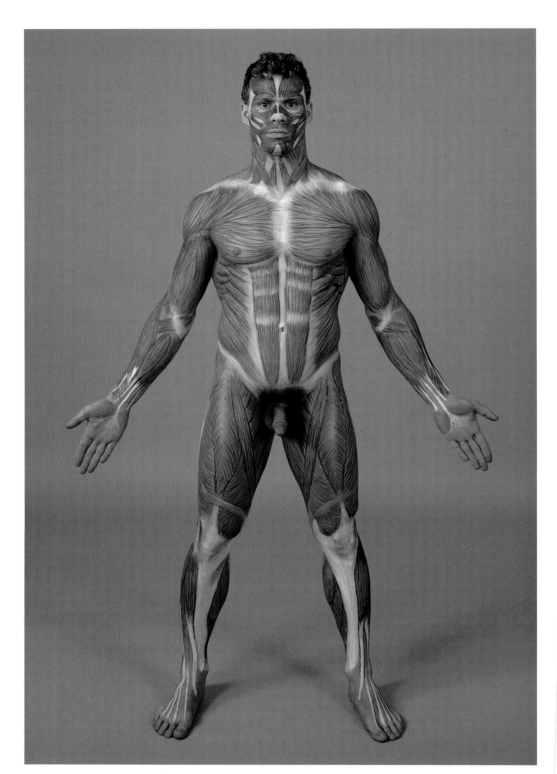

Anatomical position, anterior view. Most of the surface muscles on the front of the body are shown here. How many can you identify? The white areas are tendons or fascial sheets (aponeuroses).

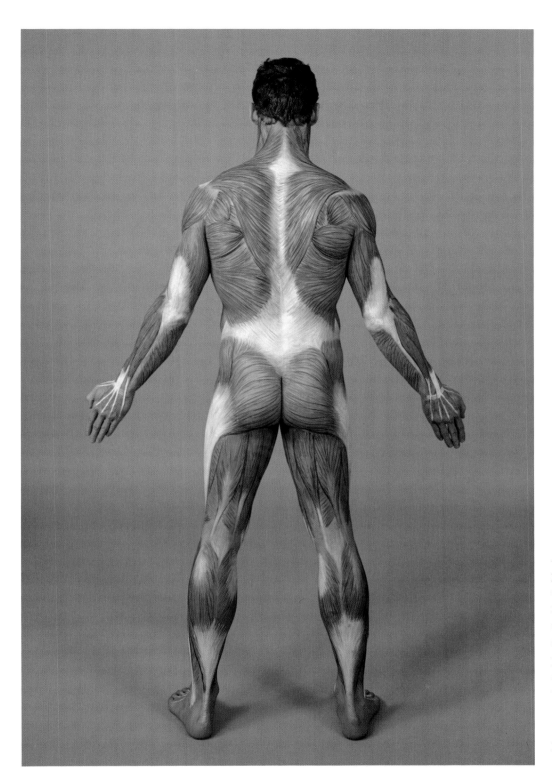

Anatomical position, posterior view. Most of the surface muscles of the back side of the body are shown here. The pearly white area above the buttocks is the lumbo-sacral fascia. It covers the deeper muscles that parallel the spine on either side.

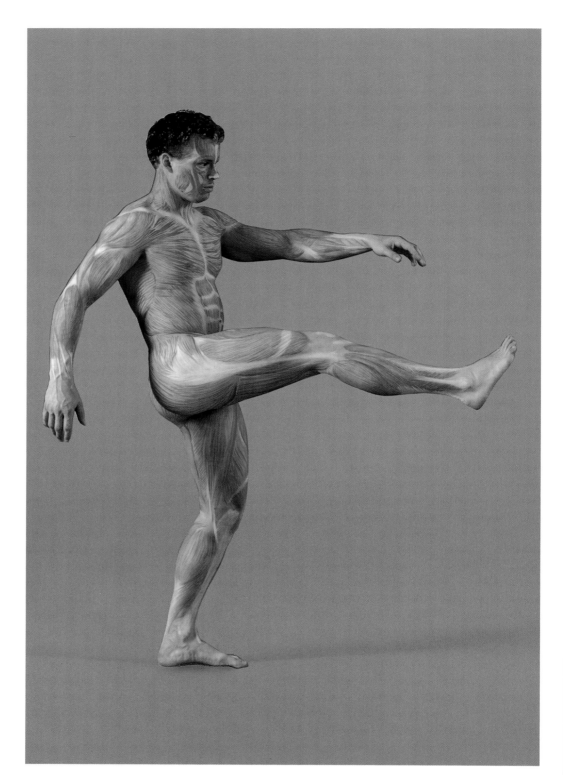

Vigorous movement away from the anatomical position causes the skin to stretch, contract, and change position as the muscles underneath change shape and position. The simulated muscles, in shifting with the skin surface, alter their shape and size according to the changes in the actual muscles.

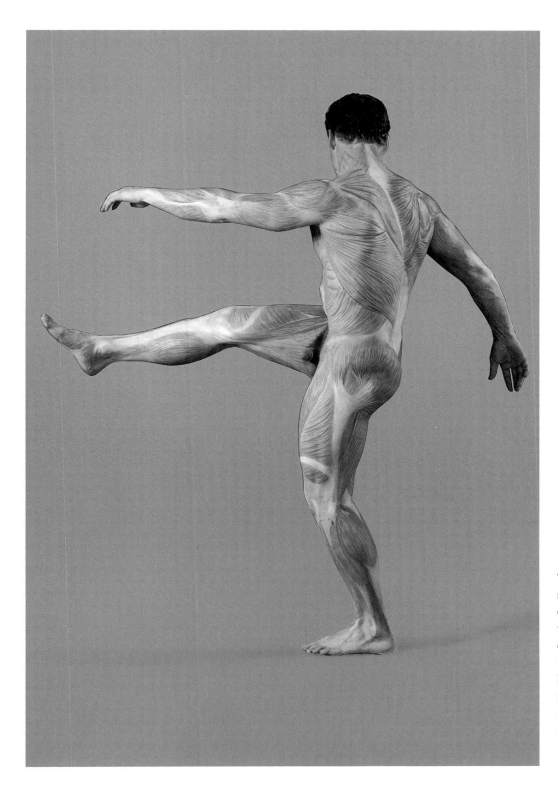

The white elongated structure along the outer surface of the thigh is a band of connective tissue (fascia). Do you know its name? In a muscular subject, it forms an elongated depression along the lateral side of the thigh.

All muscles of the legs are in a state of contraction here. Pulling back the right leg are the extensors; thrusting forward the left are the flexors. Both sets of muscles, however, are active. As antagonists, they control and regulate the violence of their opposites.

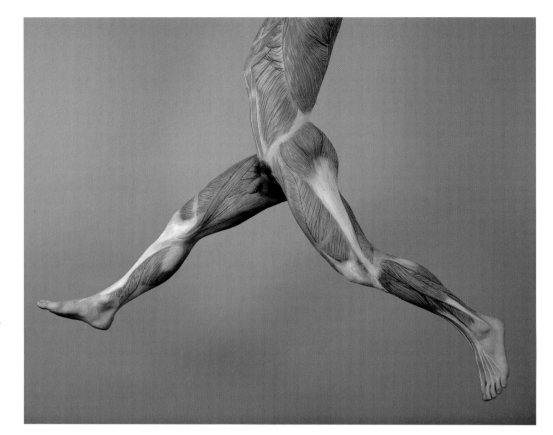

The abductor group of muscles of the thigh and pelvis pull the legs away from the midline. The largest buttock muscle, though not an abductor, braces the knee in this action via the lateral band of fascia while stabilizing the pelvis, hence its strong contraction here.

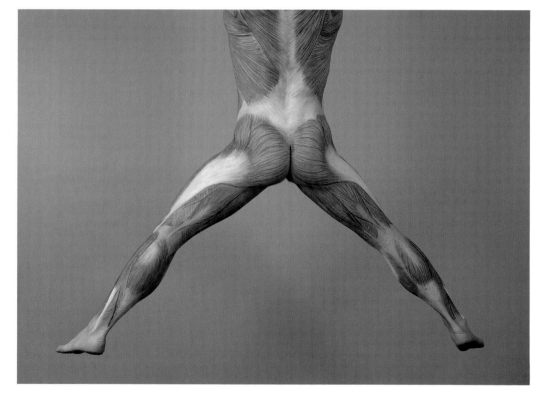

graphs of the model "with his skin on" for each of the poses. The imaginative gap of the old diagram and plaster écorché approaches is thereby considerably abridged. One has only to look at the muscles in the painted photograph to appreciate the way they produce the subtle lights and darks, hills and valleys, in the unpainted one. As the same model, in the same position, appears in both pictures, the mental effort of synthesizing the two is accordingly much reduced.

Text, in this approach, is of secondary importance, and thus I have kept it to a minimum. I believe that anyone who looks at our photographs closely and frequently, who reads the short captions under each, and who attends carefully to the labels will learn a great deal of surface anatomy. Moreover, this person will learn it almost effortlessly. For the learning of many things—things that require the grasp of some complex whole—words may not be adequate and, at worst, may constitute a barrier to comprehension. (I am reminded here of descriptions I have read of symphonies and paintings.) Anatomy is primarily learned visually. Indeed, I believe it may be the only way it is learned. Spatial relations—which is what anatomy is all about—can often be taken in at a glance. But they are next to impossible to convey in words.

That anatomy is learned visually is attested to by the number and popularity of anatomical atlases. These works, usually considered as mere supplements to major texts, consist mostly of labeled drawings and paintings of the human body. The practice of medical schools also supports the view that anatomical knowledge is mediated primarily through the eyes. First-year students are required to dissect a cadaver so that they may see for themselves just how the body is put together. The habits of the students themselves promote this practice. I have had opportunity to observe hundreds of them in two medical schools, and I was once a medical student myself. Probably no student, in the history of medical education, has ever read a Gray's, Cunningham's, or Morris's anatomy from cover to cover. Each of them owns one or more of these heavy books (Cunningham's is 1,577 pages). They consult them often, as one would consult a dictionary, and find them helpful in clearing up minute points after the students know the body in a general way. But these books are never read through as one reads, for instance, a history book. What these students do pore over, hour after hour, day after day, are things they can *see:* the cadaver itself, the drawings in the atlases, the articulated skeleton, and three-dimensional models. As a supplement, professors show movies of dissections. It all goes to show, I believe, that anatomy is primarily learned visually.

It therefore seems odd that, as far as I know, little systematic effort is made in medical schools to teach anatomy to beginning students by demonstrations on living, healthy models. That is left for the so-called clinical years when the focus is on dis-

ease and the subjects are actual patients. I would not hesitate to say that the emphasis given to normal surface anatomy in modern medical schools falls considerably below that of nineteenth-century art schools in France and Germany.

I should make clear the purpose of this book. It is a surface anatomy designed to enable one to identify the superficial structures that disclose their presence via the ever-changing topography of the skin. As such it should prove helpful to those working in a number of different areas, including artists, sculptors, medical students, physical therapists, massage therapists, and weight-lifters—in other words, to anyone interested in the muscles that give the body its outward contours and planes. The book is not designed to show precisely how the muscles move, only to show where they are and what they look like when they do move. It is primarily a visual presentation: It allows one to learn by observation rather than by dissection.

What this book can do better than most is answer the question, What causes those depressions, corregations, indentations, bulges, pockets, hollows, dimples, creases, crannies, ridges, furrows, knobs, folds, curves, grooves, tucks, knots, clefts, pits, dents, and bumps?

The Action of Muscles

There are at least 850 muscles in the human body. No authority I have consulted hazards an exact figure, not because no one has counted, but because there is disagreement about which are separate muscles and which slips off larger ones. Also, there is wide variability from one person to another, though the general plan remains the same. In man, as in most mammals, the musculature accounts for a larger share of body weight than any other tissue, some 45 percent of the total.

Muscle is the only tissue in the body capable of contracting (shortening) and relaxing (lengthening). Because of this ability, it can produce motion. Each muscle is a distinct organ composed of several elements. The muscle cells themselves, with their unique power of contractility, are found in little bundles, or *fasciculi,* about 1 ½ inches long and about ⅟₅₀₀ inch wide. Each cell has an elastic sheath, the *sarcolemma.* Note that "elastic" does not mean "contractile." Elastic substances only shorten or lengthen when acted upon by some external force. For example, when the muscle cell contracts, its elastic sarcolemma is shortened and pulled along with it. The muscle bundles are held together by elastic connective tissue, and this whole fleshy structure, the body of the muscle, made up of myriads of these bundles, is enveloped in an elastic membranous sheath.

Muscles are conventionally thought of as having an *origin* (the fixed point of attachment, usually to bone) and an insertion (where the motion takes place). Muscles both originate and insert by means of tendons, fibrous tissue united to the sarcolemma and other connective tissue in the muscle belly. The fibers of the tendinous origin and of the tendinous insertion are continuously connected throughout the length of the muscle where, intimately attached to the other connective tissue elements, they function as part of the muscle's elastic system. The presence of tendinous elements in a muscle implies an attachment to bone. The muscles of the tongue, for example, do not have tendons.

The area on a bone where a muscle attaches by means of a tendon is often small, concentrating the power of the muscle on a limited area and thereby improving leverage. A long tendon enables the muscle to be closer to the heart; thus the artery is short. A short tendon, on the other hand, would require a longer artery from the heart. As

tendons are tough and relatively invulnerable, and arteries are tender and vulnerable, it is better engineering to lengthen the tendon and shorten the artery.

Most muscles are attached to bones at both ends. The attachment closer to the spinal axis of the body is generally considered the *origin;* the one farther from the axis is the *insertion*. At first glance, it seems that the origin is the fixed point, and the insertion is where the muscle performs its action. Actually, there are no permanently fixed points; most muscles simply are attached to two bones across a joint, and each bone may function as either the fixed point or the moveable one. When the muscle contracts, the two bones are pulled toward each other; if one is fixed (for example, by the contraction of surrounding muscles or by external constraint), the other one, willy-nilly, is the one that moves. This reversal of our notions of origin and insertion is readily apparent in the flexors and extensors of the hip, knee, and elbow. For example, *gluteus maximus* is considered primarily an extensor of the hip. But when we bend over to pick up an object from the floor, we straighten up again when this muscle, now using the femur as the fixed point, draws the pelvis backward, and with it the trunk, enabling us to regain the upright posture.

Despite their somewhat arbitrary nature, the concepts of origin and insertion have their usefulness. If one knows precisely where a muscle inserts by the conventional definition, one can determine the function of the muscle even while having only a general idea of its origin. Knowing the function of a muscle sharpens one's ability both to perceive its changing contours and, if one is an artist or medical person, to depict or assess it more readily and accurately.

The following section is not meant to be an exhaustive outline of the origins, insertions, and actions of all the muscles of the body. Many muscles, buried under other tissues and organs, exert little observable effect on surface topography. Therefore, deep dissection or radiology are the appropriate avenues to them. As this book deals with surface anatomy, their inclusion here would be pointless. What follows, then, deals only with those structures that meet the eye and, with a degree of technical assistance, can be clearly apprehended in their anatomical significance by the informed observer.

The Muscles of the Trunk and Shoulder

Pectoralis Major. *Origin:* the anterior half or two-thirds of the clavicle, the anterior surface of the manubrium and sternum, and the cartilages of ribs one through six. *Insertion:* lateral border of the sulcus intertubercularis of the humerus. *Action:* adduc-

tion and medial rotation of the arm. The clavicular fibers help the deltoid flex the humerus. The other, lower, fibers extend the humerus when it is fully flexed. This muscle is important in climbing. When the shoulders are fixed, it aids respiration by raising the six upper ribs.

Serratus Anterior. *Origin:* lateral aspect of the upper eight or nine ribs. *Insertion:* threefold, the portion from the first and second ribs inserts on the inner aspect of the medial angle of the scapula; the portion from the second to fourth ribs inserts into the vertebral margin of the scapula; the portion from ribs five through nine inserts into the inner aspect of the inferior angle of the scapula. *Action:* draws the scapula forward around the chest wall; acts as a fixation muscle in the early phase of abduction of the humerus and as an active agent in the later one. It makes possible pushing with the hands and outstretched arms.

Deltoideus. *Origin:* front of the lateral third of the clavicle; lateral border of the acromion process of the scapula; inferior edge of the spine of the scapula; deep fascia of the infraspinatus. *Insertion:* above the radial groove of the humerus where it merges with the tendon of the pectoralis major. *Action:* abducts the humerus, pulling the arm forward and laterally; anterior fibers assist the clavicular portion of the pectoralis major to flex and medially rotate the humerus; posterior fibers augment the extensors and lateral rotators.

Teres Major. *Origin:* lower third of the axillary margin of the scapula; fascial septa between the subscapularis and infraspinatus. *Insertion:* medial border of the sulcus intertubercularis of the humerus where its tendon adheres to that of latissimus dorsi. *Action:* medially rotates and adducts the humerus.

Teres Minor. *Origin:* caudal section of the infraspinatus fossa and lateral margin of the scapula; infraspinatus fascia. *Insertion:* most distal of the three facets on the larger tubercle of the humerus; capsule of the shoulder joint. *Action:* laterally rotates and adducts the humerus.

Infraspinatus. *Origin:* infra-spinous fossa of the scapula and covering fascia. *Insertion:* middle facet on the larger tubercle of the humerus and capsule of the shoulder joint. *Action:* lateral rotation of the humerus.

Rhomboideus Major. *Origin:* spinous processes and supraspinous ligaments of the second to fifth thoracic vertebrae. *Insertion:* vertebral margin of the scapula between

its spine and inferior angle. *Action:* rotates inferior angle of the scapula medially; with the trapezius, it braces the shoulders back.

Trapezius. *Origin:* medial third of the superior nuchal line; external occipital protuberance; spinous processes of the cervical vertebrae; spines of the thoracic vertebrae and supraspinous ligaments. *Insertion:* lateral third of the clavicle; acromion process and spine of the scapula. *Action:* upper fibers elevate the scapula; the lower depress the scapula; middle fibers pull the scapulae together and help rotate them. Normal tone keeps the shoulders squared.

Latissimus Dorsi. *Origin:* spines of the lower six thoracic vertebrae and posterior layer of the lumbo-dorsal fascia; lower three or four ribs; inferior angle of the scapula (small slip only). *Insertion:* intertubercular sulcus of the humerus. *Action:* adducts and extends the humerus (as when the arm is lowered in swimming); assists in rotating the arm medially; draws the body up after the arms in climbing; assists the abdominal muscles in violent expiration.

Obliquus Externus Abdominis. *Origin:* lateral surfaces of the lower eight ribs, slips interdigitating with the serratus anterior and latissimus dorsi. *Insertion:* lower fibers —external lip of the anterior half of the iliac crest; the remainder—aponeurosis of the anterior abdominal wall. *Action:* keeps the viscera in place and forces the viscera against the diaphragm during expiration; one side bends the spine laterally, and the two together flex it; increases abdominal pressure for rectal evacuation.

Rectus Abdominis. *Origin:* fifth to seventh costal cartilages and xiphoid process of the sternum. *Insertion:* ligaments in front of the symphysis pubis; crest of the symphysis pubis. (Authorities disagree about which should be called origin and which insertion. According to Cunningham's, it arises from the symphysis pubis.) *Action:* flexes the vertebral column, pulling the sternum toward the pubis (thereby acting as antagonist to the sacrospinalis); compresses the abdominal contents.

The Muscles of the Neck

Sternocleidomastoideus. *Origin:* anterior surface of the manubrium; medial third of the clavicle. *Insertion:* lateral surface of the mastoid portion of the temporal bone; superior nuchal line of the occipital bone. *Action:* flexes the head laterally and rotates it to opposite side; acting together, they flex the head forward.

Levator Scapulae. *Origin:* posterior tubercles of the transverse processes of the upper four cervicle vertebrae. *Insertion:* vertebral margin of the scapula from the medial angle to its spine. *Action:* rotates the scapula and rotates the inferior angle medially; with the trapezius, it elevates the point of the shoulder.

Splenius Capitis. *Origin:* nuchal ligament and spinous processes of the third to seventh cervicle vertebrae; first three thoracic vertebrae. *Insertion:* lateral third of the superior nuchal line; mastoid process. *Action:* rotates the head toward the splenius capitas that is contracting; together, they extend the head and neck.

Scalenus Anterior. *Origin:* anterior tubercles of the transverse processes of the third through sixth cervicle vertebrae. *Insertion:* scalene tubercle and ridge; first rib. *Action:* together, they laterally flex the vertebral column; singly, it bends the neck to the side; elevates the first and second ribs.

Scalenus Medius. *Origin:* posterior tubercles of the transverse processes of the last six cervicle vertebrae. *Insertion:* cranial surface of the first rib dorsal to the subclavian groove. *Action:* same as the scalenus anterior.

Scalenus Posterior. *Origin:* posterior tubercles of the transverse processes of the last three cervicle vertebrae. *Insertion:* outer surface of the second rib. *Action:* same as the scalenus anterior and the scalenus medius.

Sternohyoid. *Origin:* inner surface of the manubrium; sternoclavicular joint. *Insertion:* hyoid bone. *Action:* fixes the hyoid; assists in swallowing and phonation.

Omohyoid. *Origin:* superior margin of the scapula. *Insertion:* lateral section of the hyoid bone. *Action:* same as the sternohyoid.

Digastric. *Origin:* mastoid notch of the temporal bone. *Insertion:* digastric fossa of the mandible. *Action:* opens the jaws by depressing the lower jaw; fixes the hyoid.

The Facial Muscles

Orbicularis Oculi. *Origin:* orbital part—maxilla, medial angle of the eye, medial palpebral ligament; palpebral part—medial palpebral ligament; lacrimal part—posterior lacrimal crest. *Insertion:* surrounds and occupies the eyelids as a sphincter. *Action:* closes the lids and compresses the lacrimal sac to expel tears.

Occipitofrontalis. *Origin:* supraorbital ridge; skin of forehead. *Insertion:* galea aponeurotica. *Action:* wrinkles the forehead and moves the scalp.

Nasalis. *Origin:* maxilla over the canine teeth; alar cartilage. *Insertion:* fascia over the bridge of the nose and the skin at the tip. *Action:* twitches the nose and dilates and contracts the nostrils.

Zygomaticus Major and Minor. *Origin:* malar and lateral surface of the zygomatic bone. *Insertion:* angle of the mouth. *Action:* produces facial expressions involving the corners of the mouth.

Orbicularis Oris. *Origin:* sphincter surrounding the lips between the skin and mucous membrane with fibers from the buccinator. *Insertion:* skin of the lips. *Action:* protrudes and shapes the lips.

Depressor Anguli Oris. *Origin:* oblique line of the mandible. *Insertion:* corner of the mouth and the lower lip. *Action:* draws the mouth down at the corners.

Levator Labii. *Origin:* frontal process of the maxilla and infraorbital margin. *Insertion:* ala of the nose and upper lip. *Action:* raises the ala of the nose.

Mentalis. *Origin:* incisive fossa of the mandible. *Insertion:* skin of the chin. *Action:* lifts and wrinkles the skin of the chin.

Temporalis. *Origin:* temporal fascia and temporal fossa of the mandible. *Insertion:* coronoid process and anterior border of the ramus of the mandible; skin superior and anterior to the ear. *Action:* helps close the mouth and clench the teeth.

Masseter. *Origin:* inferior border of the zygomatic arch and deep surface of the zygomatic arch. *Insertion:* lateral surface of the ramus and angle of the mandible; coronoid process. *Action:* raises the lower jaw as in chewing.

The Muscles of the Arm

Biceps. *Origin:* long head—supraglenoid tubercle of the scapula; short head—tip of coracoid process of the scapula. *Insertion:* posterior half of the radial tuberosity; aponeurosis of the biceps merges with the antebrachial fascia. *Action:* flexes and supinates

the forearm; tenses the antebrachial fascia; helps flex the shoulder joint; stabilizes the head of the humerus.

Coricobrachialis. *Origin:* tip of the coracoid process; tendon of the pectoralis major. *Insertion:* medial border of the humerus. *Action:* flexes and adducts the arm.

Brachialis. *Origin:* distal half of the anterior aspect of the humerus; medial and lateral intermuscular septa. *Insertion:* interior ligament of the elbow; distal surface of the coronoid process; volar surface of the ulna. *Action:* flexes the forearm.

Anconeus. *Origin:* lateral epicondyle of the humerus; medial and lateral intermuscular septa. *Insertion:* lateral aspect of the olecranon; dorsal surface of the ulna as far distally as the oblique line. *Action:* extends the elbow and braces the extended elbow joint when pushing.

Triceps Brachii. *Origin:* long head—infra-glenoidal tuberosity; lateral head—lateral border of the humerus; medial head—posterior surface of the humerus. *Insertion:* posterior part of the proximal end of the olecranon of the ulna; deep fascia of the forearm. *Action:* extends the forearm; adducts and extends the arm; braces the elbow joint when it is extended and pushing.

Extensor Carpi Radialis Longus. *Origin:* distal third lateral supracondylar ridge of the humerus; lateral intermuscular septum. *Insertion:* base of the second metacarpal. *Action:* extends and abducts the hand.

Extensor Carpi Radialis Brevis. *Origin:* lateral epicondyle of the humerus. *Insertion:* base of the third metacarpal. *Action:* assists the extensor carpi radialis longus.

Abductor Pollicis Longus. *Origin:* posterior surface of the ulna and radius; interosseous membrane. *Insertion:* base of the thumb; first metacarpal. *Action:* abducts the thumb; extends the first phalanx of the thumb; abducts the hand.

Extensor Pollicis Brevis. *Origin:* posterior surface of the radius; interosseous membrane. *Insertion:* base of the proximal phalanx of the thumb. *Action:* assists the abductor pollicis longus.

Extensor Digitorum. *Origin:* lateral epicondyle of the humerus; antebrachial fascia. *Insertion:* middle and distal phalanges of the fingers by means of the four tendons.

Action: extends the hand and fingers two, three, four, and five; spreads the fingers apart.

Extensor Carpi Ulnaris. *Origin:* lateral epicondyle of the humerus; antebrachial fascia. *Insertion:* base of the fifth metacarpal on the dorsal side. *Action:* adducts and slightly extends the hand.

Flexor Carpi Radialis. *Origin:* medial epicondyle of the humerus; antebrachial fascia. *Insertion:* base of the second metacarpal on the palmar side. *Action:* flexes the wrist and elbow; abducts the wrist; pronates the forearm.

Palmaris Longus. *Origin:* medial epicondyle of the humerus; antebrachial fascia. *Insertion:* aponeurosis of the palm. *Action:* tenses the palmar aponeurosis; weakly flexes the elbow and wrist.

The Muscles of the Hip and Thigh

Gluteus Maximus. *Origin:* dorsum ilii above the superior gluteal line; tendon of the sacrospinalis; dorsal surface of the sacrum and coccyx; posterior surface of the sacro-tuberous ligament. *Insertion:* fascia lata over the greater trochanter of the femur; gluteal tuberosity of the femur. *Action:* extends the thigh; straightens the lower limb as in climbing and running; lower fibers adduct the thigh and rotate it laterally; extends the trunk on the lower limbs; raises the trunk from a sitting position.

Gluteus Medius. *Origin:* lateral surface of the ilium between the anterior and posterior lines. *Insertion:* posterior-superior angle of the great trochanter. *Action:* abducts the thigh in all positions and rotates medially when the thigh is extended.

Tensor Fasciae Latae. *Origin:* anterior superior iliac spine. *Insertion:* into a splitting of fascia lata and into the ilio-tibial tract. *Action:* abducts and medially rotates the thigh; extends the knee joint through the ilio-tibial tract; counteracts the backward pull of the gluteus maximus.

Biceps Femoris. *Origin:* short head—linea aspera of the femur; long head—ischial tuberosity of the pelvis. *Insertion:* head of the fibula; lateral condyle of the tibia; deep fascia on the lateral aspect of the leg. *Action:* flexes the knee joint; long head helps extend the thigh; rotates the leg laterally when the knee is flexed.

Semimembranosus. *Origin:* superior and lateral facet of the ischial tuberosity. *Insertion:* postero-medial aspect of the medial condyle of the tibia. *Action:* flexes the knee; rotates the flexed tibia medially; extends the hip.

Semitendinosus. *Origin:* inferior and medial facet of the ischial tuberosity. *Insertion:* medial side of the tibia distal to the medial condyle; deep fascia of the leg. *Action:* flexes the knee; medially rotates the flexed tibia; extends the hip.

Gracilis. *Origin:* lower half of the edge of the symphysis pubis and the border of the pubic arch. *Insertion:* medial surface of the tibia distal to the medial condyle. *Action:* flexes the knee, adducts the thigh; when the knee is flexed, it medially rotates the tibia.

Adductor Longus. *Origin:* anterior surface body of the pubis in the angle between the crest and the symphysis. *Insertion:* middle third of the medial lip of the linea aspera. *Action:* adducts the thigh; assists in flexion and lateral rotation.

Adductor Magnus. *Origin:* lower part of the inferior pubic ramus; ramus of the ischium; ischial tuberosity. *Insertion:* linea aspera; medial epicondylic line of the femur; adductor tubercle of the medial condyle of the femur. *Action:* proximal part—adducts the thigh and assists in flexion and lateral rotation; distal part—extends the femur and assists in medial rotation.

Sartorius. *Origin:* anterior superior iliac spine. *Insertion:* medial margin of the tibial tuberosity. *Action:* flexes, laterally rotates, and abducts the thigh; flexes the leg; assists in medial rotation of the tibia.

Pectineus. *Origin:* pectineal line of the pubis and pectineal portion of the fascia lata. *Insertion:* pectineal line of the femur. *Action:* adducts the thigh and aids in flexion and lateral rotation of the hip joint.

THE QUADRICEPS FEMORIS GROUP

Vastus Medialis. *Origin:* linea aspera of the femur. *Insertion:* common tendon to the patella; continues over the patella into the patellar ligament. *Action:* extends the leg.

Vastus Lateralis. *Origin:* capsule of the hip joint; tubercle of the femur; anterior surface of the shaft of the femur medial to the trochanter; distal border of the trochanter; gluteal tuberosity of the femur and tendon of the gluteus maximus; proximal half of the linea aspera; fascia lata and intermuscular septum. *Insertion:* tendon of the rectus femoris; proximal and lateral border of the patella in front of the lateral condyle of the tibia. *Action:* extends the leg.

Vastus Intermedius. *Origin:* proximal two-thirds of the body of the femur, that is, the anterior and lateral surfaces. *Insertion:* tendons of the rectus and vasti. *Action:* extends the leg.

Rectus Femoris. *Origin:* straight head—anterior inferior iliac spine; reflected head—groove on the dorsum ilii above the acetabulum. *Insertion:* proximal border of the patella. *Action:* joins with the rest of the quadriceps to extend the leg; flexes and abducts the thigh.

The Muscles of the Lower Leg

Gastrocnemius. *Origin:* medial head—medial condyle of the femur and capsule of the knee; lateral head—lateral condyle of the femur and capsule of the knee. *Insertion:* posterior surface of the broad membranous tendon that narrows distally into the tendo calcaneus. *Action:* flexes the knee and extends the ankle.

Soleus. *Origin:* posterior surfaces of the head and proximal third of the fibula; soleal line and middle third of the medial border of the tibia. *Insertion:* tendo calcaneus. *Action:* extends the ankle.

Tibialis Anterior. *Origin:* lateral condyle and surface of the tibia; interosseous membrane. *Insertion:* medial surface of the first cuneiform and medial side of the base of the first metatarsal. *Action:* dorsi-flexes the ankle (raises the foot) and helps invert the foot.

Extensor Digitorum Longus. *Origin:* lateral condyle of the tibia; proximal three-fourths of the fibula; interosseous membrane; crural fascia; anterior muscular septum of the leg. *Insertion:* four medial toes. *Action:* extends the four medial toes.

Peroneus Longus. *Origin:* lateral condyle of the tibia; head and proximal two-thirds of the lateral surface of the fibula; intermuscular septa and fascia. *Insertion:* tendon

hooks around the lateral malleolus, crosses the lateral side of the calcaneus, passes below the trochlear process and into the lateral sides of the first cuneiform and the base of the first metatarsal. *Action:* pronates (everts and abducts) and flexes the foot.

Peroneus Brevis. *Origin:* lateral surface of the fibula. *Insertion:* tuberosity and dorsal surface of the base of the fifth metatarsal. *Action:* everts and plantar-flexes the foot.

The Appearance of Muscles

18

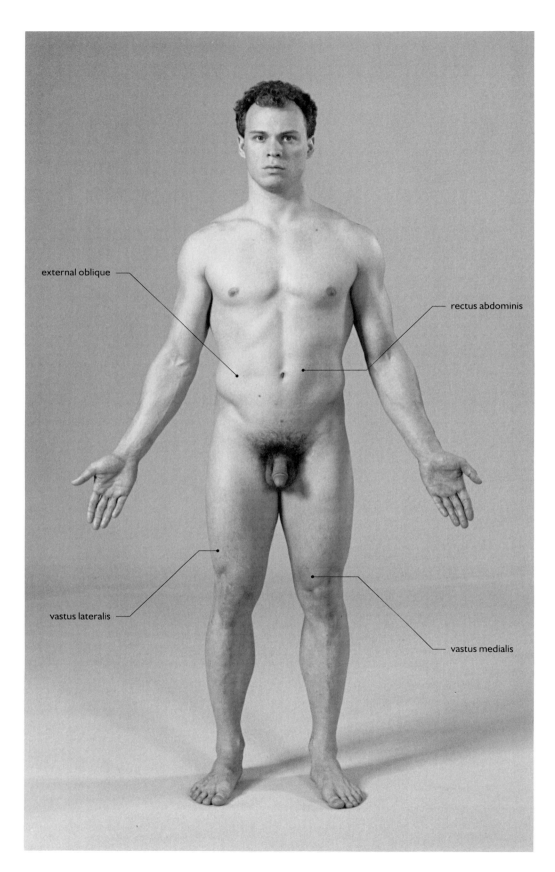

external oblique

rectus abdominis

vastus lateralis

vastus medialis

Figure 2.
Anatomical position,
anterior view. Even
with the body more
or less relaxed, as in
this posture, certain
muscles are strongly
contracted to
provide support and
balance. Note the
bulging of *vastus
lateralis* and *vastus
medialis* just above
the knees. Also
somewhat tensed
are the abdominal
muscles that provide
support for the
viscera; here the
external oblique and
rectus abdominis are
conspicuous.

19

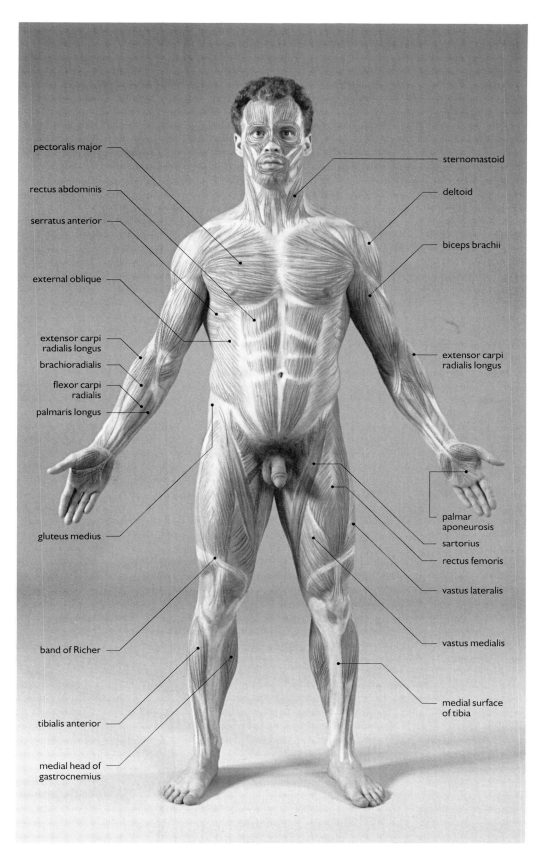

pectoralis major

rectus abdominis

serratus anterior

external oblique

extensor carpi
radialis longus

brachioradialis

flexor carpi
radialis

palmaris longus

gluteus medius

band of Richer

tibialis anterior

medial head of
gastrocnemius

sternomastoid

deltoid

biceps brachii

extensor carpi
radialis longus

palmar
aponeurosis

sartorius

rectus femoris

vastus lateralis

vastus medialis

medial surface
of tibia

Figure 3.
As with the four
points of the
compass, certain
standardized
positions have
always been
prescribed by
science as a means
of orientation for
descriptions and
measurements. The
terms *caudal* and
cephalic, medial and
lateral, superior and
inferior, among
others, are based on
the convention of
the anatomical
position.

20

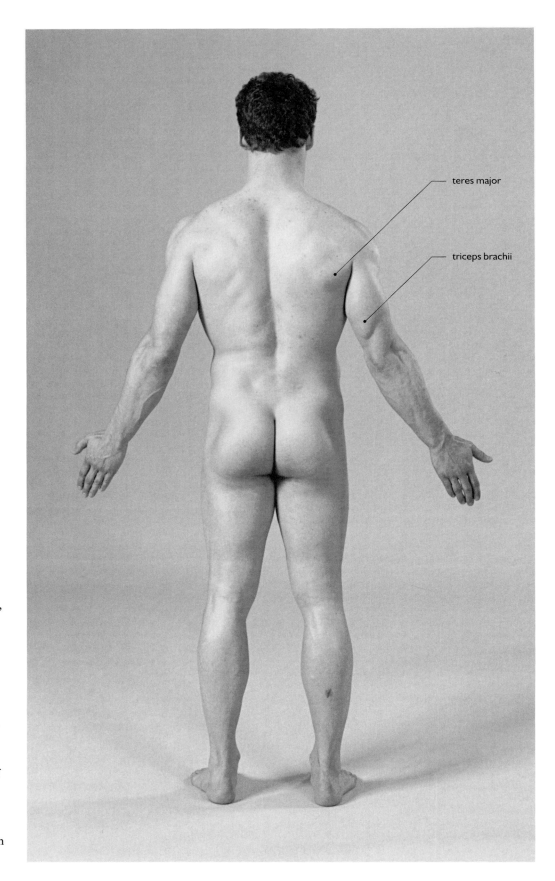

teres major

triceps brachii

Figure 4.
Anatomical position, posterior view. Several muscles are in a state of considerable contraction here. Most evident are *triceps brachii*, which are working to extend the arms against the action of the flexors on the anterior side. Also bulging is *teres major*, which helps in extending the arm.

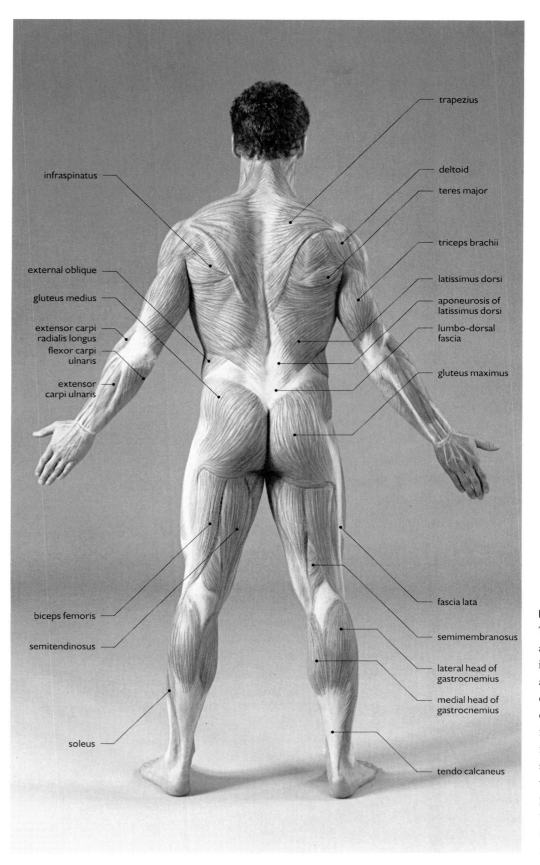

infraspinatus

external oblique

gluteus medius

extensor carpi
radialis longus

flexor carpi
ulnaris

extensor
carpi ulnaris

biceps femoris

semitendinosus

soleus

trapezius

deltoid

teres major

triceps brachii

latissimus dorsi

aponeurosis of
latissimus dorsi

lumbo-dorsal
fascia

gluteus maximus

fascia lata

semimembranosus

lateral head of
gastrocnemius

medial head of
gastrocnemius

tendo calcaneus

Figure 5.
The object of the
anatomical position
is to expose all
analogous surfaces
on the various parts
of the body. Except
for the soles of the
feet, which ideally
should face the
viewer, it accomp-
lishes its purpose,
though not perfectly,
as in the case of a
moth upon a pin.

22

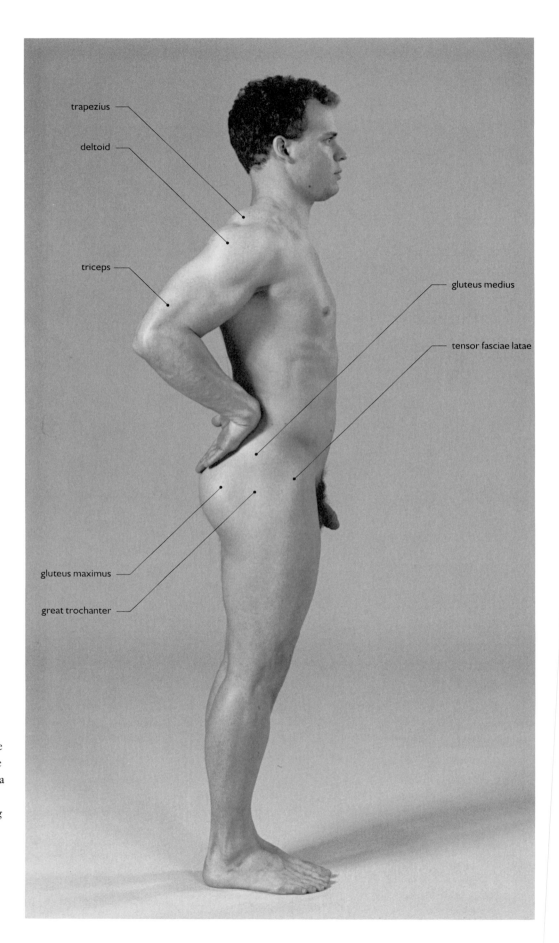

trapezius

deltoid

triceps

gluteus medius

tensor fasciae latae

gluteus maximus

great trochanter

Figure 6.
Trapezius, deltoid,
and *triceps* are
equally tensed and
conspicuous. Note
the elevation in the
center of the hip
area produced by the
great trochanter of the
femur. It appears as a
depression when the
muscles surrounding
it—*gluteus maximus,*
gluteus medius, and
tensor fasciae latae—
are significantly
contracted and swell
up around it.

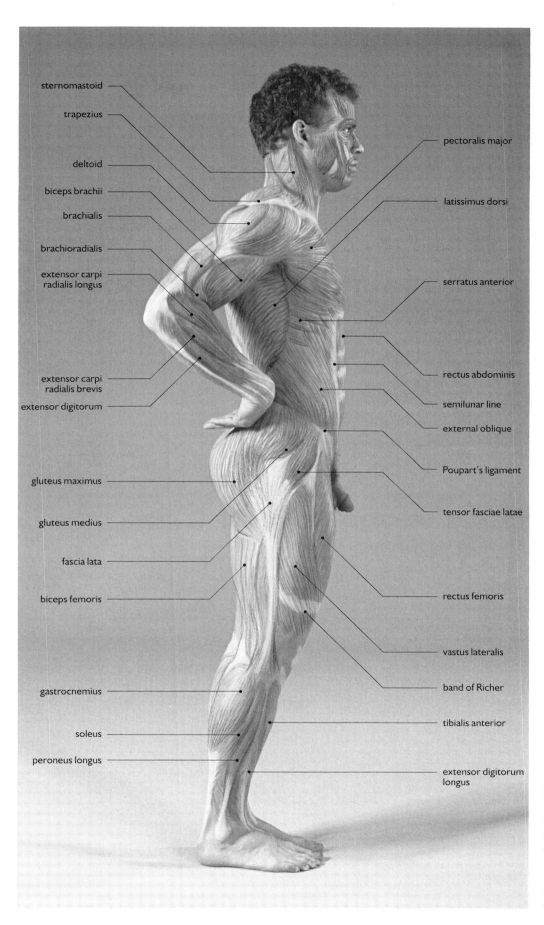

sternomastoid

trapezius

deltoid

biceps brachii

brachialis

brachioradialis

extensor carpi
radialis longus

extensor carpi
radialis brevis

extensor digitorum

gluteus maximus

gluteus medius

fascia lata

biceps femoris

gastrocnemius

soleus

peroneus longus

pectoralis major

latissimus dorsi

serratus anterior

rectus abdominis

semilunar line

external oblique

Poupart's ligament

tensor fasciae latae

rectus femoris

vastus lateralis

band of Richer

tibialis anterior

extensor digitorum
longus

Figure 7.
This is a departure
from the strict
anatomical position.
The right arm is
extended so that the
torso and hip are not
obscured.

24

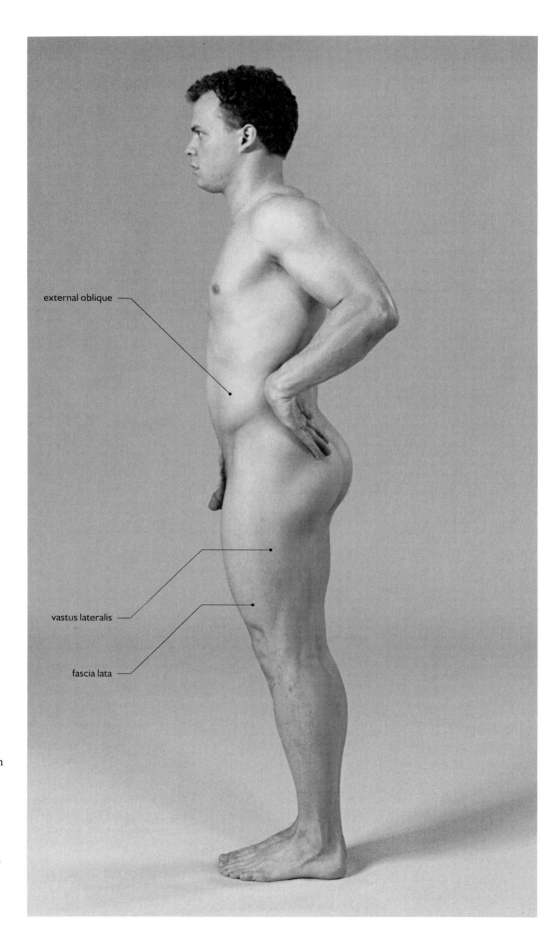

external oblique

vastus lateralis

fascia lata

Figure 8.
Can you make out
the straplike *fascia
lata* beneath the
skin? Except for a
small portion of
vastus lateralis, which
is posterior to it,
it forms a border
between the exten-
sors and flexors of
the lower leg. The
forward and inferior
borders of *exter-
nal oblique* are also
evident in this pose.

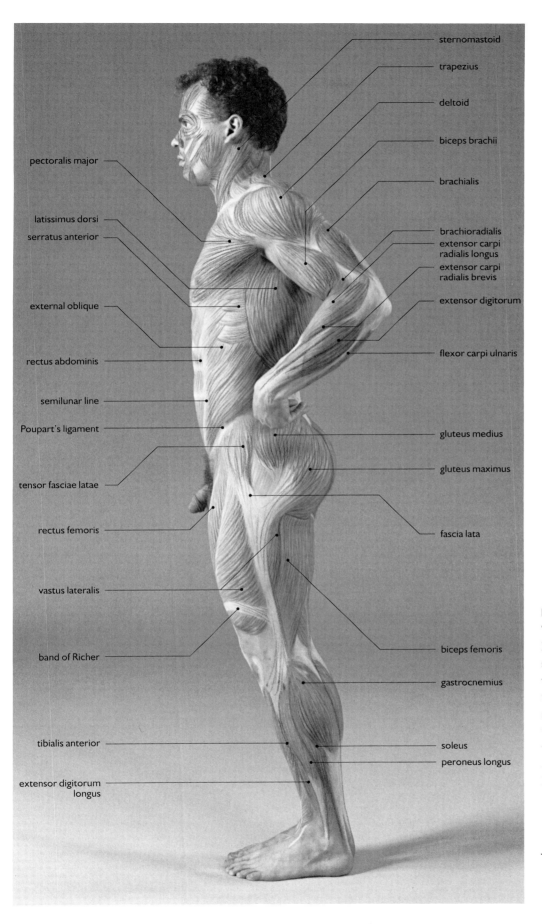

sternomastoid

trapezius

deltoid

biceps brachii

brachialis

brachioradialis
extensor carpi
radialis longus
extensor carpi
radialis brevis

extensor digitorum

flexor carpi ulnaris

gluteus medius

gluteus maximus

fascia lata

biceps femoris

gastrocnemius

soleus
peroneus longus

pectoralis major

latissimus dorsi
serratus anterior

external oblique

rectus abdominis

semilunar line

Poupart's ligament

tensor fasciae latae

rectus femoris

vastus lateralis

band of Richer

tibialis anterior

extensor digitorum
longus

Figure 9.
The opposite of
Figs. 6 and 7 is
shown here for those
who find it unhelpful
to consult the right
side of a figure when
they are seeking
visual information
about the left. Note
how the fascial band
extending down
from the two *gluteus*
muscles and *tensor
fasciae latae* spans the
knee joint, thereby
providing lateral
support.

26

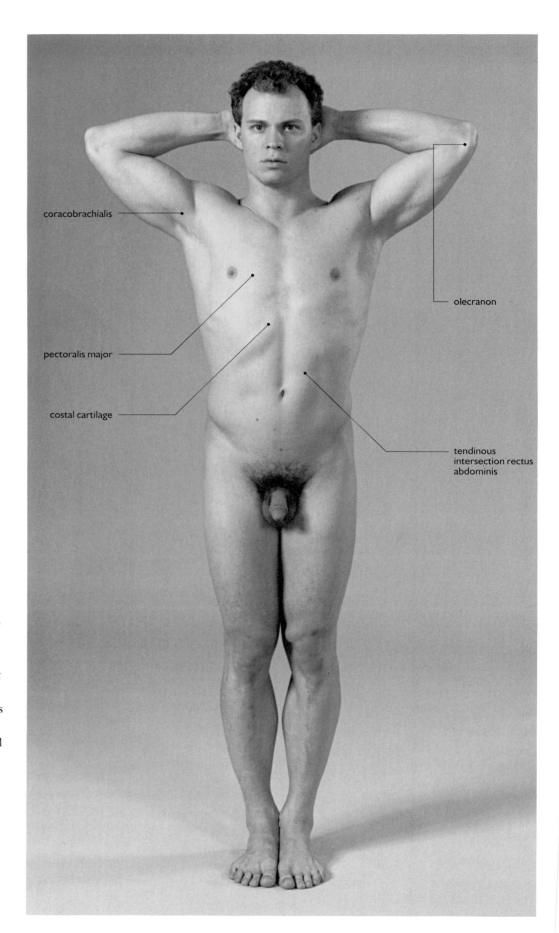

coracobrachialis

olecranon

pectoralis major

costal cartilage

tendinous
intersection rectus
abdominis

Figure 10.
Note how in this
position *pectoralis
major* is flattened
and almost passively
stretched. This is
because it has no
active role in raising
the arm. Note also
how raising the arms
elevates the rib cage
and makes the costal
cartilages slanting
down from the
sternum more
conspicuous. It also
brings into play
rectus abdominis,
several tendinous
intersections of
which are clearly
visible here.

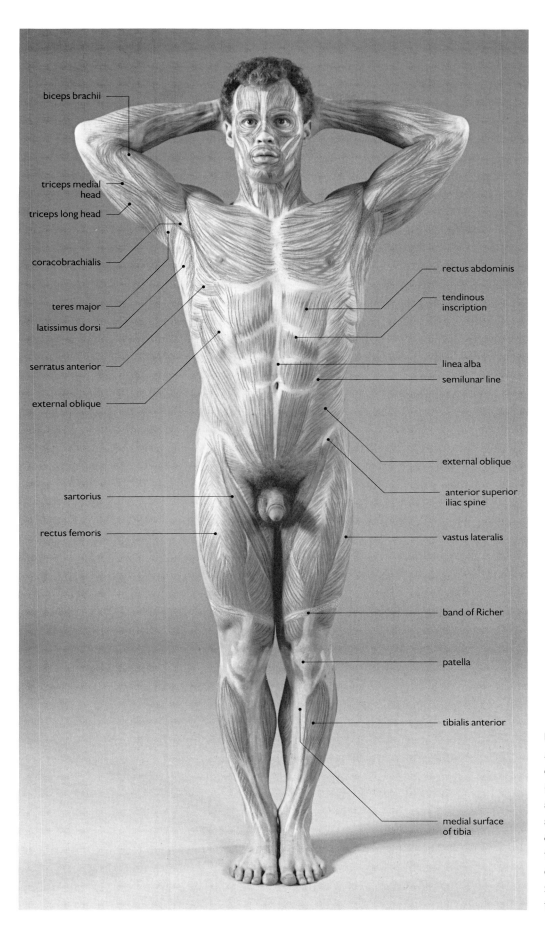

biceps brachii

triceps medial head

triceps long head

coracobrachialis

teres major

latissimus dorsi

serratus anterior

external oblique

sartorius

rectus femoris

rectus abdominis

tendinous inscription

linea alba

semilunar line

external oblique

anterior superior iliac spine

vastus lateralis

band of Richer

patella

tibialis anterior

medial surface of tibia

Figure 11.
A change in position of a part of the body (in this case, the arms) will bring about reciprocal changes—in muscle tension and degree of contraction—in most other parts of the muscular system.

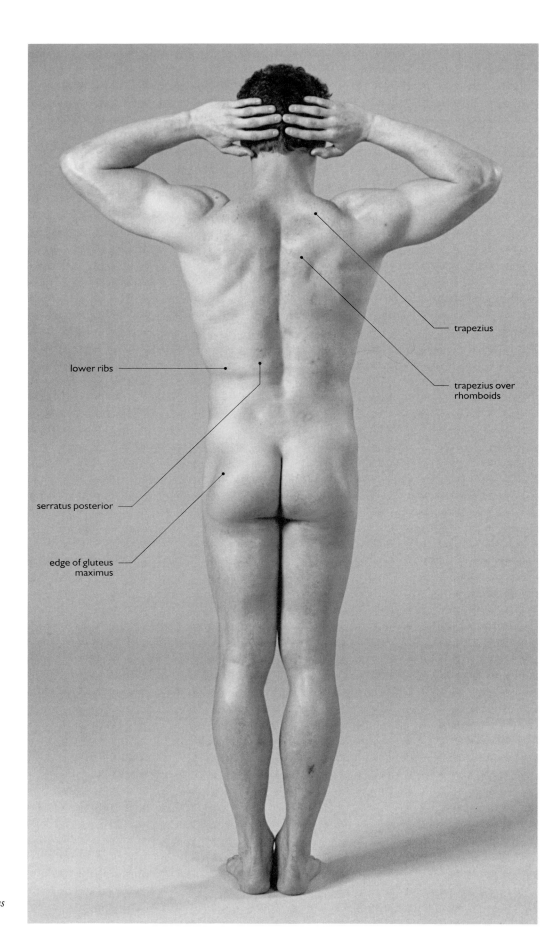

lower ribs ————

serratus posterior ————

edge of gluteus ————
maximus

trapezius

trapezius over
rhomboids

Figure 12.
The transverse
shadow just above
the lumbar area is
caused by the lower
ribs, the deep
*serratus posterior
inferior,* and
subcutaneous fat.
The midportion of
trapezius bulges
noticeably here, in
part pushed up by
the underlying
powerful *rhomboideus
major* and *minor.*

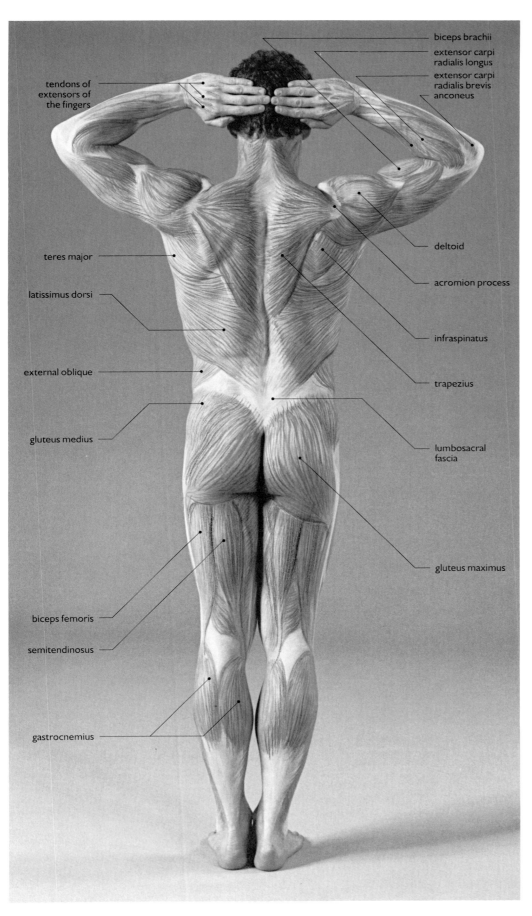

biceps brachii

extensor carpi
radialis longus

extensor carpi
radialis brevis

anconeus

tendons of
extensors of
the fingers

deltoid

acromion process

teres major

latissimus dorsi

infraspinatus

external oblique

trapezius

gluteus medius

lumbosacral
fascia

gluteus maximus

biceps femoris

semitendinosus

gastrocnemius

Figure 13.
This is the obverse
of the poses in Figs.
10 and 11.

30

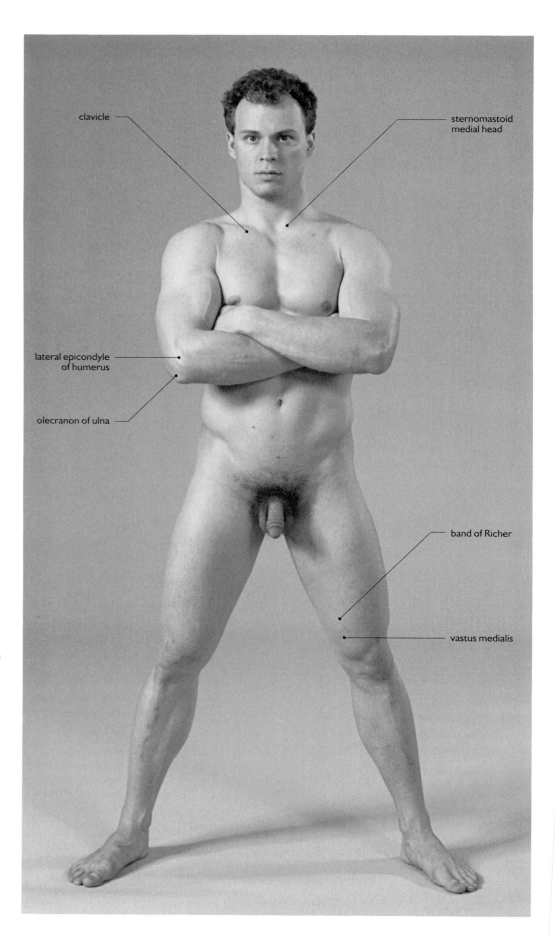

clavicle

sternomastoid
medial head

lateral epicondyle
of humerus

olecranon of ulna

band of Richer

vastus medialis

Figure 14.
The combination of flexion of the arms and pressure against the hands in this position causes *biceps* to bulge. Note also that in a wide-based stance, the legs tend to be rotated somewhat outward. The weight of the arms against the abdomen can be seen activating *rectus abdominis* and causing the lower border of *external oblique* (Poupart's ligament) to be more conspicuous.

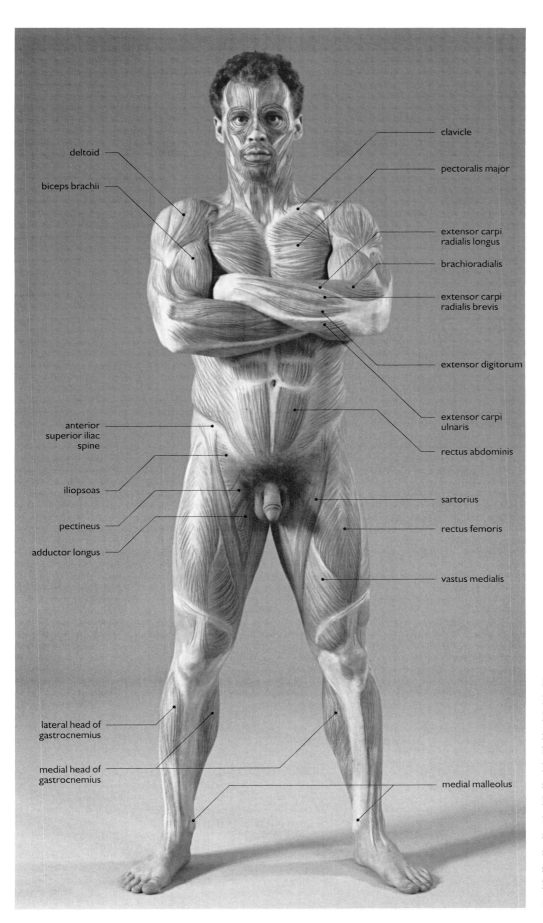

deltoid

biceps brachii

clavicle

pectoralis major

extensor carpi
radialis longus

brachioradialis

extensor carpi
radialis brevis

extensor digitorum

anterior
superior iliac
spine

extensor carpi
ulnaris

rectus abdominis

iliopsoas

pectineus

adductor longus

sartorius

rectus femoris

vastus medialis

lateral head of
gastrocnemius

medial head of
gastrocnemius

medial malleolus

Figure 15.
Because of a man's
higher center of
gravity as a result of
broader and more
heavily muscled
shoulders and arms,
he is more likely
than a woman to
adopt a wide-based
stance when he
stands and when he
kneels. (See Figs.
162 and 163.)

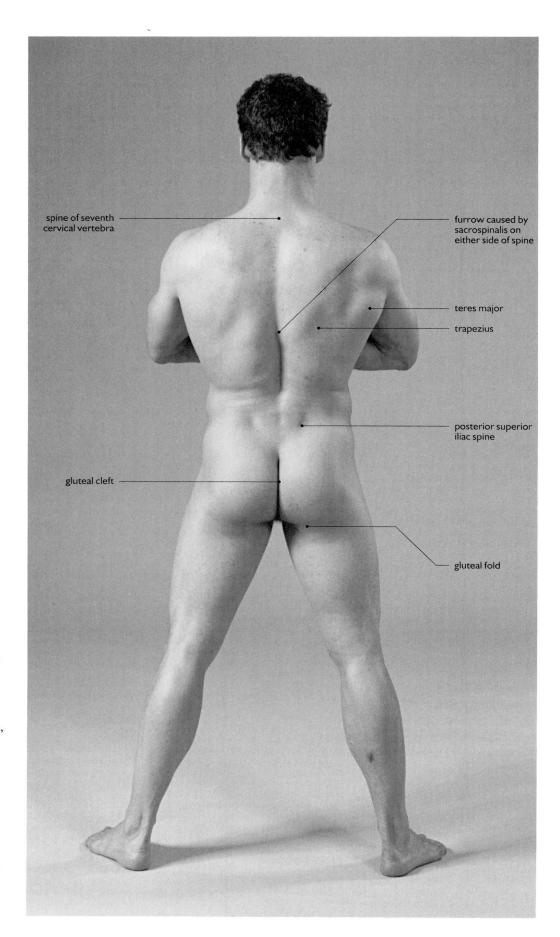

spine of seventh
cervical vertebra

furrow caused by
sacrospinalis on
either side of spine

teres major

trapezius

posterior superior
iliac spine

gluteal cleft

gluteal fold

Figure 16.
Teres major on
the right side is
unmistakably clear
here; so is the right
lower border of
trapezius. The dark
midline shadow just
above the lumbar
area is caused by
the space between
sacrospinalis muscles,
which form the
"tenderloin" on
either side of the
spinal column. As
with the great
trochanter, bony
protuberances
become concavities,
because adjacent
muscle masses
overhang them.

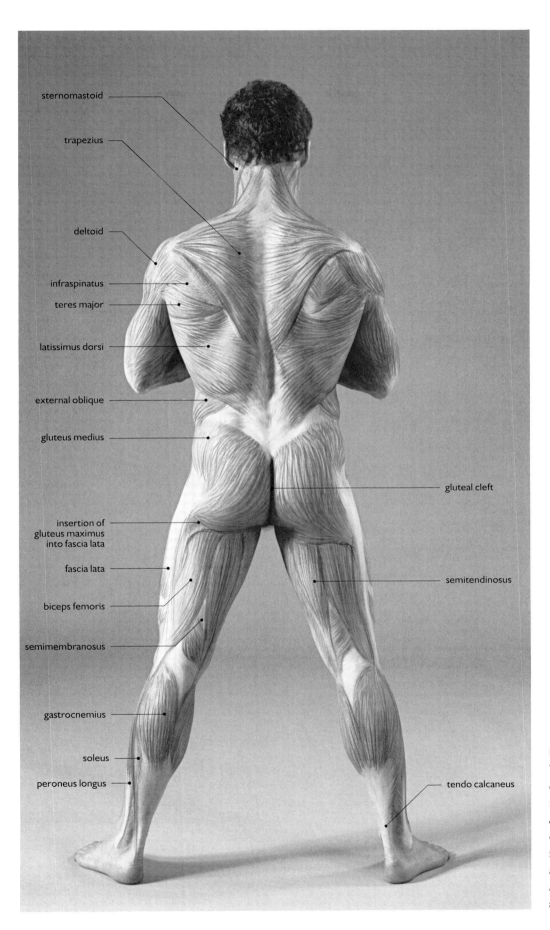

sternomastoid

trapezius

deltoid

infraspinatus

teres major

latissimus dorsi

external oblique

gluteus medius

insertion of
gluteus maximus
into fascia lata

fascia lata

biceps femoris

semimembranosus

gastrocnemius

soleus

peroneus longus

gluteal cleft

semitendinosus

tendo calcaneus

Figure 17.
With the arms
crossed over the
front of the body,
deltoid becomes less
evident from the
rear. Also, both
trapezius and
latissimus dorsi flatten
and spread laterally.

34

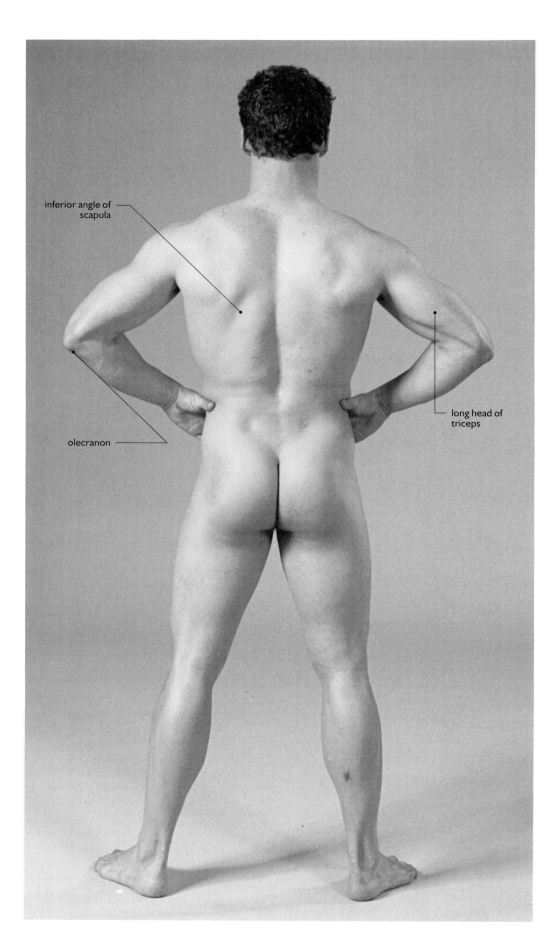

inferior angle of
scapula

long head of
triceps

olecranon

Figure 18.
This posture is
known as "arms
akimbo." The long
head of *triceps* is
especially evident
with the arms in this
position. It forms a
ridge from the
armpit to the inner
aspect of the elbow
(olecranon process
of ulna bone).

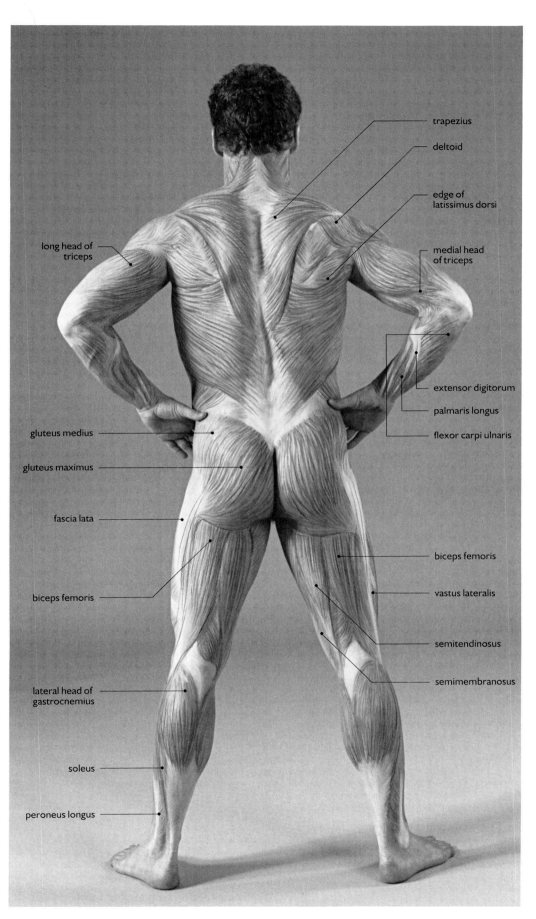

trapezius

deltoid

edge of
latissimus dorsi

medial head
of triceps

long head of
triceps

extensor digitorum

palmaris longus

flexor carpi ulnaris

gluteus medius

gluteus maximus

fascia lata

biceps femoris

biceps femoris

vastus lateralis

semitendinosus

semimembranosus

lateral head of
gastrocnemius

soleus

peroneus longus

Figure 19.
With the shoulders
rotated somewhat
posteriorly, *deltoid*
becomes more
obvious from the
rear. In contrast
with the previous
pose, *trapezius* and
latissimus dorsi are
contracted;
consequently, the
chest appears
narrower.

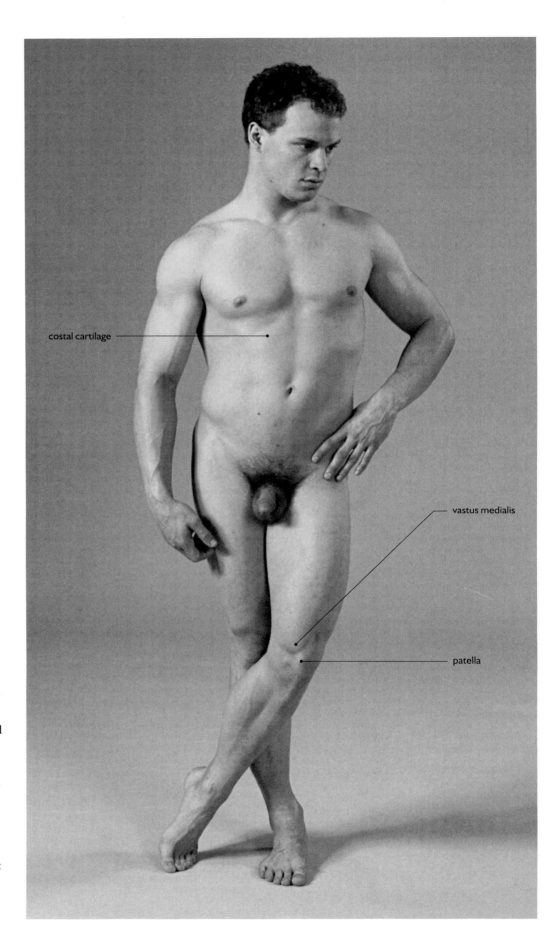

costal cartilage ————————————•

——— vastus medialis

——— patella

Figure 20.
This photograph
shows a "relaxed"
sculptor's-model
pose. Despite their
seeming lack of
exertion, the *deltoids*
are prominent and
obviously contracted
as their anterior
fibers rotate the
arms slightly inward
and their medial
ones raise them a
bit. The "relaxed"
left *vastus lateralis* is
not really flaccid but
ensures that the left
leg is stabilized as a
prop for balance.

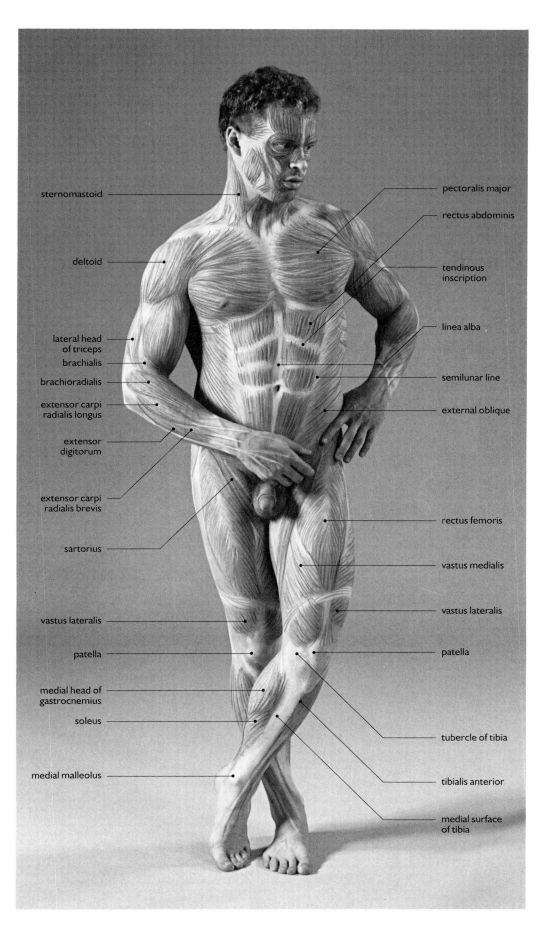

sternomastoid

pectoralis major

rectus abdominis

deltoid

tendinous
inscription

lateral head
of triceps

linea alba

brachialis

brachioradialis

semilunar line

extensor carpi
radialis longus

external oblique

extensor
digitorum

extensor carpi
radialis brevis

rectus femoris

sartorius

vastus medialis

vastus lateralis

vastus lateralis

patella

patella

medial head of
gastrocnemius

soleus

tubercle of tibia

medial malleolus

tibialis anterior

medial surface
of tibia

Figure 21.
In this pose, both
arms are under
minimal tension,
performing little
work. The left leg is
bearing almost no
weight. However,
the right knee is
"locked," and the
extensors (noticeably
vastus lateralis) are
contracted and
elevated.

38

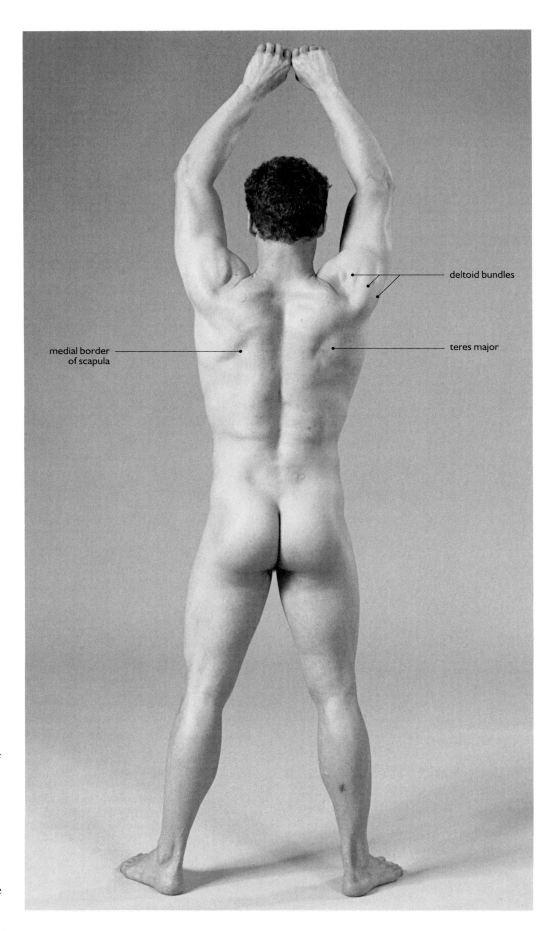

deltoid bundles

teres major

medial border
of scapula

Figure 22.
This model's *deltoids* are well developed, and in this pose their various fiber bundles can be perceived as separate masses. At least five discrete segments on either side can be seen here.

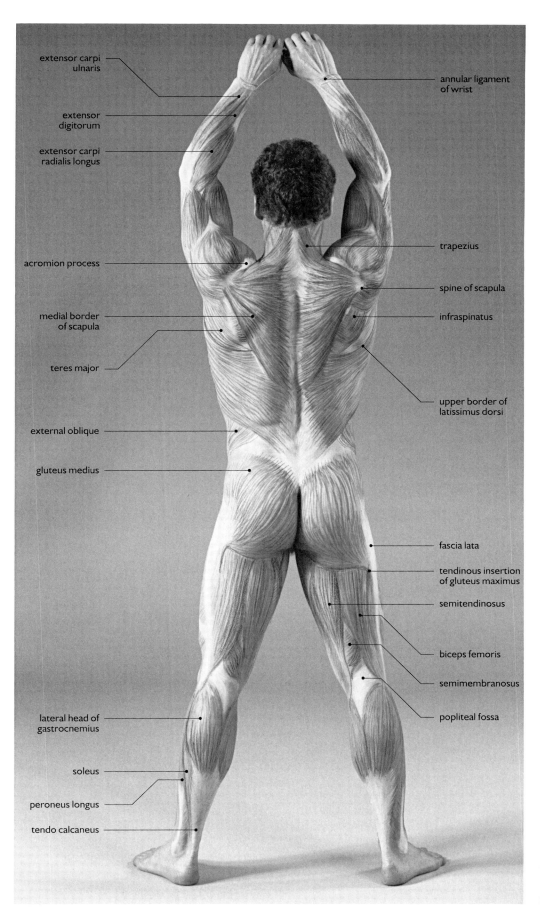

extensor carpi ulnaris

extensor digitorum

extensor carpi radialis longus

acromion process

medial border of scapula

teres major

external oblique

gluteus medius

lateral head of gastrocnemius

soleus

peroneus longus

tendo calcaneus

annular ligament of wrist

trapezius

spine of scapula

infraspinatus

upper border of latissimus dorsi

fascia lata

tendinous insertion of gluteus maximus

semitendinosus

biceps femoris

semimembranosus

popliteal fossa

Figure 23.
With the arms elevated in this way, the scapulae are elevated and rotated further away from the midline. In spite of its covering of muscle (*trapezius, infraspinatus,* and *rhomboideus*), the raised medial border of the scapula can be clearly observed, especially on the model's left.

40

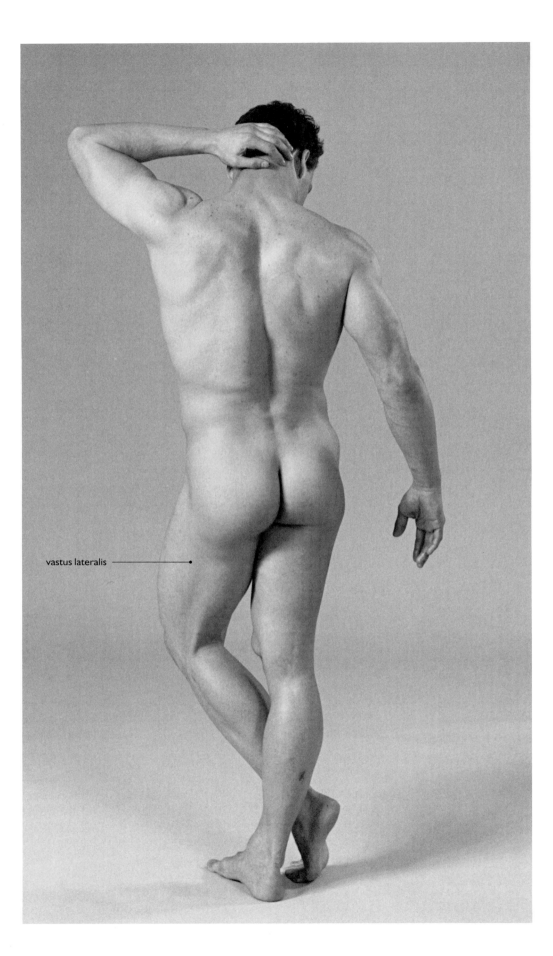

vastus lateralis ————————•

Figure 24.
The gluteal fold under the right buttock has disappeared from under the left. The fold obscures the actual shape of the underlying *gluteus maximus*, which does not have the rounded lower border suggested by the fold. Here the mass of the left buttock conforms more closely to the actual shape of the muscle.

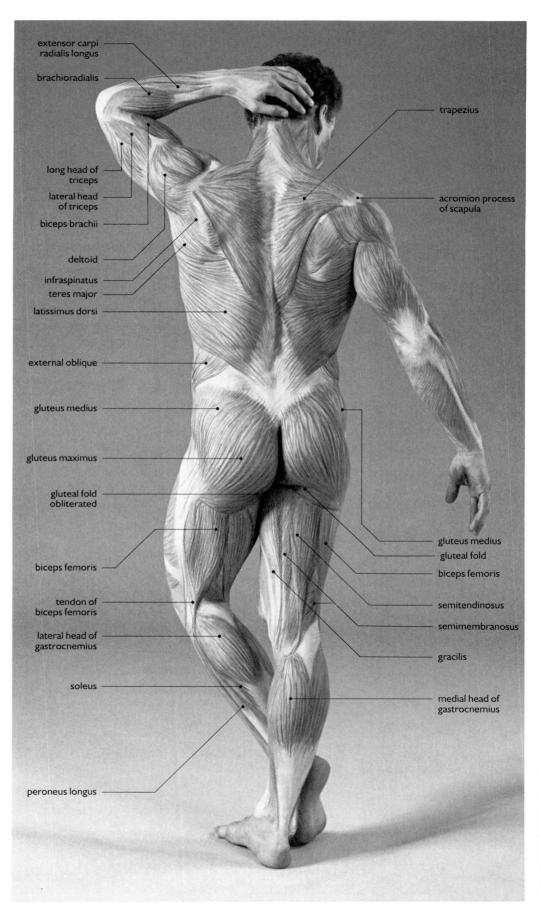

extensor carpi
radialis longus

brachioradialis

long head of
triceps

lateral head
of triceps

biceps brachii

deltoid

infraspinatus

teres major

latissimus dorsi

external oblique

gluteus medius

gluteus maximus

gluteal fold
obliterated

biceps femoris

tendon of
biceps femoris

lateral head of
gastrocnemius

soleus

peroneus longus

trapezius

acromion process
of scapula

gluteus medius

gluteal fold

biceps femoris

semitendinosus

semimembranosus

gracilis

medial head of
gastrocnemius

Figure 25.
This pose and the
one in Fig. 27 are
mirror images. The
pose is archetypal,
turning up
predictably in all
painting and
sculpture studios.

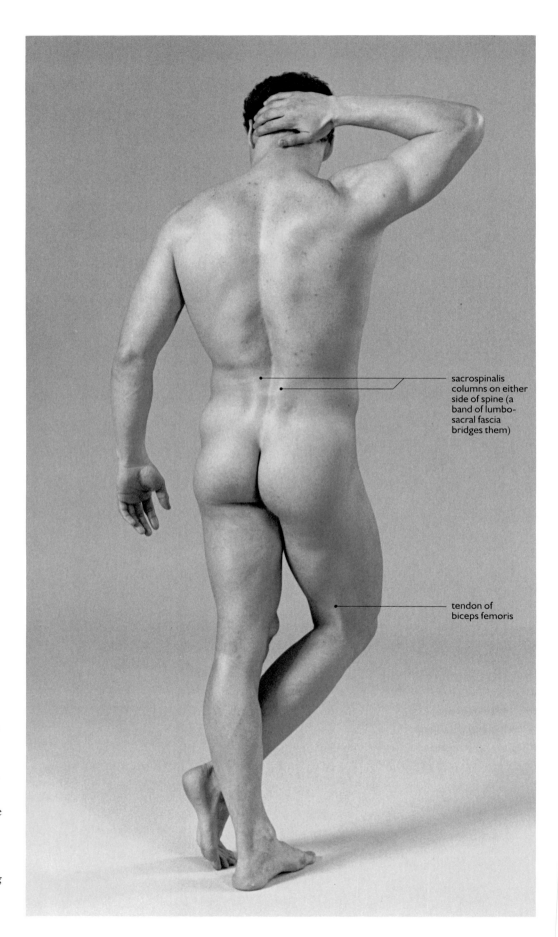

sacrospinalis
columns on either
side of spine (a
band of lumbo-
sacral fascia
bridges them)

tendon of
biceps femoris

Figure 26.
Viewed from some
angles on the living
model, *gluteus maxi-
mus* and *gluteus
medius* appear fused
into one undifferen-
tiated mass. This is
true of the right side
only in this photo-
graph. On the left,
medius can be seen
as a distinct swelling
superior and lateral
to *maximus*.

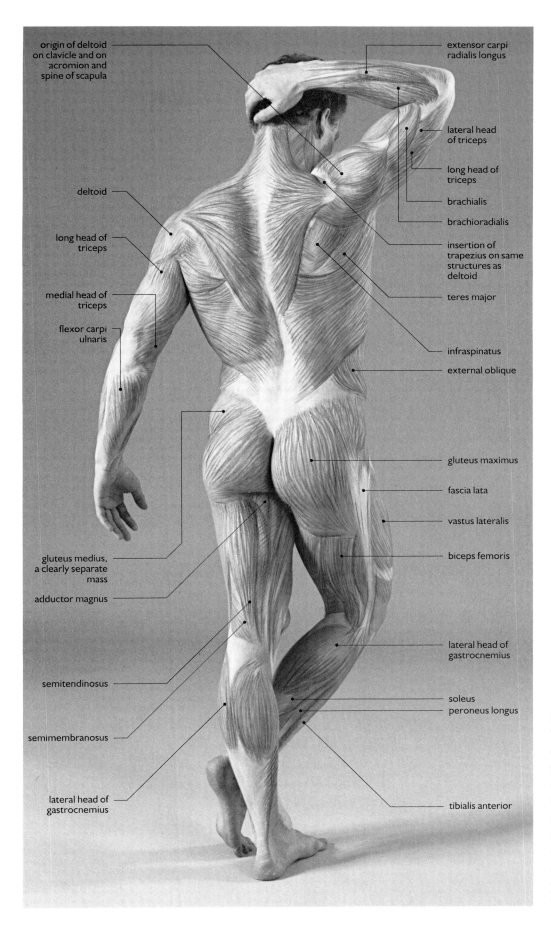

origin of deltoid on clavicle and on acromion and spine of scapula

extensor carpi radialis longus

lateral head of triceps

long head of triceps

brachialis

brachioradialis

insertion of trapezius on same structures as deltoid

teres major

deltoid

long head of triceps

medial head of triceps

flexor carpi ulnaris

infraspinatus

external oblique

gluteus maximus

fascia lata

vastus lateralis

biceps femoris

gluteus medius, a clearly separate mass

adductor magnus

lateral head of gastrocnemius

semitendinosus

soleus

peroneus longus

semimembranosus

lateral head of gastrocnemius

tibialis anterior

Figure 27.
The right shoulder clearly shows the proximity of the origin of *deltoid* and the insertion of *trapezius* as these muscles converge in the connective tissue on the acromion process and spine of the scapula.

44

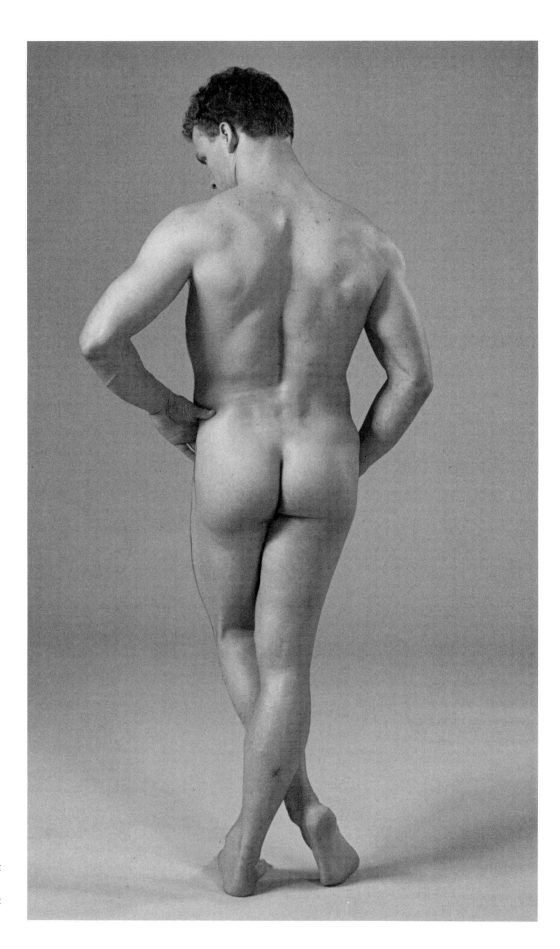

Figure 28.
The *teres major* of both sides is clearly discernible here. Also, the shadow under the left scapula area enhances the highlight marking the swelling of *latissimus dorsi* just inferior to it on that side. In this photograph, that muscle is pulling back somewhat, because of the slight backward and medial displacement of the arm.

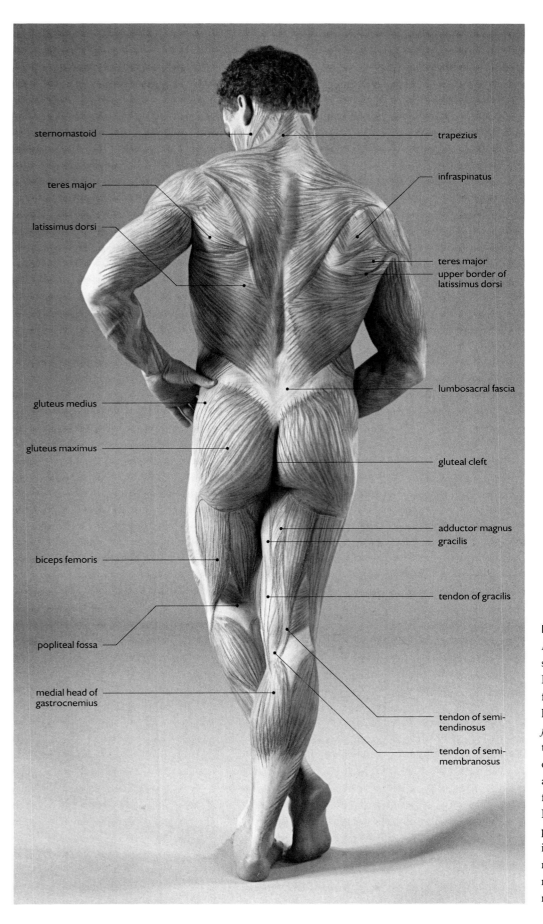

sternomastoid

trapezius

teres major

infraspinatus

latissimus dorsi

teres major

upper border of
latissimus dorsi

lumbosacral fascia

gluteus medius

gluteus maximus

gluteal cleft

adductor magnus
gracilis

biceps femoris

tendon of gracilis

popliteal fossa

medial head of
gastrocnemius

tendon of semi-
tendinosus

tendon of semi-
membranosus

Figure 29.
A "relaxed" pose
similar to that in
Fig. 21 but seen
from behind. The
hamstring (*biceps
femoris*) of the left
thigh and its tendon
can be seen tensed
and bulging as it
flexes the lower leg.
No matter the
position, no muscle
is ever entirely
relaxed but, rather,
maintains a constant
readiness or "tone."

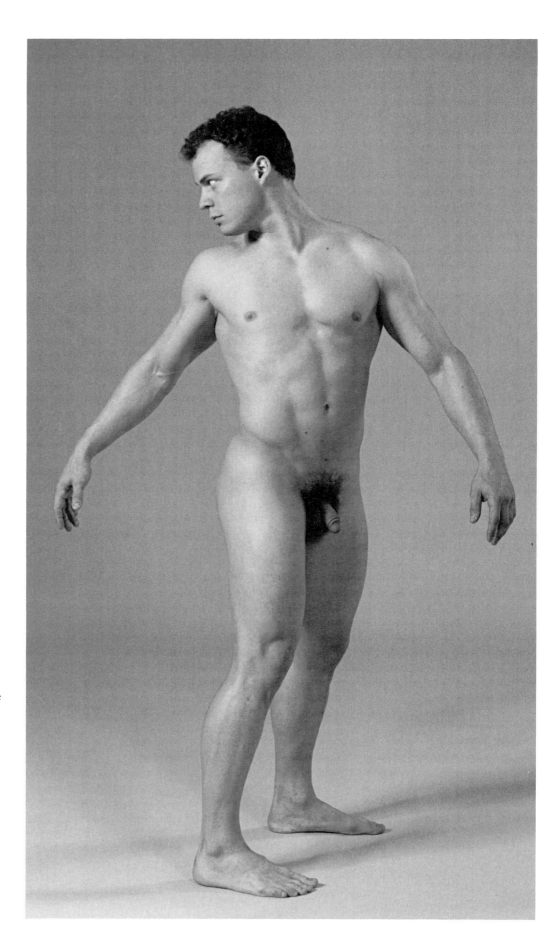

Figure 30.
In this *contrapposto* pose, the twist in the abdominal area clearly brings out *rectus abdominis* and its tendinous intersections. The lower border of *external oblique* on the model's right is also rendered conspicuous. The entire outline of his right *biceps brachii* is also clear.

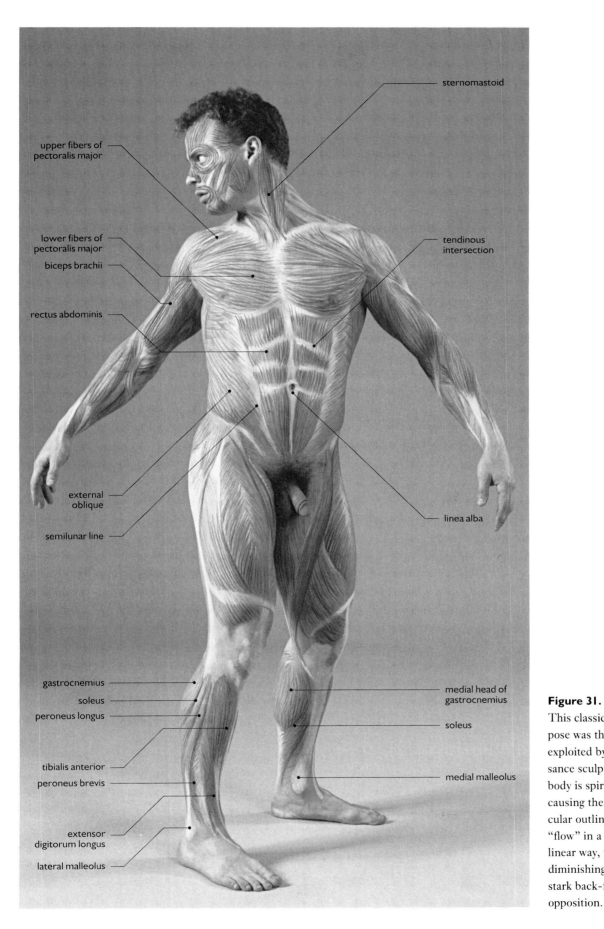

sternomastoid

upper fibers of
pectoralis major

lower fibers of
pectoralis major

biceps brachii

rectus abdominis

tendinous
intersection

external
oblique

linea alba

semilunar line

gastrocnemius

soleus

peroneus longus

medial head of
gastrocnemius

soleus

tibialis anterior

peroneus brevis

medial malleolus

extensor
digitorum longus

lateral malleolus

Figure 31.
This classical
pose was the sort
exploited by Renais-
sance sculptors. The
body is spiraled,
causing the mus-
cular outlines to
"flow" in a curvi-
linear way, thereby
diminishing the
stark back-front
opposition.

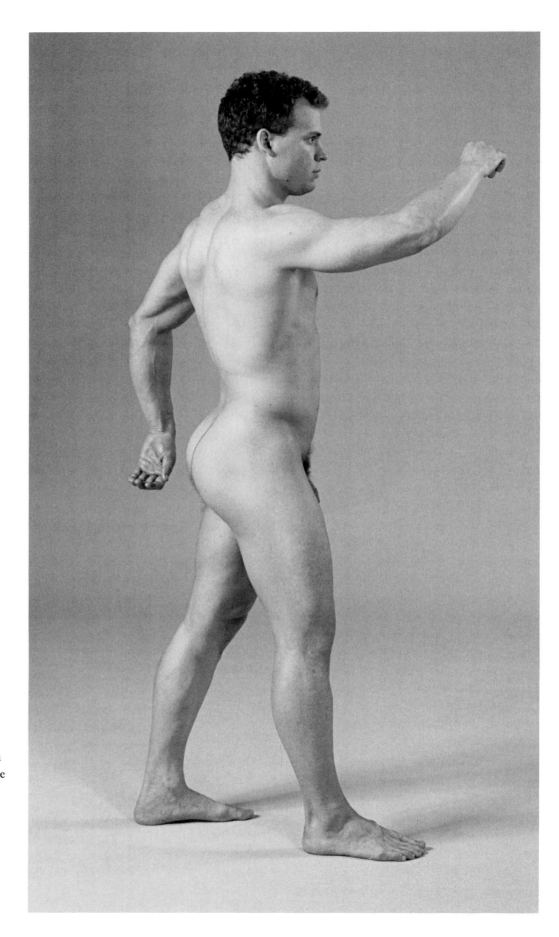

48

Figure 32.
In addition to the curve of *latissimus dorsi* swinging up from the lumbar area and into the armpit, this pose shows the upper portion of *trapezius* sweeping back from the lateral end of the clavicle and up posteriorly as far as the lower border of the skull. In its course, it forms the two conspicuous "cords" at the back of the neck.

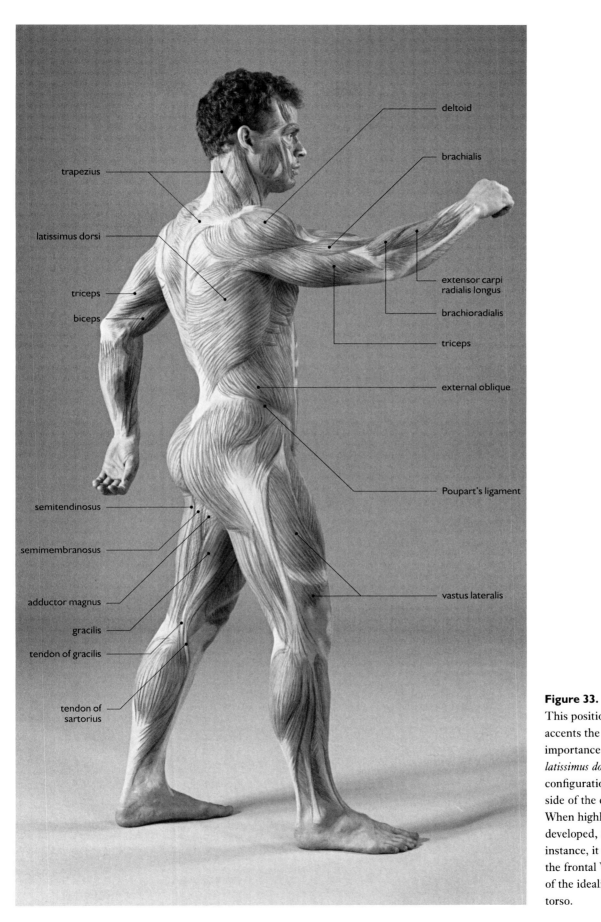

trapezius

latissimus dorsi

triceps

biceps

semitendinosus

semimembranosus

adductor magnus

gracilis

tendon of gracilis

tendon of
sartorius

deltoid

brachialis

extensor carpi
radialis longus

brachioradialis

triceps

external oblique

Poupart's ligament

vastus lateralis

Figure 33.
This position
accents the
importance of
latissimus dorsi in the
configuration of the
side of the chest.
When highly
developed, as in this
instance, it creates
the frontal V-shape
of the idealized male
torso.

50

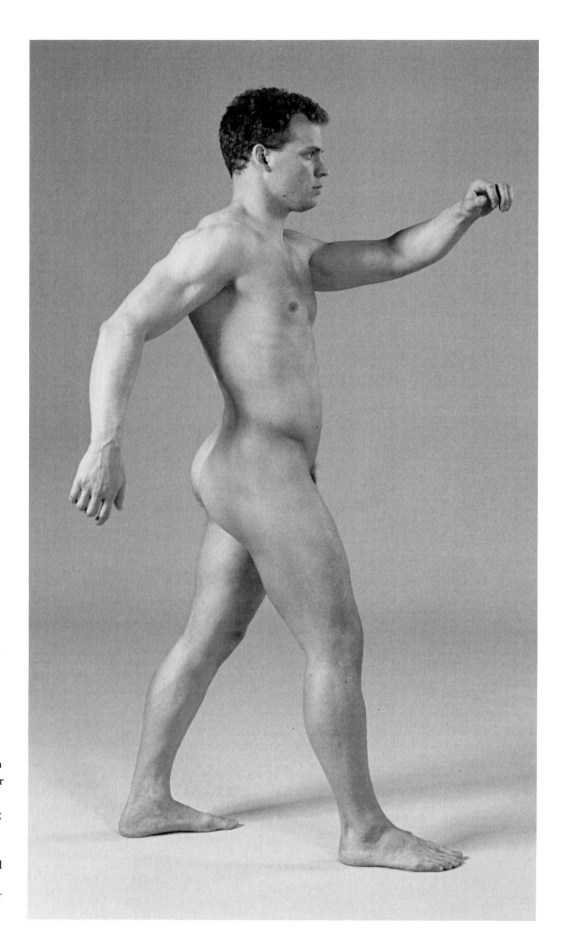

Figure 34.
The slight
prominence of the
great trochanter can
be seen at the center
of the hip area
where it is overhung
superiorly by the
bulge of *gluteus
medius* and preceded
anteriorly and
superiorly by that of
tensor fasciae latae.

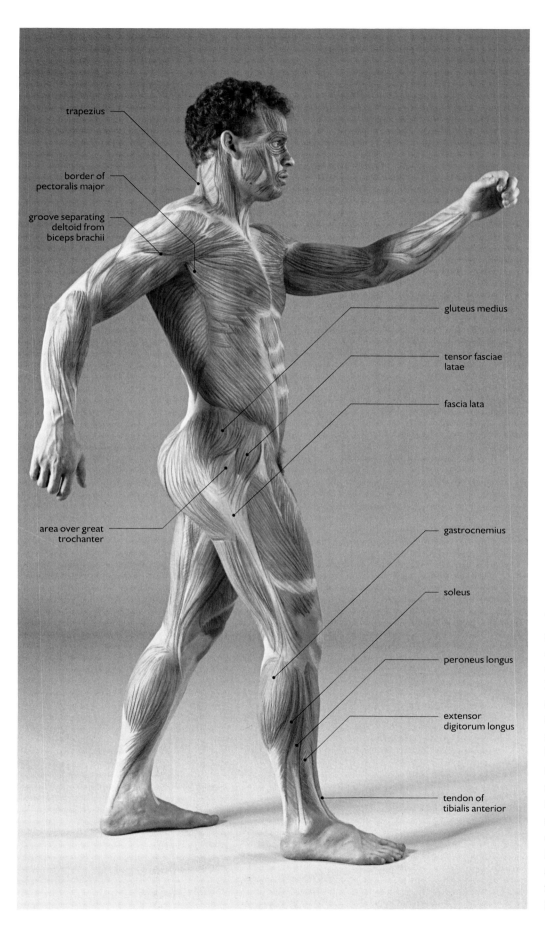

trapezius

border of
pectoralis major

groove separating
deltoid from
biceps brachii

area over great
trochanter

gluteus medius

tensor fasciae
latae

fascia lata

gastrocnemius

soleus

peroneus longus

extensor
digitorum longus

tendon of
tibialis anterior

Figure 35.
This photograph
shows a slightly
contrapposto variation
of the pose in
Fig. 33. Here the
contribution of
trapezius to the
conformation of the
back of the neck is
even clearer. Note
also the deep groove
caused by the fascia
separating the right
deltoid from *biceps
brachii*, remarkably
apparent even in the
unpainted version
(Fig. 34).

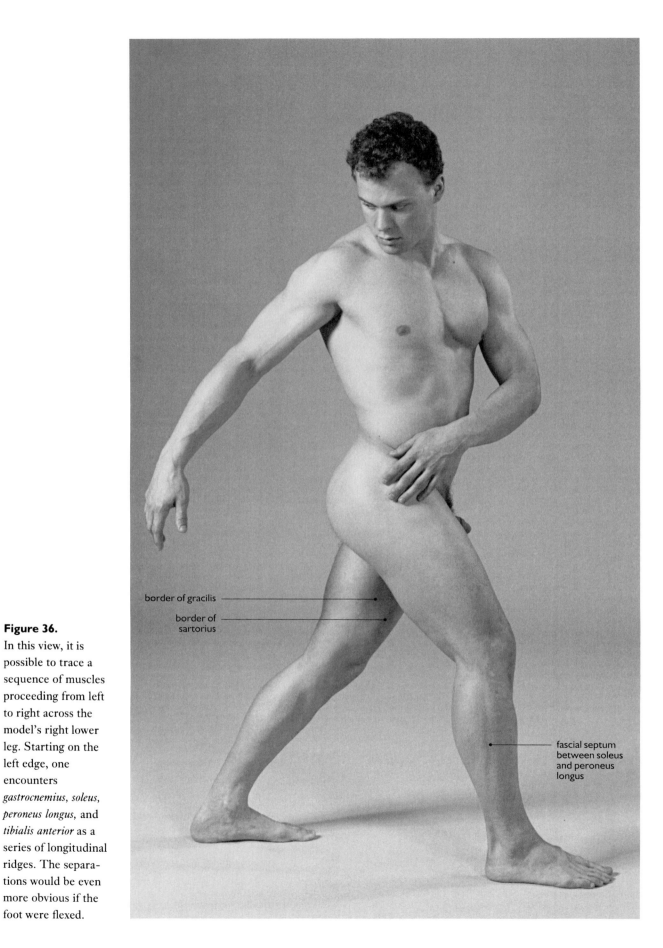

border of gracilis

border of
sartorius

fascial septum
between soleus
and peroneus
longus

Figure 36.
In this view, it is
possible to trace a
sequence of muscles
proceeding from left
to right across the
model's right lower
leg. Starting on the
left edge, one
encounters
gastrocnemius, soleus,
peroneus longus, and
tibialis anterior as a
series of longitudinal
ridges. The separa-
tions would be even
more obvious if the
foot were flexed.

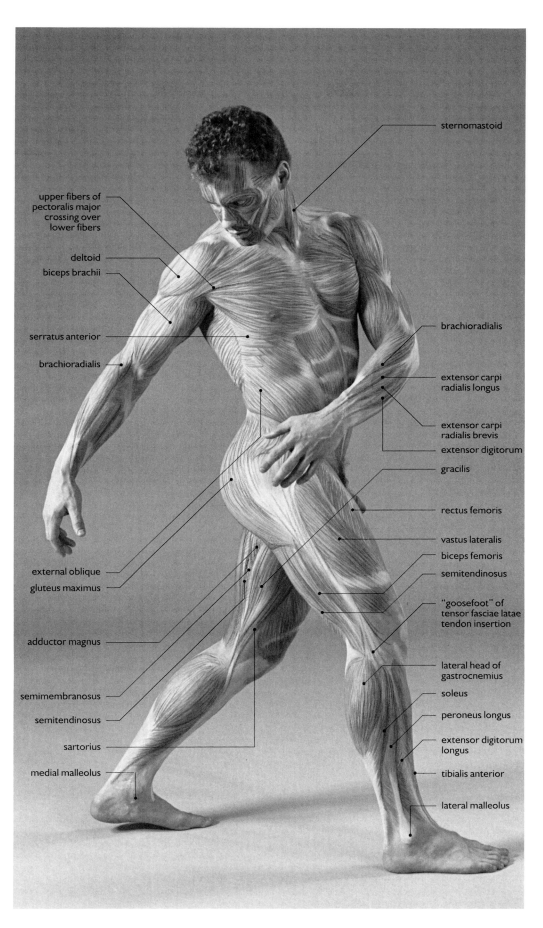

53

sternomastoid

upper fibers of
pectoralis major
crossing over
lower fibers

deltoid

biceps brachii

serratus anterior

brachioradialis

brachioradialis

extensor carpi
radialis longus

extensor carpi
radialis brevis

extensor digitorum

gracilis

rectus femoris

vastus lateralis

biceps femoris

semitendinosus

"goosefoot" of
tensor fasciae latae
tendon insertion

external oblique

gluteus maximus

lateral head of
gastrocnemius

soleus

peroneus longus

extensor digitorum
longus

adductor magnus

semimembranosus

semitendinosus

sartorius

medial malleolus

tibialis anterior

lateral malleolus

Figure 37.
This classical
pose shows that a
motionless figure
can nevertheless
suggest movement.
Note that the upper
fibers of *pectoralis
major* (right side)
cross over the lower
fibers, enabling it to
function almost as
two separate
muscles: The lower
portion lowers the
arm and pulls down
the shoulder while
the upper part lifts
the shoulder and
pulls the arm
forward.

54

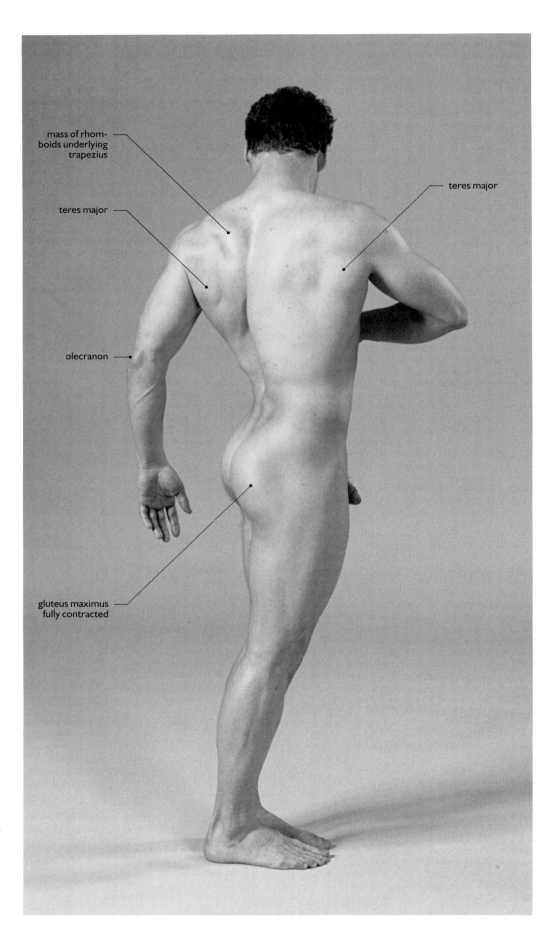

mass of rhom-
boids underlying
trapezius

teres major

teres major

olecranon

gluteus maximus
fully contracted

Figure 38.
The contracting and
billowing of *trapezius*
and *latissimus dorsi*
are more evident
on the unpainted
surface than on
the painted one in
Fig. 39. Also, for the
pelvis to be fixed to
resist the torsion of
the shoulder girdle,
gluteus maximus must
contract almost fully.
Note the parallel
"cords" of *sacro-
spinalis* just superior
to the cleft between
the buttocks.

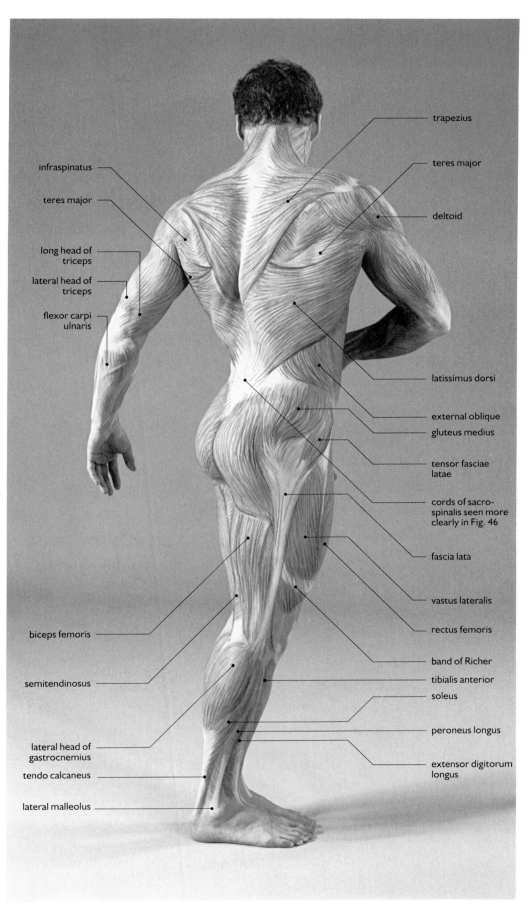

infraspinatus

teres major

long head of triceps

lateral head of triceps

flexor carpi ulnaris

biceps femoris

semitendinosus

lateral head of gastrocnemius

tendo calcaneus

lateral malleolus

trapezius

teres major

deltoid

latissimus dorsi

external oblique

gluteus medius

tensor fasciae latae

cords of sacro-spinalis seen more clearly in Fig. 46

fascia lata

vastus lateralis

rectus femoris

band of Richer

tibialis anterior

soleus

peroneus longus

extensor digitorum longus

Figure 39.
Twisting of the torso here serves to emphasize the roles of *trapezius* and *latissimus dorsi*. The former is contracted into a longitudinal paraspinal bulge medial to the left shoulder blade; *latissimus* billows out under the right armpit.

56

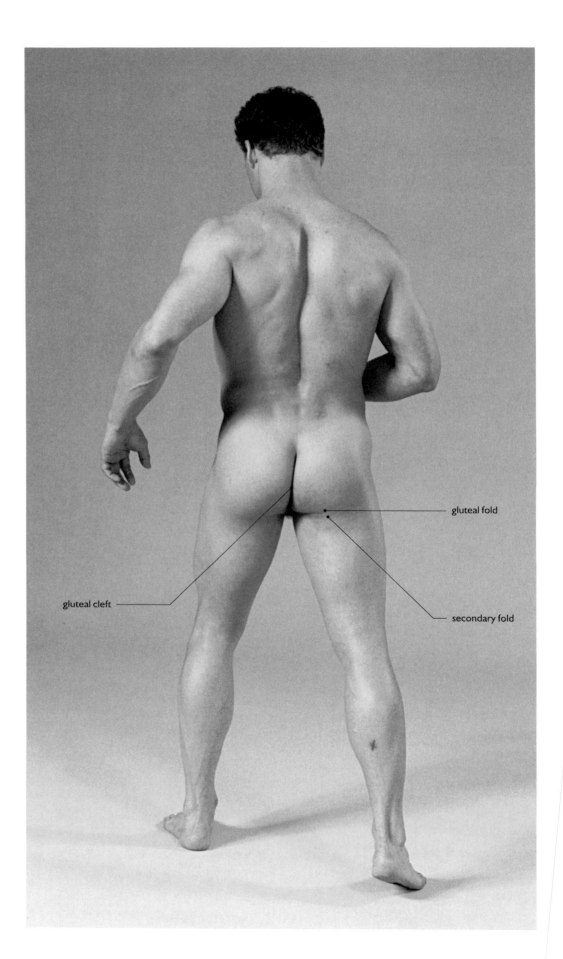

gluteal fold

gluteal cleft

secondary fold

Figure 40.
The gluteal fold in
this photograph is
evident under the
model's right but-
tock and partially
obliterated under
the left one. The
fold is to be distin-
guished from the
cleft, which is the
vertical fissure that
separates the two
buttocks.

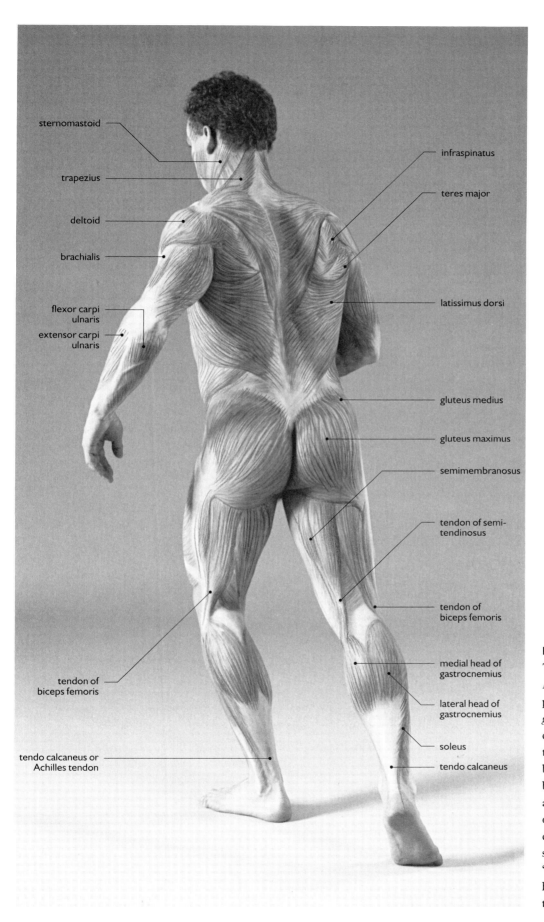

sternomastoid

trapezius

deltoid

brachialis

flexor carpi
ulnaris

extensor carpi
ulnaris

tendon of
biceps femoris

tendo calcaneus or
Achilles tendon

infraspinatus

teres major

latissimus dorsi

gluteus medius

gluteus maximus

semimembranosus

tendon of semi-
tendinosus

tendon of
biceps femoris

medial head of
gastrocnemius

lateral head of
gastrocnemius

soleus

tendo calcaneus

Figure 41.
The calcaneus, or
Achilles, tendon that
proceeds from
gastrocnemius of the
calf and inserts on
the calcaneus or heel
bone is evident in
both legs here. Note
also how the tendons
of the hamstrings
descend on opposite
sides of the knee.
"Ham" means the
hollow, or back, of
the knee.

58

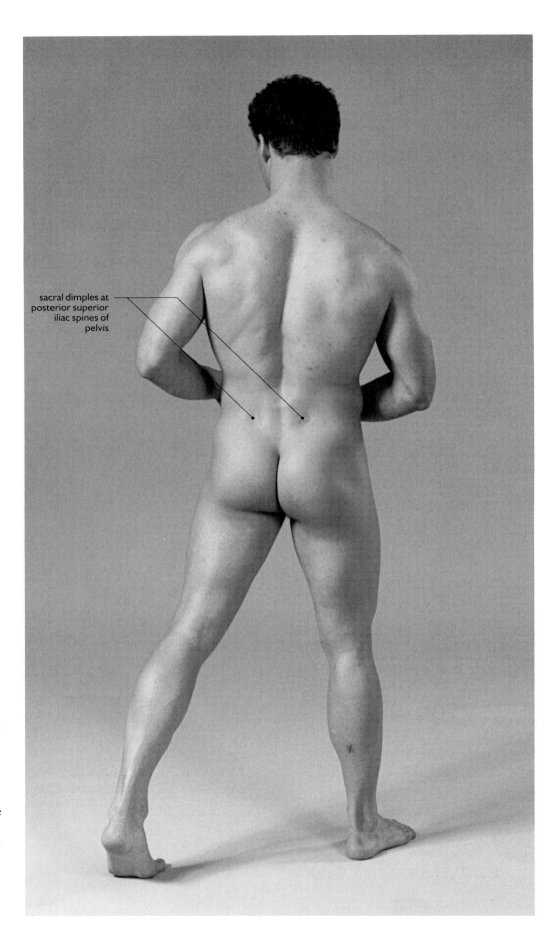

sacral dimples at
posterior superior
iliac spines of
pelvis

Figure 42.
The sacrum is like a
keystone, a wedge-
shaped bone trans-
mitting the weight
of the spinal col-
umn to the pelvis
and ultimately to the
legs. The two obvi-
ous sacral dimples
that form the base
of a triangle whose
apex is the top of the
gluteal cleft are the
sites of the posterior
superior iliac spines
to which *sacrospi-
nalis* muscles are
attached.

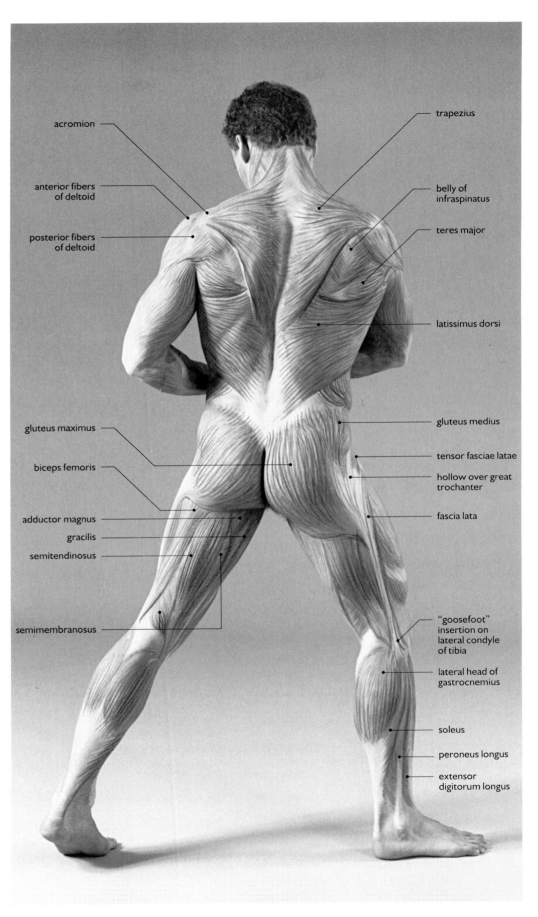

acromion

anterior fibers
of deltoid

posterior fibers
of deltoid

gluteus maximus

biceps femoris

adductor magnus

gracilis

semitendinosus

semimembranosus

trapezius

belly of
infraspinatus

teres major

latissimus dorsi

gluteus medius

tensor fasciae latae

hollow over great
trochanter

fascia lata

"goosefoot"
insertion on
lateral condyle
of tibia

lateral head of
gastrocnemius

soleus

peroneus longus

extensor
digitorum longus

Figure 43.
The *fascia lata*,
shown clearly here
on the right thigh,
is a broad, thick,
glistening tendinous
strip of parallel
connective tissue
fibers. It connects
the muscle *tensor
fasciae latae* to the
lateral condyle of the
tibia. As can be
seen, both *gluteus
maximus* and *medius*
contribute fibers
to it.

60

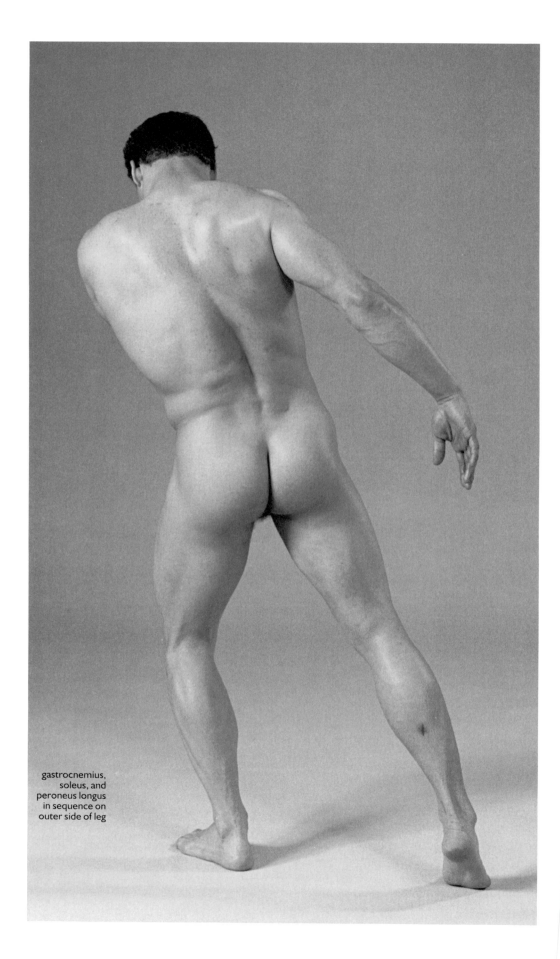

Figure 44.
The dimples are, as is often the case, the site of a bony prominence surrounded by muscle that swells around it, causing it to appear as a concavity. In this photograph, the bony knobs are the iliac spines mentioned in Fig. 42. The muscles are the terminations of the *sacrospinalis* group that parallel the vertebral column.

gastrocnemius, soleus, and peroneus longus in sequence on outer side of leg

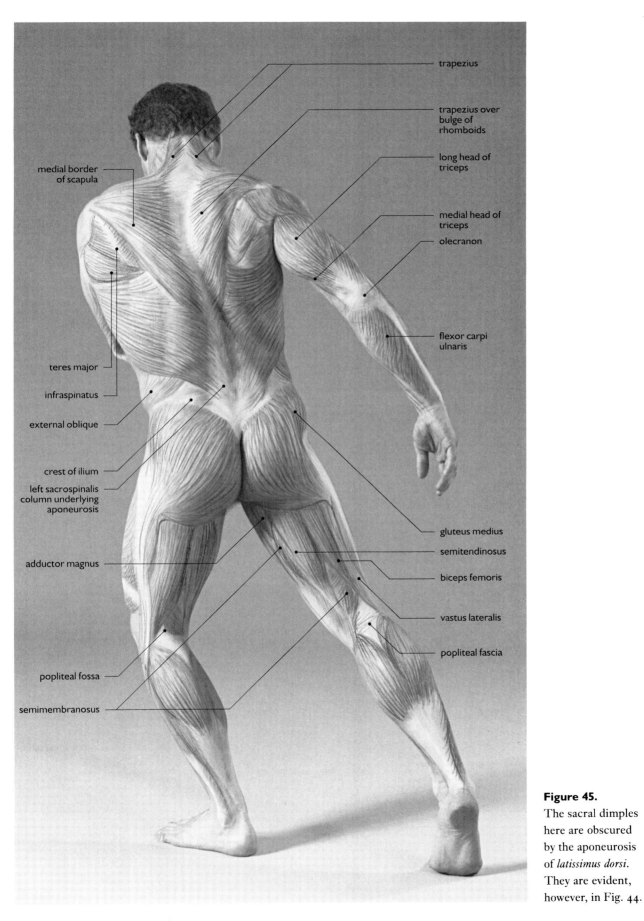

trapezius

trapezius over bulge of rhomboids

long head of triceps

medial head of triceps

olecranon

flexor carpi ulnaris

medial border of scapula

teres major

infraspinatus

external oblique

crest of ilium

left sacrospinalis column underlying aponeurosis

adductor magnus

popliteal fossa

semimembranosus

gluteus medius

semitendinosus

biceps femoris

vastus lateralis

popliteal fascia

Figure 45.
The sacral dimples here are obscured by the aponeurosis of *latissimus dorsi*. They are evident, however, in Fig. 44.

62

Figure 46.
In tilting the pelvis *away* from the direction of the bend, the model further limits the degree of possible lateral movement. Had he flexed the right leg more and straightened the left, thus tilting the base of the spinal column (sacrum) *toward* the desired side, he could have bent over further (as in Fig. 47). Note the compression of *external oblique* on the right.

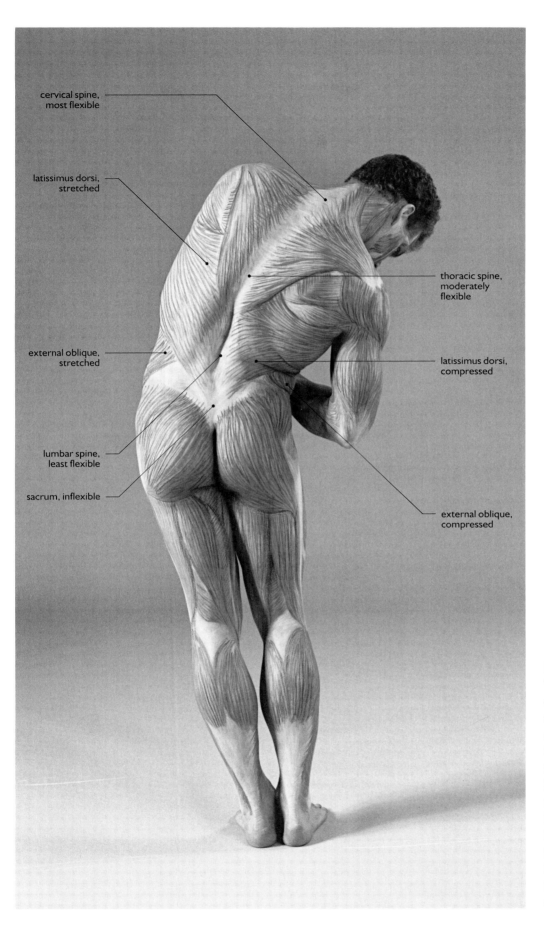

cervical spine,
most flexible

latissimus dorsi,
stretched

thoracic spine,
moderately
flexible

external oblique,
stretched

latissimus dorsi,
compressed

lumbar spine,
least flexible

sacrum, inflexible

external oblique,
compressed

Figure 47.
The spinal column
can bend laterally
to some extent. It
curves sideways
furthest and most
freely at the neck,
less so in the
thoracic region, and
least of all in the
lumbar region. Note
the amount of "give"
in the relaxed
latissimus dorsi (right
side).

64

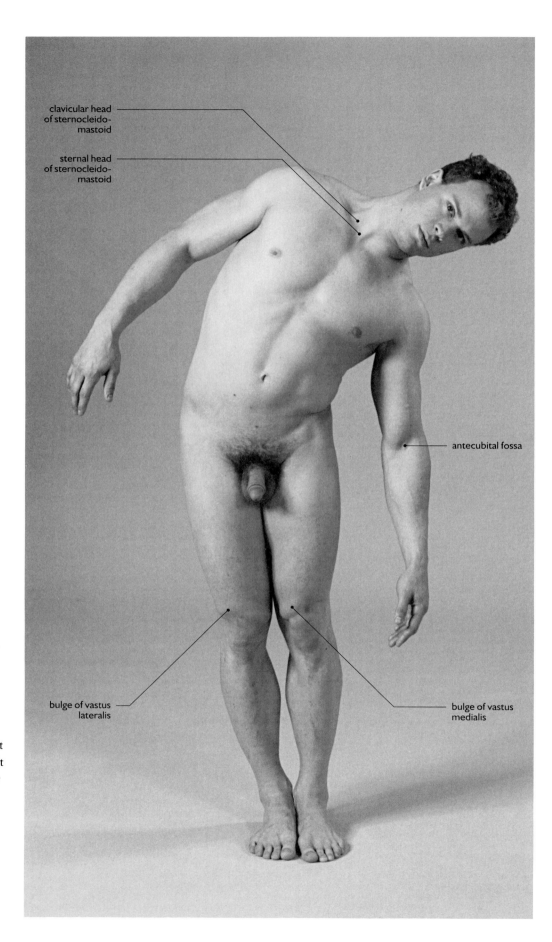

clavicular head
of sternocleido-
mastoid

sternal head
of sternocleido-
mastoid

antecubital fossa

bulge of vastus
lateralis

bulge of vastus
medialis

Figure 48.
Lateral bending as
seen from the front.
The left *external
oblique,* compressed
by the chest wall,
bulges laterally and
resembles a "love
handle" (that is, a fat
deposit). Note how it
overhangs the upper
thigh and exagger-
ates the anatomical
disjunction of the
abdomen and the
thigh ordinarily
formed by its lower
border (Poupart's
ligament).

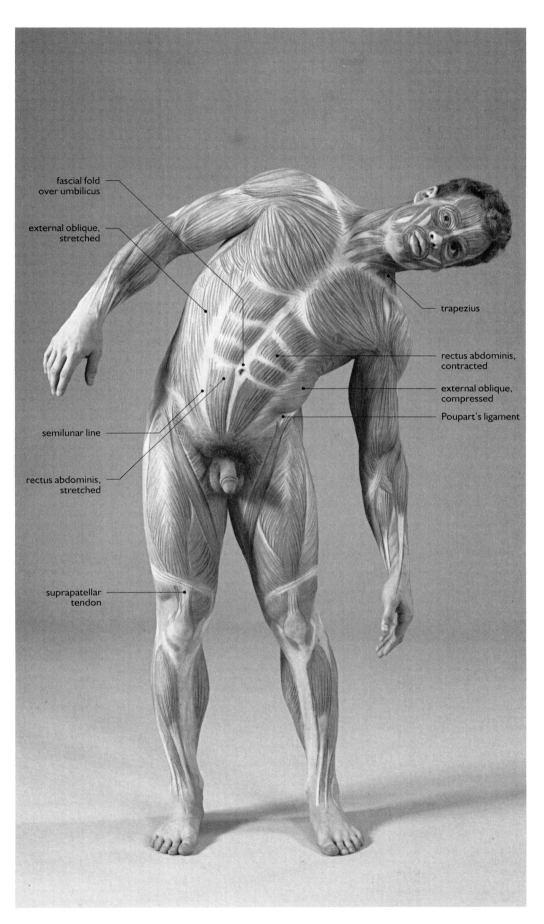

fascial fold
over umbilicus

external oblique,
stretched

trapezius

rectus abdominis,
contracted

external oblique,
compressed

Poupart's ligament

semilunar line

rectus abdominis,
stretched

suprapatellar
tendon

Figure 49.
The *external oblique*
on the model's right
side relaxes and
expands as it
contracts on his left.
The same applies to
rectus abdominis and
to *trapezius* (which is
visible above the
clavicles).

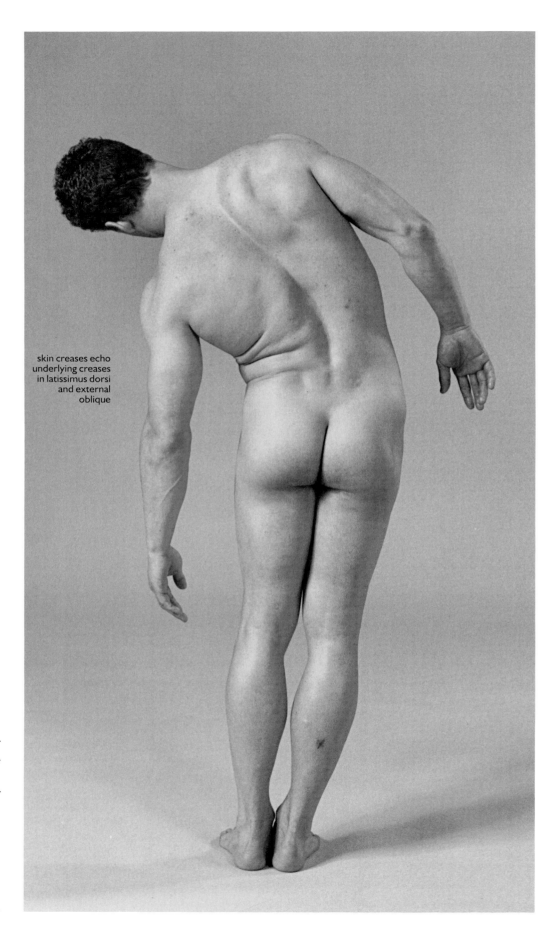

skin creases echo
underlying creases
in latissimus dorsi
and external
oblique

Figure 50.
The skin creases
approximate those
of the underlying
latissimus dorsi,
which, on the left,
becomes almost flac-
cid in this maneuver.
On the right, it
maintains tone, play-
ing out gradually,
keeping the move-
ment smooth and
nonviolent. The
cerebellum orches-
trates this complex
interplay of muscles.

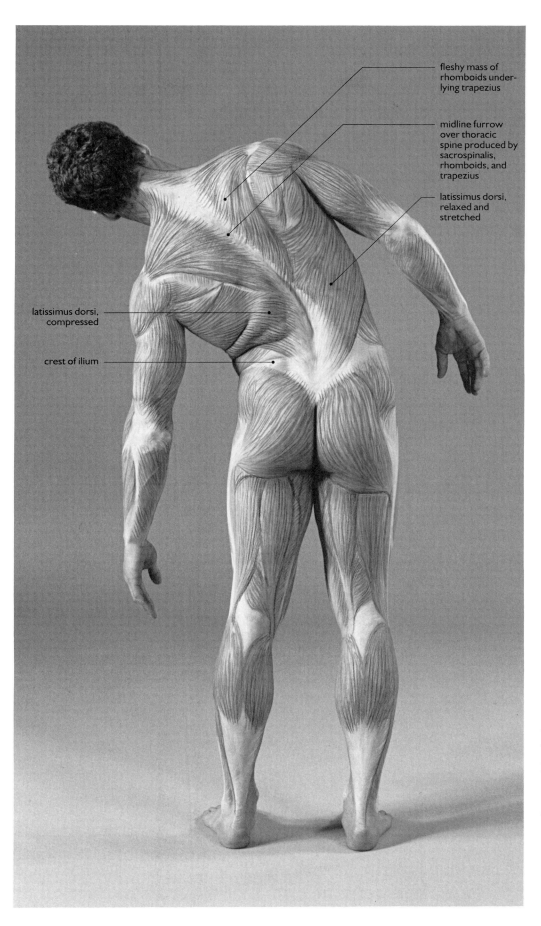

fleshy mass of rhomboids under-lying trapezius

midline furrow over thoracic spine produced by sacrospinalis, rhomboids, and trapezius

latissimus dorsi, relaxed and stretched

latissimus dorsi, compressed

crest of ilium

Figure 51.
The model is bending laterally here, with his shoulders and neck somewhat pulled back by *trapezius* (in contrast with Figs. 46 and 47, where his neck is flexed and his shoulders are hunched).

68

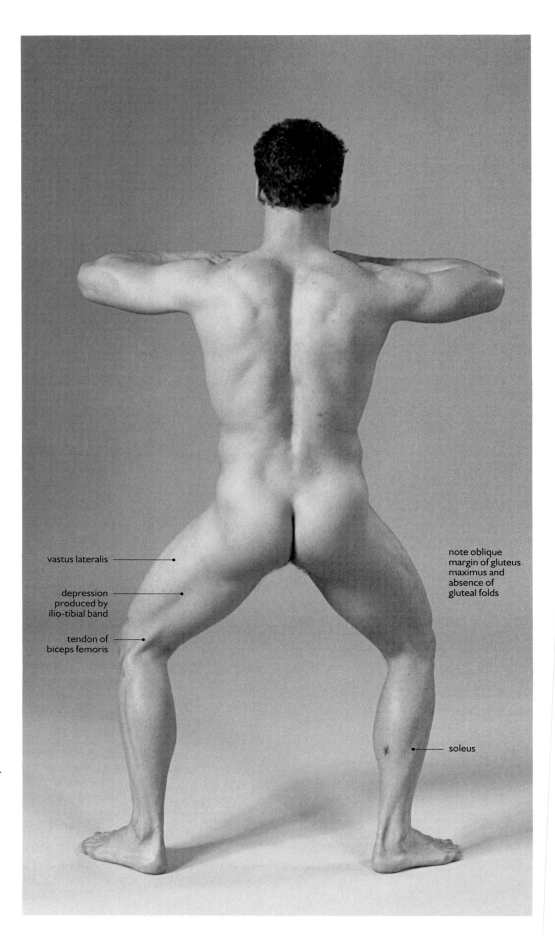

vastus lateralis

depression
produced by
ilio-tibial band

tendon of
biceps femoris

note oblique
margin of gluteus
maximus and
absence of
gluteal folds

soleus

Figure 52.
A variation from
Fig. 53, this pose
shows the gluteal
folds obliterated
with the thighs
sufficiently flexed.
Here the thigh
bones are not
parallel to the line of
gravity, so the
muscles are under
much strain, bearing
the entire weight.
The flexors and
extensors (including
gluteus maximus) are
all hard.

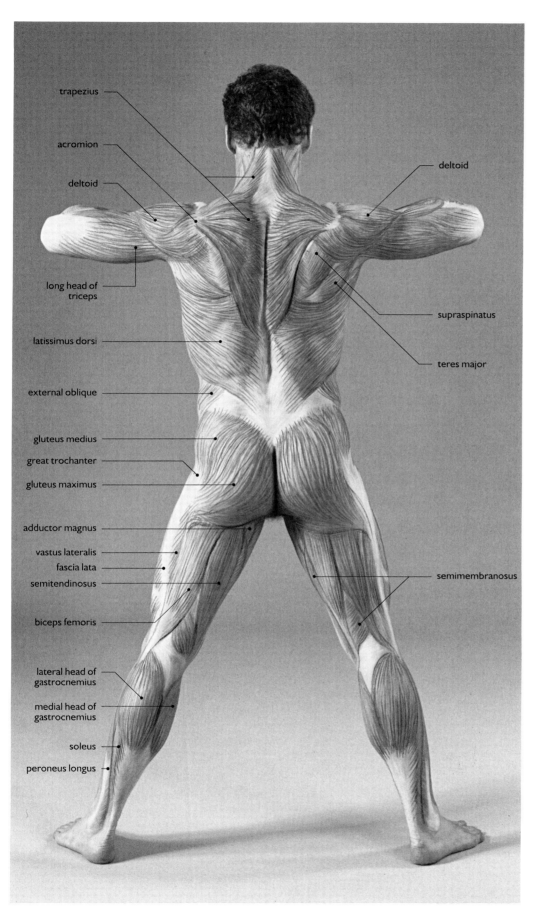

trapezius

acromion

deltoid

long head of
triceps

latissimus dorsi

external oblique

gluteus medius

great trochanter

gluteus maximus

adductor magnus

vastus lateralis

fascia lata

semitendinosus

biceps femoris

lateral head of
gastrocnemius

medial head of
gastrocnemius

soleus

peroneus longus

deltoid

supraspinatus

teres major

semimembranosus

Figure 53.
This pose allows
maximum abduction
of the arms without
calling into play the
outward rotation of
the scapula.
Supraspinatus and
deltoid are the prime
movers, with
pectoralis major and
latissimus dorsi as
antagonists, for they
adduct the arm.
Trapezius is flexed,
stabilizing the
scapula to prevent
its being pulled
laterally.

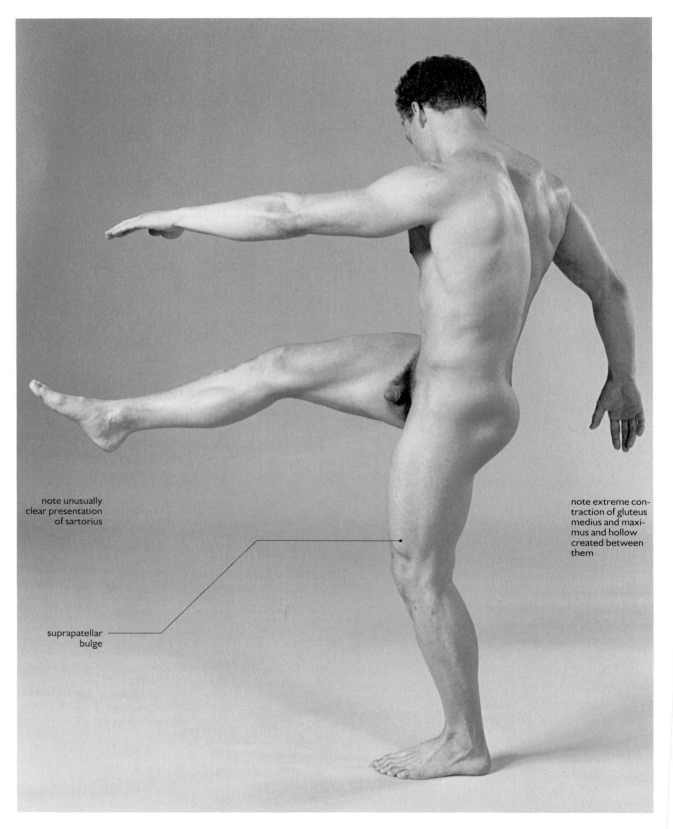

note unusually
clear presentation
of sartorius

note extreme con-
traction of gluteus
medius and maxi-
mus and hollow
created between
them

suprapatellar
bulge

Figure 54.

Numerous muscles are tensed and therefore easily identifiable here. In especially high relief are *sartorius* and *vastus medialis* of the right thigh. *Gluteus medius, tensor fasciae latae,* and the ilio-tibial band of the left are also apparent.

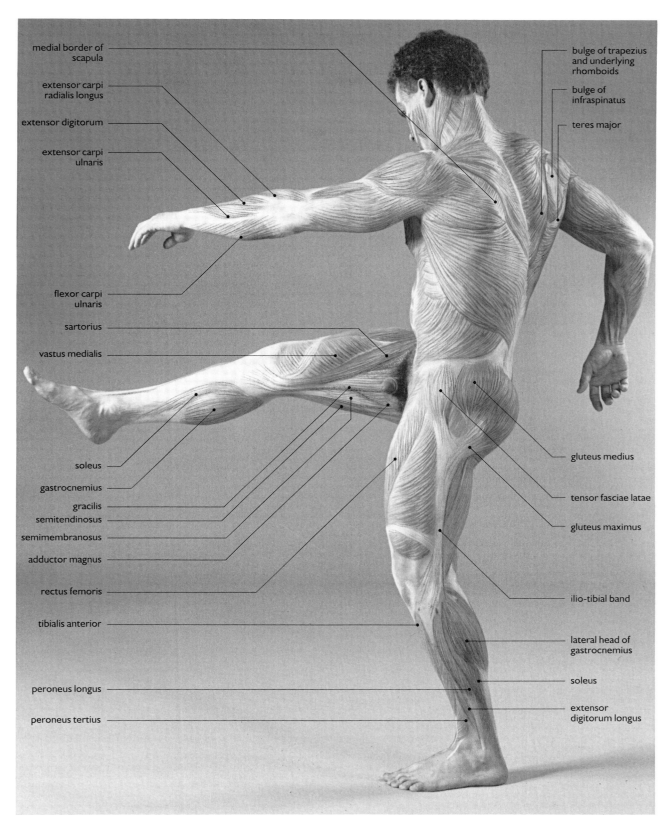

scapula

extensor carpi
radialis longus

extensor digitorum

extensor carpi
ulnaris

flexor carpi
ulnaris

sartorius

vastus medialis

soleus

gastrocnemius

gracilis

semitendinosus

semimembranosus

adductor magnus

rectus femoris

tibialis anterior

peroneus longus

peroneus tertius

bulge of trapezius
and underlying
rhomboids

bulge of
infraspinatus

teres major

gluteus medius

tensor fasciae latae

gluteus maximus

ilio-tibial band

lateral head of
gastrocnemius

soleus

extensor
digitorum longus

71

Figure 55.
There are well over four hundred muscles, surface and deep, on either side of the body. In a vigorous gesture such as this, virtually every one of them plays a role, either as prime mover, antagonist, or stabilizer.

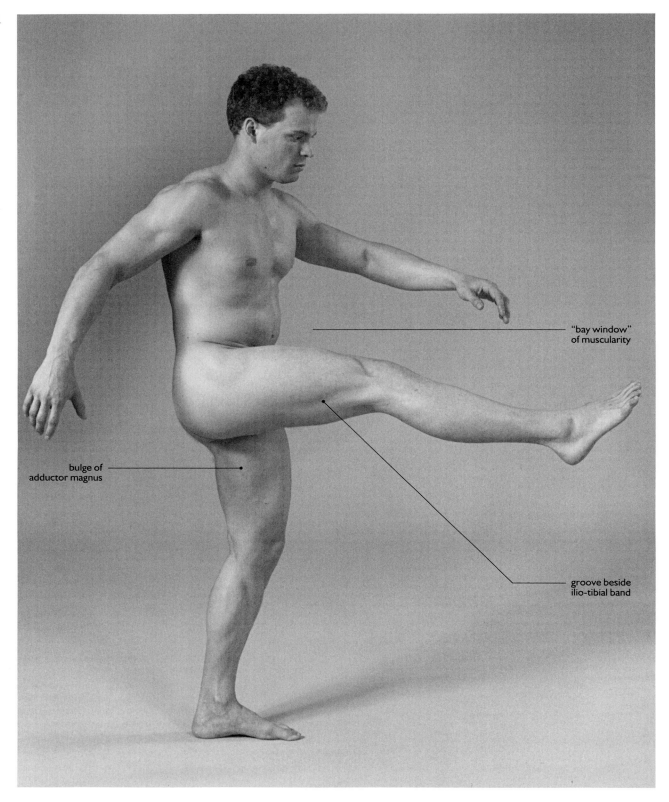

"bay window"
of muscularity

bulge of
adductor magnus

groove beside
ilio-tibial band

Figure 56.

Nonobese, fit subjects do not have concave ("scaphoid") abdomens, but mildly convex ones. Our model's "bay window" results mostly from contraction of *rectus abdominis, external oblique,* and underlying muscles of the abdominal wall.

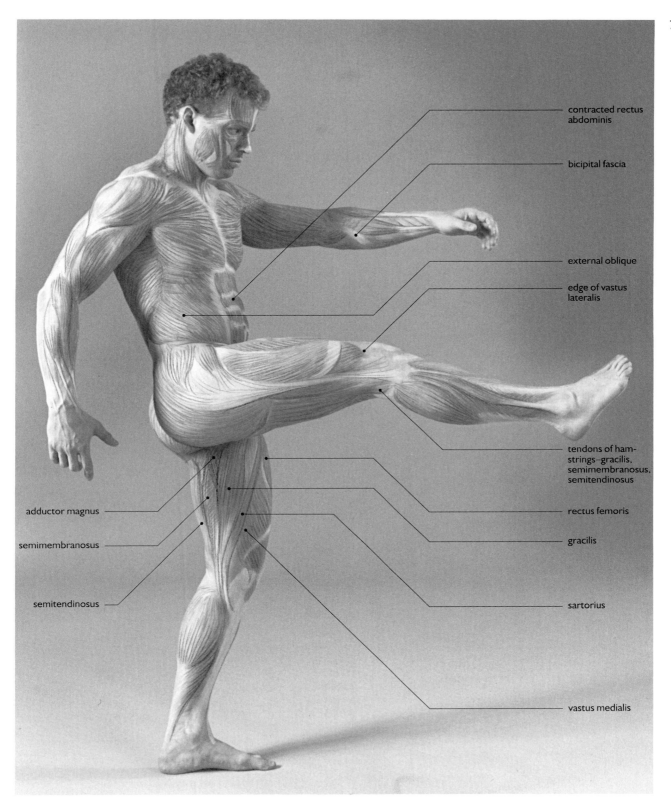

contracted rectus abdominis

bicipital fascia

external oblique

edge of vastus lateralis

tendons of ham-strings–gracilis, semimembranosus, semitendinosus

rectus femoris

gracilis

sartorius

vastus medialis

adductor magnus

semimembranosus

semitendinosus

Figure 57.

If instead of gently deploying the limbs, the model were performing some kind of work here (such as violently kicking a football), some eight hundred fifty muscles would be cooperating under the immediate directorship of the cerebellum and ultimate management of the cerebral cortex.

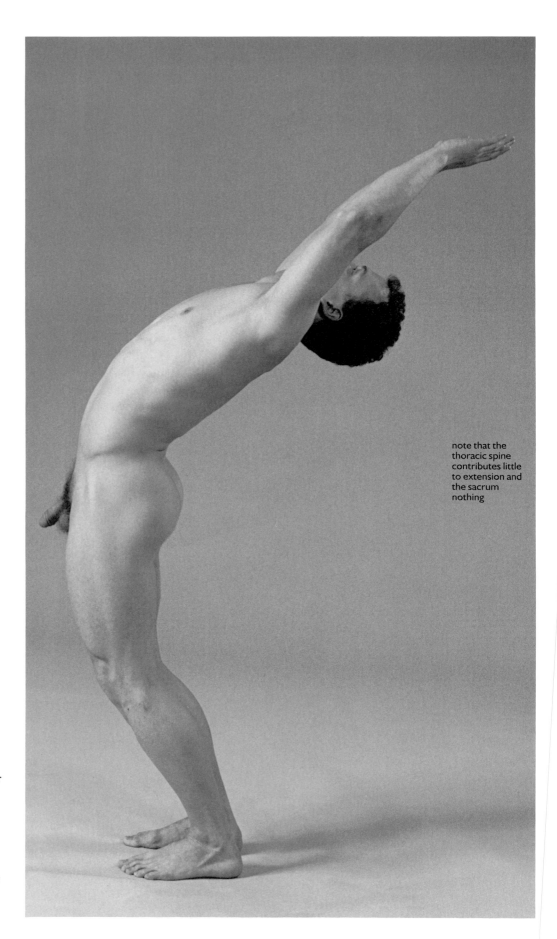

note that the
thoracic spine
contributes little
to extension and
the sacrum
nothing

Figure 58.
Clearly visible in
this pose is the
entire length of
tensor fasciae latae
from its origin on
the anterior superior
iliac spine,
throughout its
fascial band
(iliotibial tract), to
its final insertion
point at the superior
extremity of the
tibia.

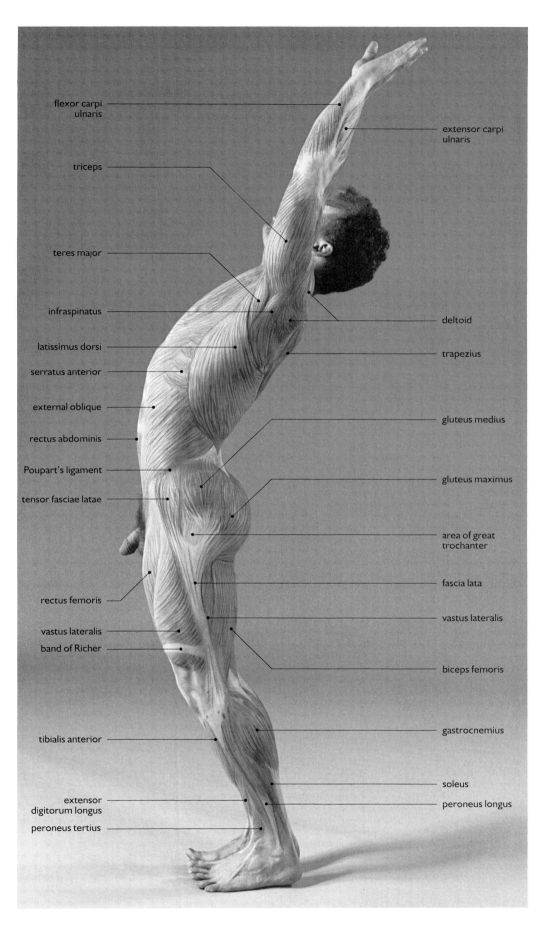

flexor carpi
ulnaris

extensor carpi
ulnaris

triceps

teres major

infraspinatus

deltoid

latissimus dorsi

trapezius

serratus anterior

external oblique

gluteus medius

rectus abdominis

Poupart's ligament

gluteus maximus

tensor fasciae latae

area of great
trochanter

fascia lata

rectus femoris

vastus lateralis

vastus lateralis

band of Richer

biceps femoris

tibialis anterior

gastrocnemius

soleus

extensor
digitorum longus

peroneus longus

peroneus tertius

Figure 59.
The "bay window"
has disappeared.
The abdominal
muscles are both
stretched and
contracted,
providing support
for the intestines
within. The slight
remaining bulge can
clearly be seen as
the contribution of
rectus abdominis.

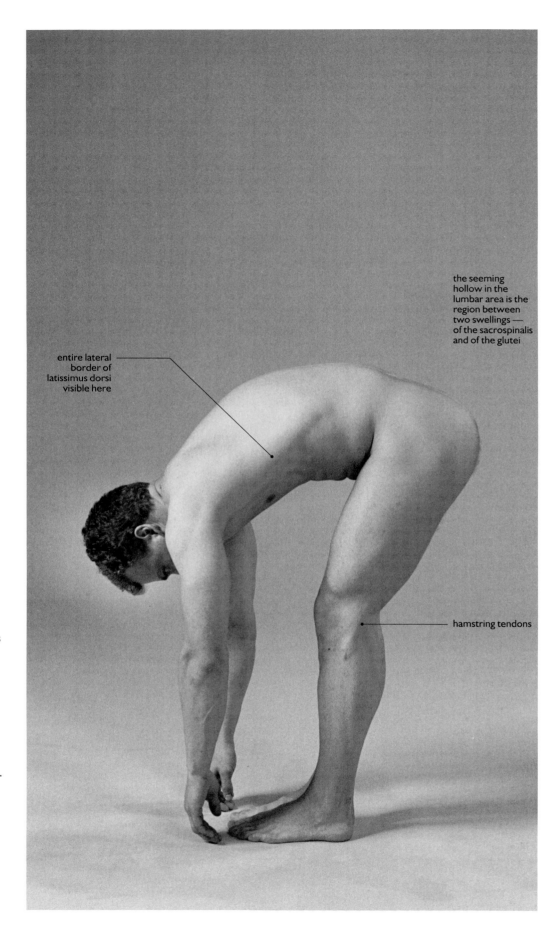

the seeming
hollow in the
lumbar area is the
region between
two swellings —
of the sacrospinalis
and of the glutei

entire lateral
border of
latissimus dorsi
visible here

hamstring tendons

Figure 60.

The *vastus lateralis* is seen trying to overcome the limits of extension imposed by the shortness of the hamstrings. What limits its success are pain signals from the hamstrings. Just how tightly the hamstrings are stretched can be appreciated by observing how taut their tendons are toward the back of the knee.

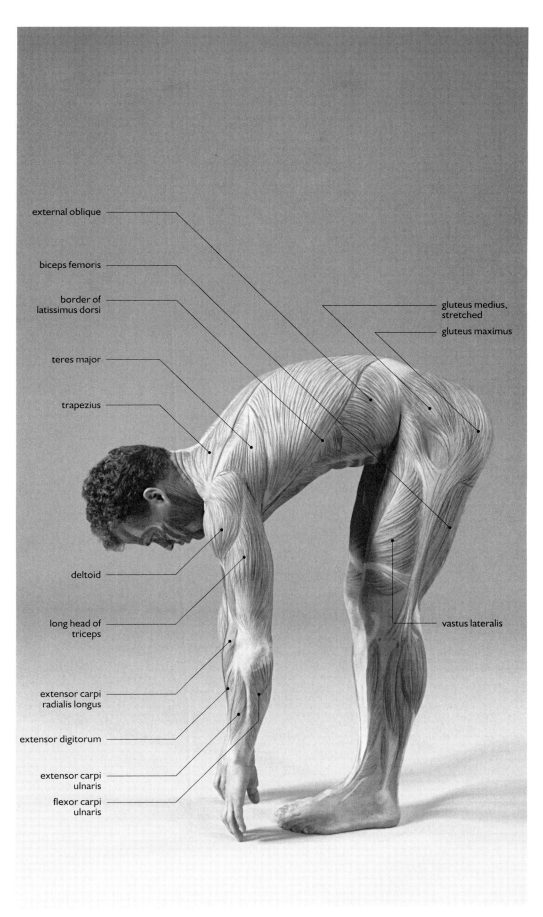

external oblique

biceps femoris

border of
latissimus dorsi

teres major

trapezius

deltoid

long head of
triceps

extensor carpi
radialis longus

extensor digitorum

extensor carpi
ulnaris

flexor carpi
ulnaris

gluteus medius,
stretched

gluteus maximus

vastus lateralis

Figure 61.
The hamstrings in
this position limit
the full extension of
the legs. Because
their legs are shorter
relative to their
torsos, women can
often touch the
ground without
flexing their legs, a
feat within the
capability of only
unusually flexible
men.

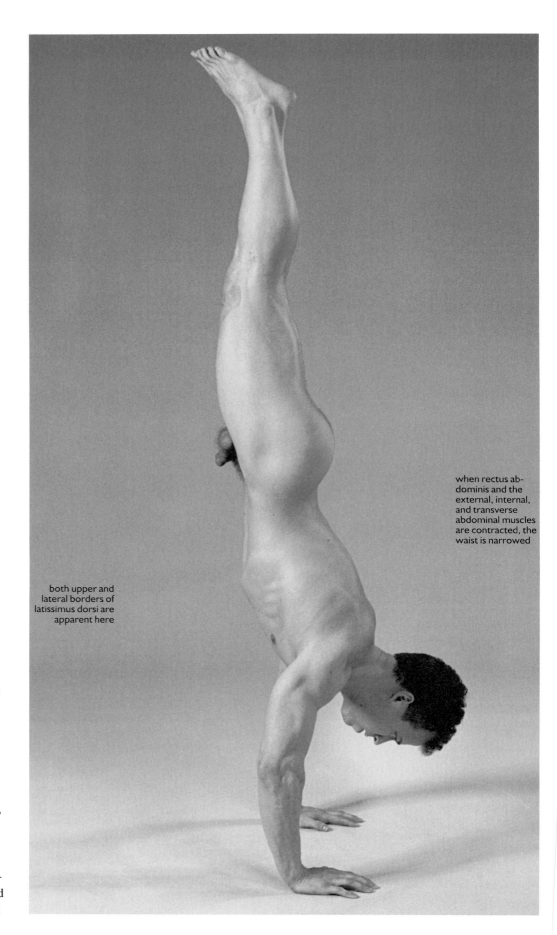

when rectus abdominis and the external, internal, and transverse abdominal muscles are contracted, the waist is narrowed

both upper and lateral borders of latissimus dorsi are apparent here

Figure 62.
The smaller the base, the more delicate the balance —hands and arms are, therefore, less secure than feet and legs. Balance, in addition to orchestration of the muscular ensemble, is the function of that Toscanini of the central nervous system, the cerebellum. The handstand gives it much to do!

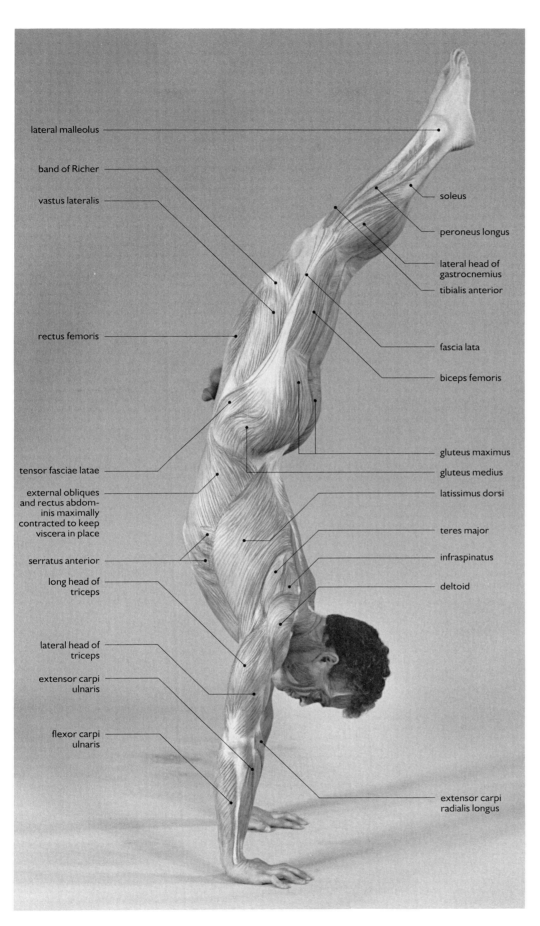

lateral malleolus

band of Richer

vastus lateralis

rectus femoris

tensor fasciae latae

external obliques
and rectus abdom-
inis maximally
contracted to keep
viscera in place

serratus anterior

long head of
triceps

lateral head of
triceps

extensor carpi
ulnaris

flexor carpi
ulnaris

soleus

peroneus longus

lateral head of
gastrocnemius

tibialis anterior

fascia lata

biceps femoris

gluteus maximus

gluteus medius

latissimus dorsi

teres major

infraspinatus

deltoid

extensor carpi
radialis longus

Figure 63.
The abdominal
protrusion of Figs.
60 and 61, caused by
relaxation and
crowding of the
muscular wall, is
gone. Here the
muscles are
confronted with an
unaccustomed task
—overcoming the
seemingly reversed
pull of gravity. Most
are tensely
contracted.

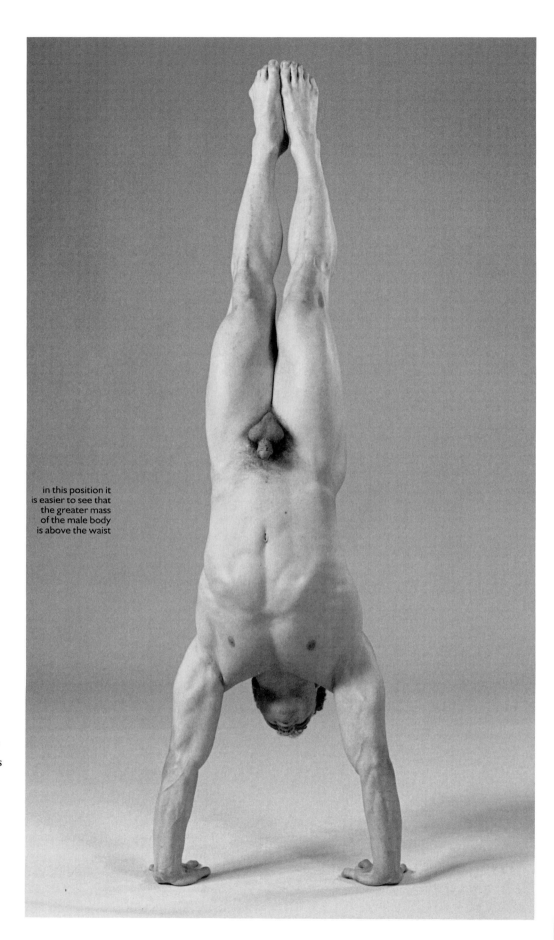

in this position it
is easier to see that
the greater mass
of the male body
is above the waist

Figure 64.
With the abdominal
contents shifted
toward the
diaphragm, the
upper *rectus* strains
at support. Note
how *serratus anterior*
bulges as it stabilizes
the scapula; in fact,
all the shoulder
muscles are at
maximum capacity,
the relatively fragile
shoulder girdle
bearing the weight
normally borne by
the stouter pelvis.

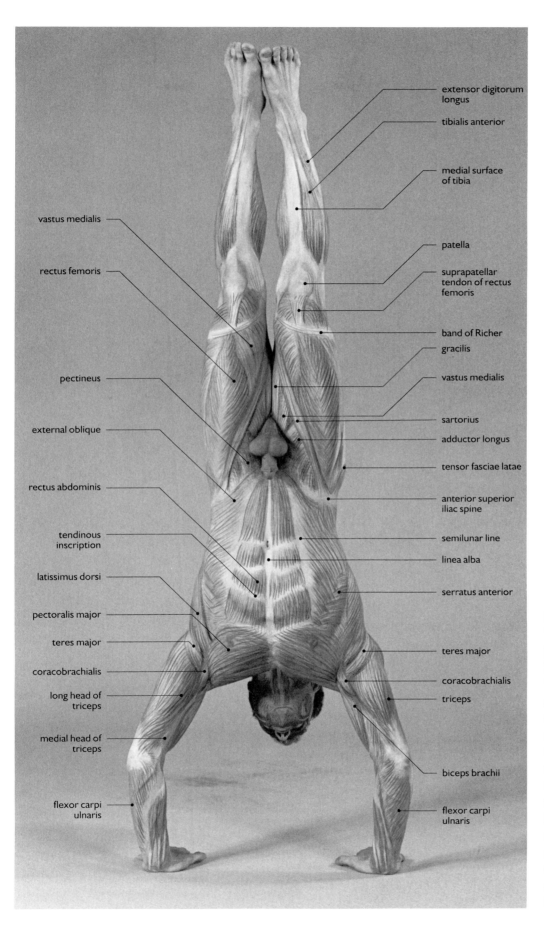

extensor digitorum longus

tibialis anterior

medial surface of tibia

patella

suprapatellar tendon of rectus femoris

band of Richer

gracilis

vastus medialis

sartorius

adductor longus

tensor fasciae latae

anterior superior iliac spine

semilunar line

linea alba

serratus anterior

teres major

coracobrachialis

triceps

biceps brachii

flexor carpi ulnaris

vastus medialis

rectus femoris

pectineus

external oblique

rectus abdominis

tendinous inscription

latissimus dorsi

pectoralis major

teres major

coracobrachialis

long head of triceps

medial head of triceps

flexor carpi ulnaris

Figure 65.
This pose is just before the handstand's peak. The arms are still slightly flexed and abducted and rotated forward—all of this puts great stress on the musculature of both arms and shoulders. But in Fig. 64, the arms are fully extended, thereby shifting a good deal of the weight to the bones.

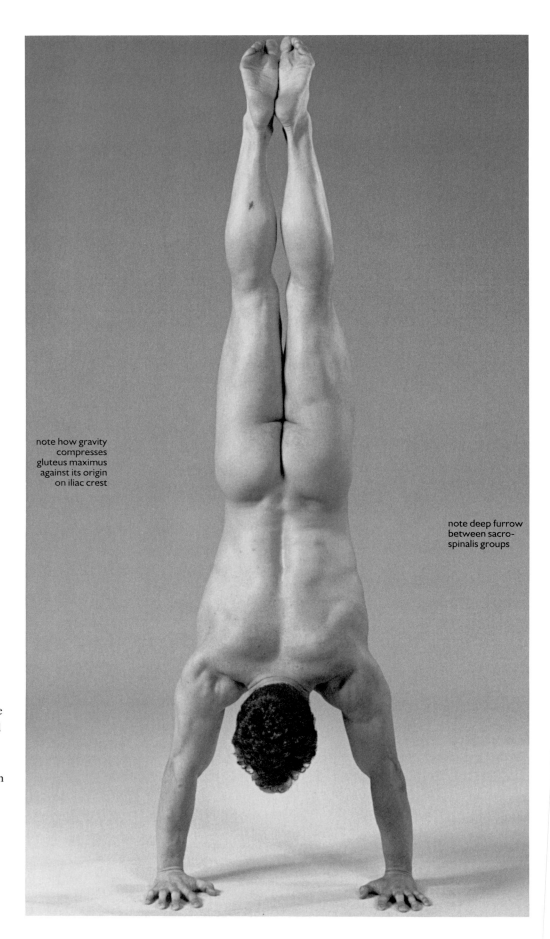

note how gravity compresses gluteus maximus against its origin on iliac crest

note deep furrow between sacro-spinalis groups

Figure 66.
If one ran one's finger along the central furrow of the back, one would feel the vertebral spines, another instance in which an indentation is a disguised pro-tuberance—in this case, a series of them. Here *sacro-spinalis* on either side are maximally contracted and swelled.

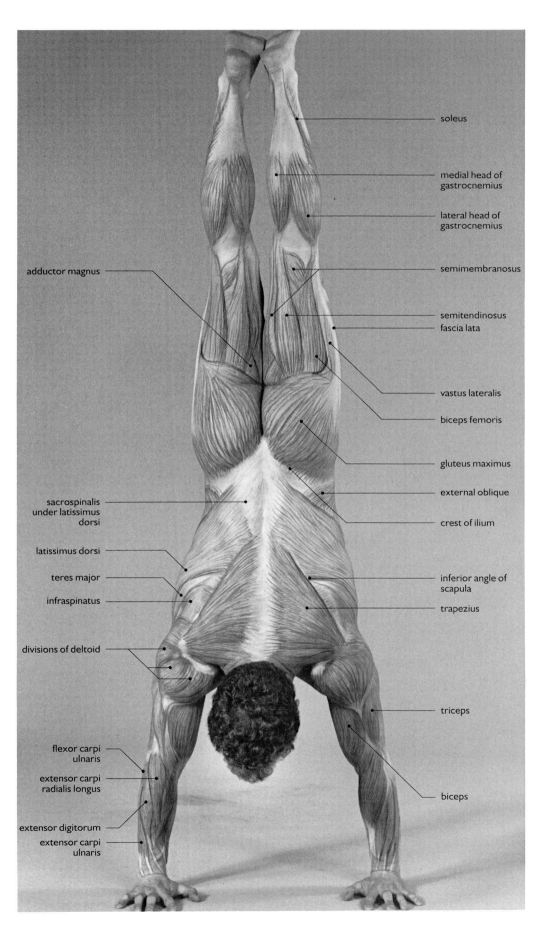

soleus

medial head of
gastrocnemius

lateral head of
gastrocnemius

semimembranosus

semitendinosus
fascia lata

vastus lateralis

biceps femoris

gluteus maximus

external oblique

crest of ilium

inferior angle of
scapula

trapezius

triceps

biceps

adductor magnus

sacrospinalis
under latissimus
dorsi

latissimus dorsi

teres major

infraspinatus

divisions of deltoid

flexor carpi
ulnaris

extensor carpi
radialis longus

extensor digitorum

extensor carpi
ulnaris

Figure 67.
This photograph
shows a perfect
gymnastic
handstand. The
body has assumed
that most stable of
forms, the triangle,
with its apex at the
great toes and its
basal angles at the
two hands.
Accepting the
unnaturalness of
hand-standing, this
symmetrical
alignment provides
ideal distribution of
weight and balance
and minimizes strain
on the musculature.

84

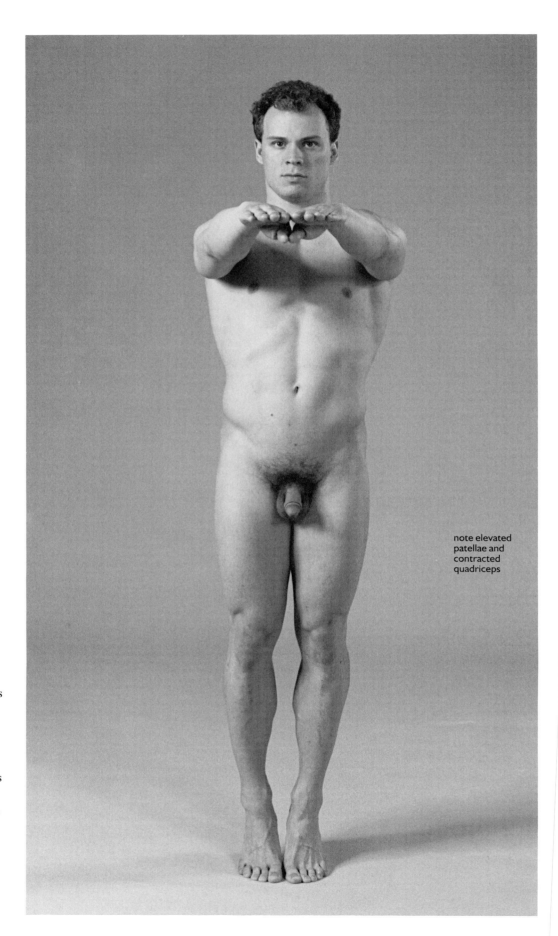

note elevated
patellae and
contracted
quadriceps

Figure 68.
When contracted, *gastrocnemius* is compact and hard as a nut. Difficult to enlarge, it grows stronger but, unlike other muscles, not bigger with vigorous workouts. Impressive calves are more a matter of nature than nurture. Here the muscle can be seen bulging medially just below the knee.

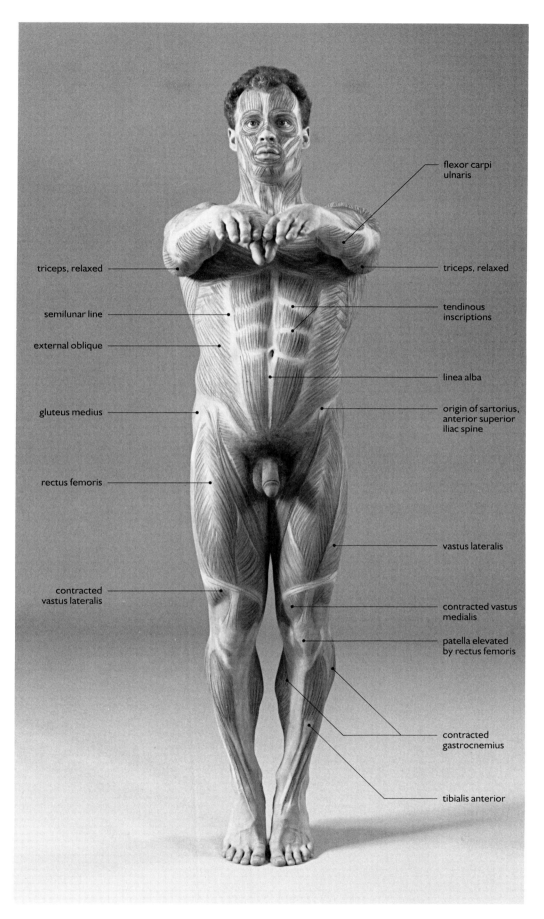

flexor carpi
ulnaris

triceps, relaxed

triceps, relaxed

semilunar line

tendinous
inscriptions

external oblique

linea alba

gluteus medius

origin of sartorius,
anterior superior
iliac spine

rectus femoris

vastus lateralis

contracted
vastus lateralis

contracted vastus
medialis

patella elevated
by rectus femoris

contracted
gastrocnemius

tibialis anterior

Figure 69.
In this diving posture, the feet are flexed and the whole body is supported by the strong contraction of a relatively small yet powerful muscle, *gastrocnemius*.

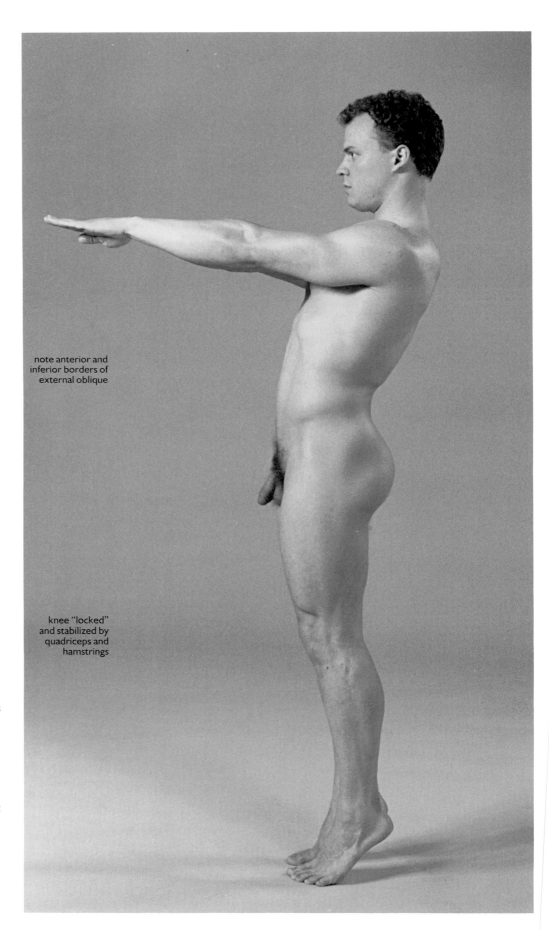

note anterior and inferior borders of external oblique

knee "locked" and stabilized by quadriceps and hamstrings

Figure 70.
Note that *gastrocnemius*, though working at full strength, does not bulge much. To maintain balance in this posture, the pelvis and knee must be rigidly stabilized. Accordingly, the hip muscles are vigorously contracted and the knee is locked.

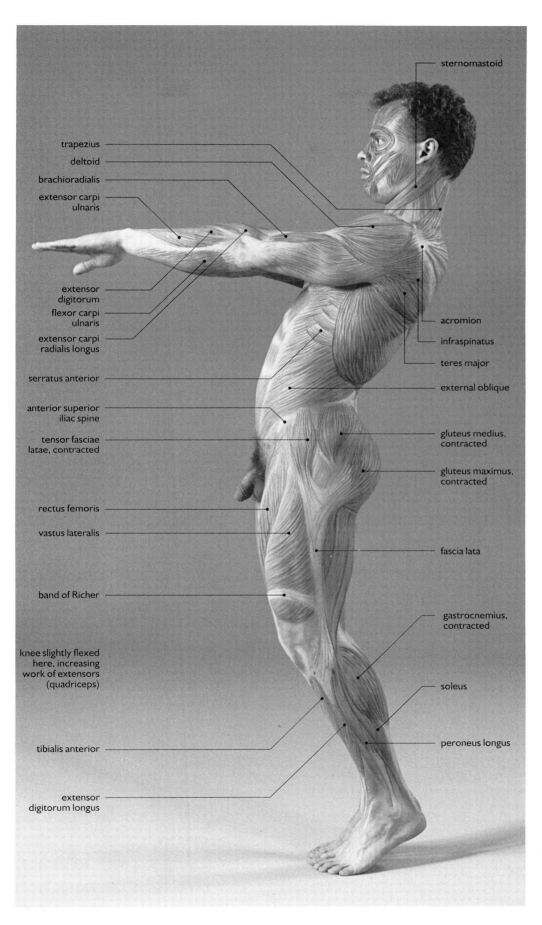

sternomastoid

trapezius

deltoid

brachioradialis

extensor carpi
ulnaris

extensor
digitorum

flexor carpi
ulnaris

extensor carpi
radialis longus

serratus anterior

anterior superior
iliac spine

tensor fasciae
latae, contracted

rectus femoris

vastus lateralis

band of Richer

knee slightly flexed
here, increasing
work of extensors
(quadriceps)

tibialis anterior

extensor
digitorum longus

acromion

infraspinatus

teres major

external oblique

gluteus medius,
contracted

gluteus maximus,
contracted

fascia lata

gastrocnemius,
contracted

soleus

peroneus longus

Figure 71.
This pose shows
close to maximum
extension of the
thoracic spine. If the
head were thrown
back, the position
would approach
opisthotonos, the
extreme contraction
of all extensors.

88

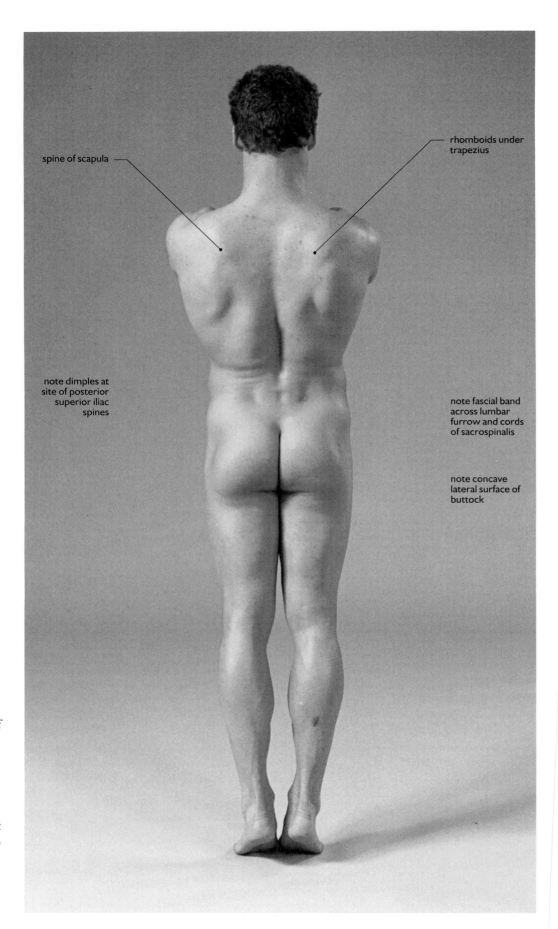

spine of scapula

rhomboids under trapezius

note dimples at site of posterior superior iliac spines

note fascial band across lumbar furrow and cords of sacrospinalis

note concave lateral surface of buttock

Figure 72.
The concave lateral surface of the buttocks, so evident here, is a hallmark of masculinity. It is formed by the relative overdevelopment of the main gluteal muscles (that serve as the hills that determine the valley) and by the paucity of fat in an area that serves as a fat depot in women.

89

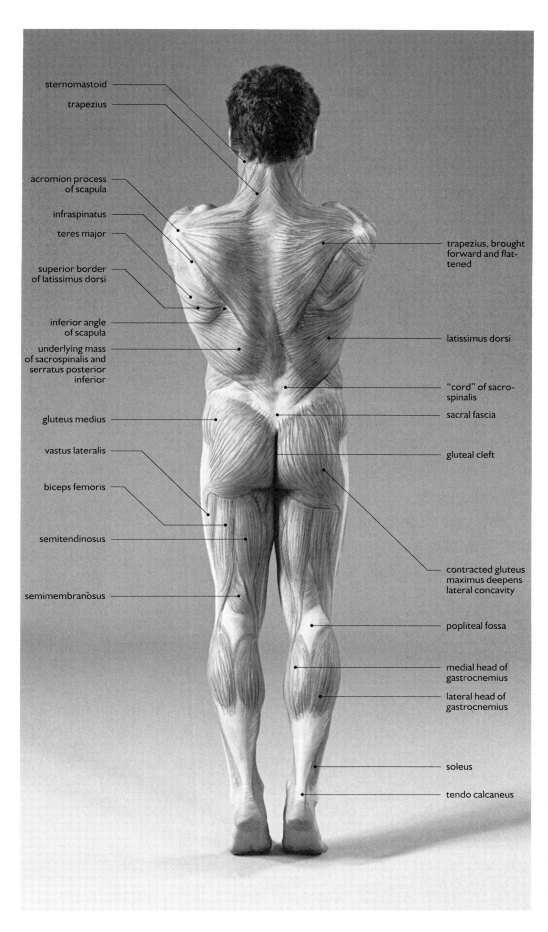

sternomastoid

trapezius

acromion process
of scapula

infraspinatus

teres major

superior border
of latissimus dorsi

inferior angle
of scapula

underlying mass
of sacrospinalis and
serratus posterior
inferior

gluteus medius

vastus lateralis

biceps femoris

semitendinosus

semimembranosus

trapezius, brought
forward and flat-
tened

latissimus dorsi

"cord" of sacro-
spinalis

sacral fascia

gluteal cleft

contracted gluteus
maximus deepens
lateral concavity

popliteal fossa

medial head of
gastrocnemius

lateral head of
gastrocnemius

soleus

tendo calcaneus

Figure 73.
The scapulas are
moved laterally in
this posture,
broadening and
thinning *trapezius*,
which covers a
greater surface. The
swelling noticeable
in the area of the left
latissimus dorsi—
which, like *trapezius*,
is stretched and
thinned—is the
mass of the
sacrospinalis group.

90

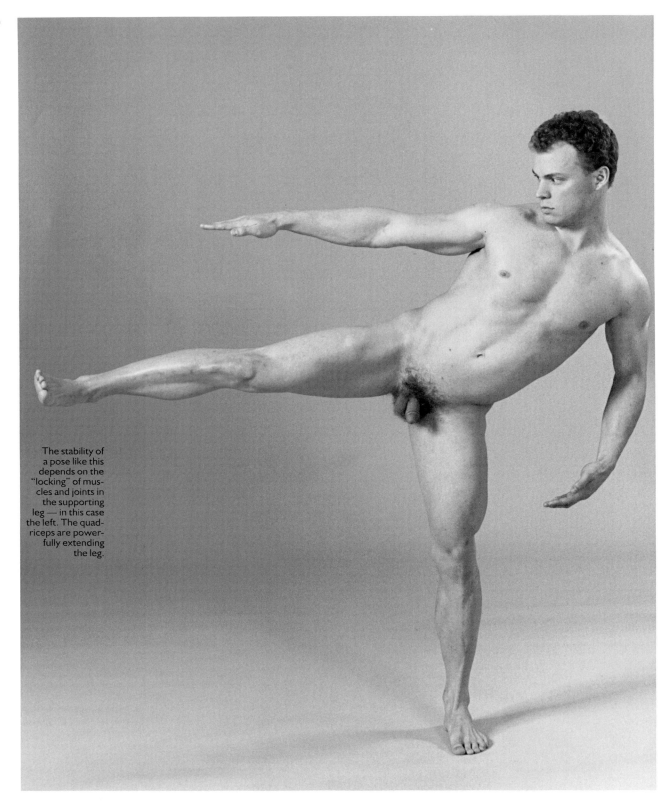

The stability of a pose like this depends on the "locking" of muscles and joints in the supporting leg — in this case the left. The quadriceps are powerfully extending the leg.

Figure 74.
Except for the skull, there is no expanse of bone near the skin's surface comparable in extent to that of the shin. Unprotected except by skin, the medial surface of the tibia is vulnerable to painful blows. Here a highlight along the model's right leg reveals its entire anterior crest.

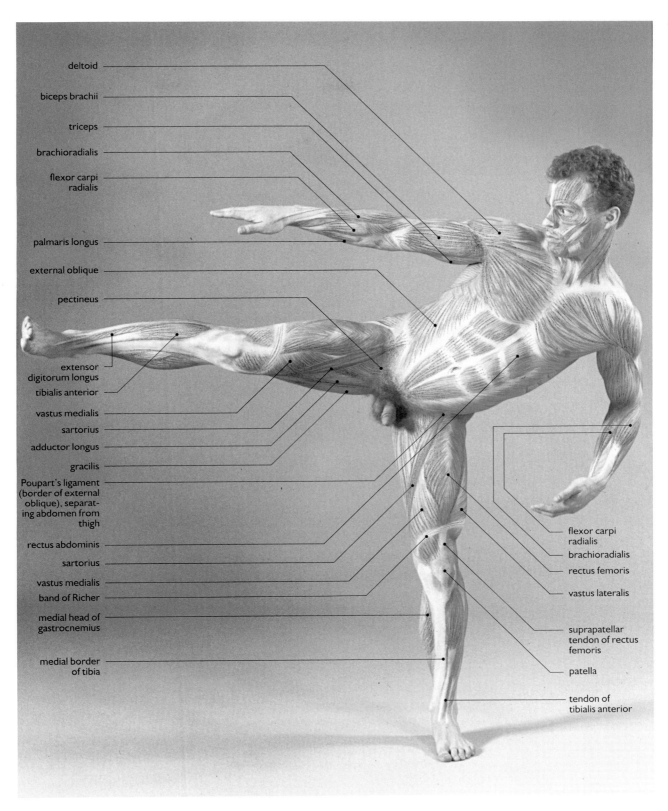

deltoid

biceps brachii

triceps

brachioradialis

flexor carpi
radialis

palmaris longus

external oblique

pectineus

extensor
digitorum longus

tibialis anterior

vastus medialis

sartorius

adductor longus

gracilis

Poupart's ligament
(border of external
oblique), separat-
ing abdomen from
thigh

rectus abdominis

sartorius

vastus medialis

band of Richer

medial head of
gastrocnemius

medial border
of tibia

flexor carpi
radialis

brachioradialis

rectus femoris

vastus lateralis

suprapatellar
tendon of rectus
femoris

patella

tendon of
tibialis anterior

Figure 75.

Striking in this karate pose is the powerfully contracted mass of *vastus lateralis* overhanging the model's left knee. The pale arching strap of connective tissue fibers above the knee, the *band of Richer*, binds the extensors and, by preventing excess ballooning, increases their efficiency.

92

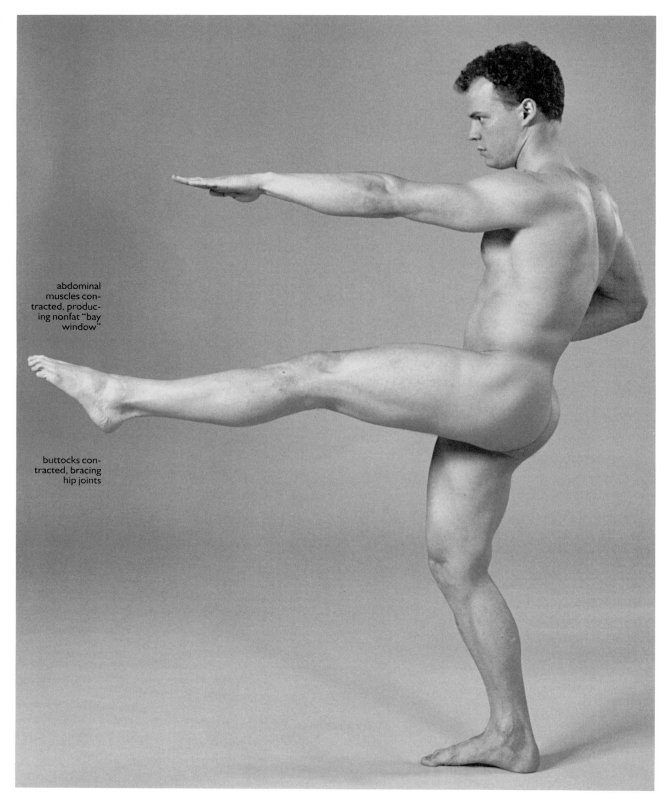

abdominal muscles contracted, producing nonfat "bay window"

buttocks contracted, bracing hip joints

Figure 76.

The *tibialis anterior* is the swelling just distal to the left knee. A flexor that raises the foot (brings it up toward the leg), it is stretched here and in opposition to the extensors. *Tensor fasciae latae* is conspicuous in this photograph.

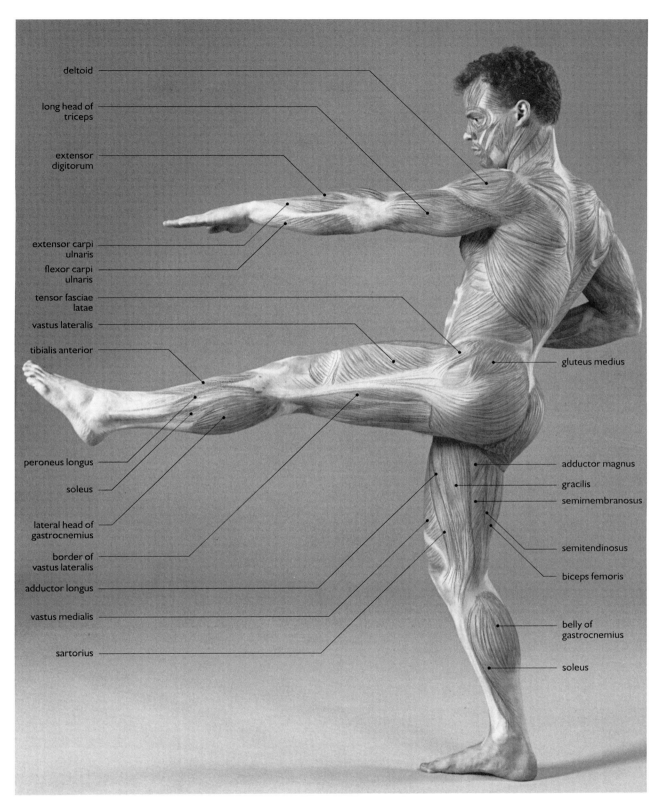

deltoid

long head of triceps

extensor digitorum

extensor carpi ulnaris

flexor carpi ulnaris

tensor fasciae latae

vastus lateralis

tibialis anterior

peroneus longus

soleus

lateral head of gastrocnemius

border of vastus lateralis

adductor longus

vastus medialis

sartorius

gluteus medius

adductor magnus

gracilis

semimembranosus

semitendinosus

biceps femoris

belly of gastrocnemius

soleus

Figure 77.

The adductor group of muscles have other functions besides adducting. *Gracilis* also flexes the thigh and rotates it inward. *Adductor magnus* extends it; *adductor longus* flexes it. *Sartorius*, which parallels *gracilis* for much of the latter's length, is an *ab*ductor, among other functions.

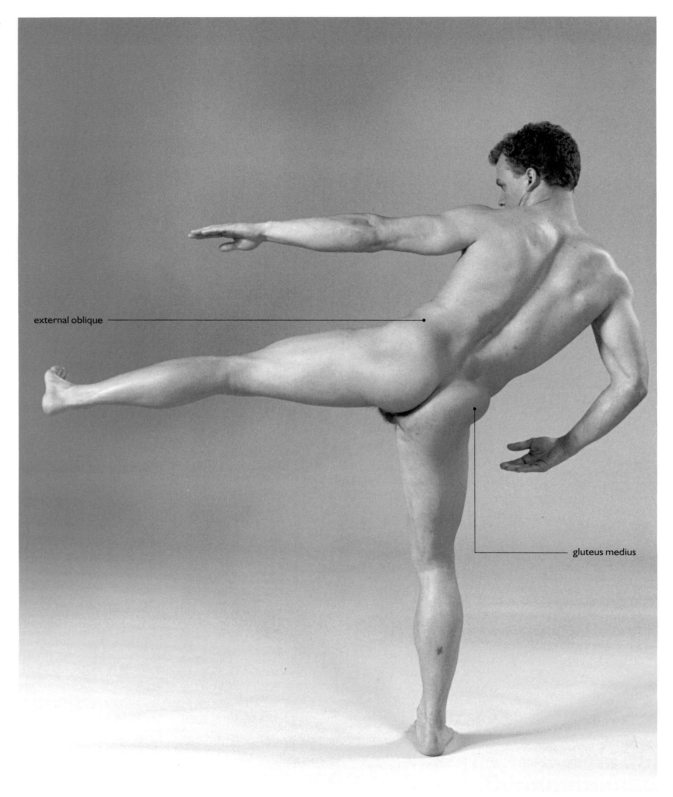

external oblique

gluteus medius

Figure 78.

Gracilis and *semitendinosus* are just visible toward the medial portion of the right thigh. The model's weight, in perfect balance, is distributed equally on either side of the fulcrum formed by his pelvis and right leg.

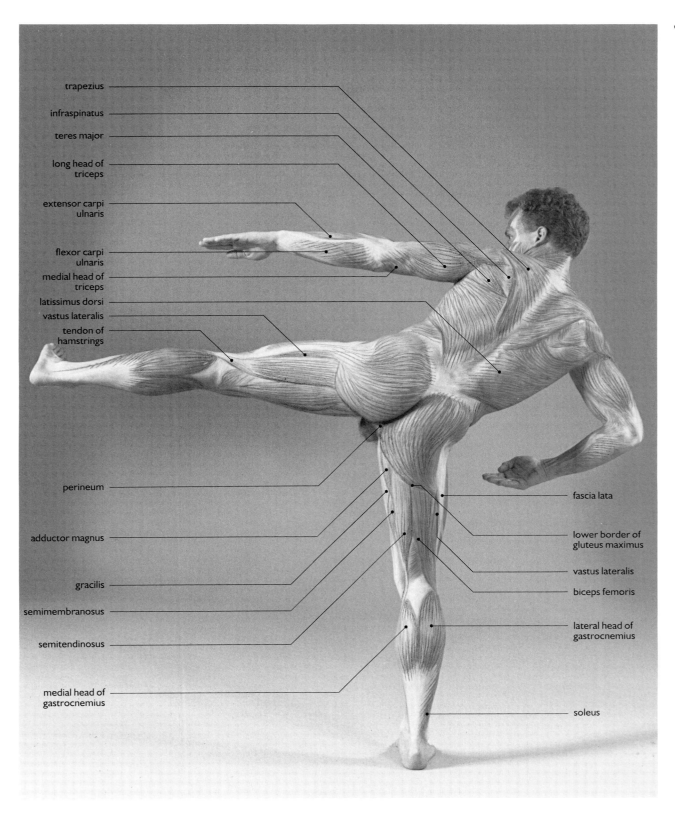

trapezius

infraspinatus

teres major

long head of triceps

extensor carpi ulnaris

flexor carpi ulnaris

medial head of triceps

latissimus dorsi

vastus lateralis

tendon of hamstrings

perineum

adductor magnus

gracilis

semimembranosus

semitendinosus

medial head of gastrocnemius

fascia lata

lower border of gluteus maximus

vastus lateralis

biceps femoris

lateral head of gastrocnemius

soleus

Figure 79.

Because both thighs are somewhat flexed here, the gluteal folds are effaced. The gluteal cleft, however, can be seen to extend between the buttocks from the base of the sacrum to the perineum, which includes the anal area and the scrotum.

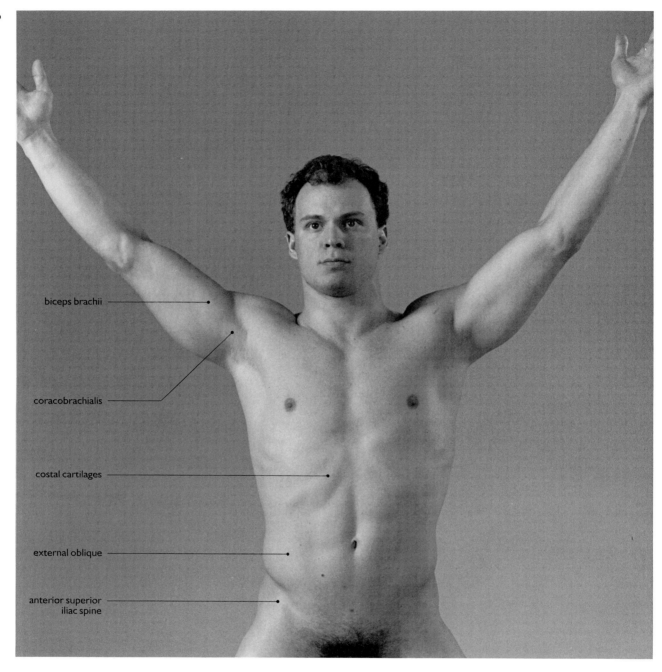

biceps brachii

coracobrachialis

costal cartilages

external oblique

anterior superior
iliac spine

Figure 80.

Contributing to the axilla is *serratus anterior*, which forms its medial wall, and *coracobrachialis*, which presents as an elevation at what otherwise would be the armpit's deepest point. Part of *biceps* also contributes to this elevation.

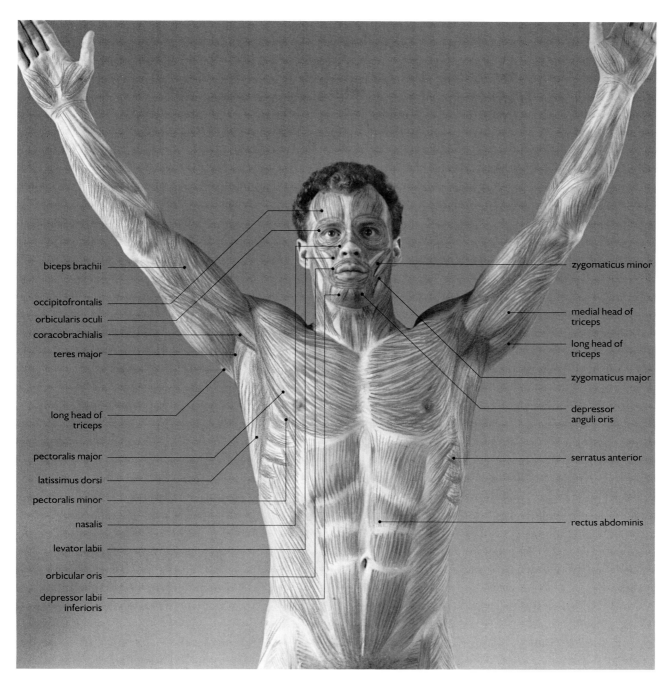

biceps brachii

occipitofrontalis
orbicularis oculi
coracobrachialis
teres major

long head of
triceps

pectoralis major

latissimus dorsi

pectoralis minor

nasalis

levator labii

orbicular oris

depressor labii
inferioris

zygomaticus minor

medial head of
triceps

long head of
triceps

zygomaticus major

depressor
anguli oris

serratus anterior

rectus abdominis

Figure 81.

The human face, so unlike that of the apes (we think), seems to turn simian when the facial musculature is considered. The axilla, or armpit, is demonstrated here. It has an anterior border formed by *pectoralis major* and a posterior one formed by *latissimus dorsi* and *teres major*.

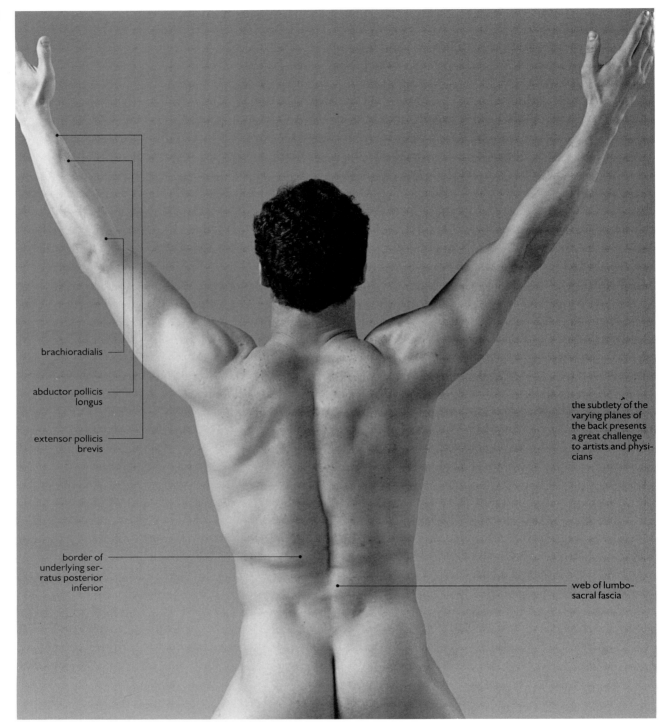

brachioradialis

abductor pollicis
longus

extensor pollicis
brevis

the subtlety of the
varying planes of
the back presents
a great challenge
to artists and physi-
cians

border of
underlying ser-
ratus posterior
inferior

web of lumbo-
sacral fascia

Figure 82.

Visible here as separate segments on the left forearm are *brachioradialis, adductor pollicis longus,* and *extensor pollicis brevis.* The transverse band at the upper border of the sacrum (between and superior to the dimples caused by the posterior superior iliac spines) is a web of lumbosacral fascia.

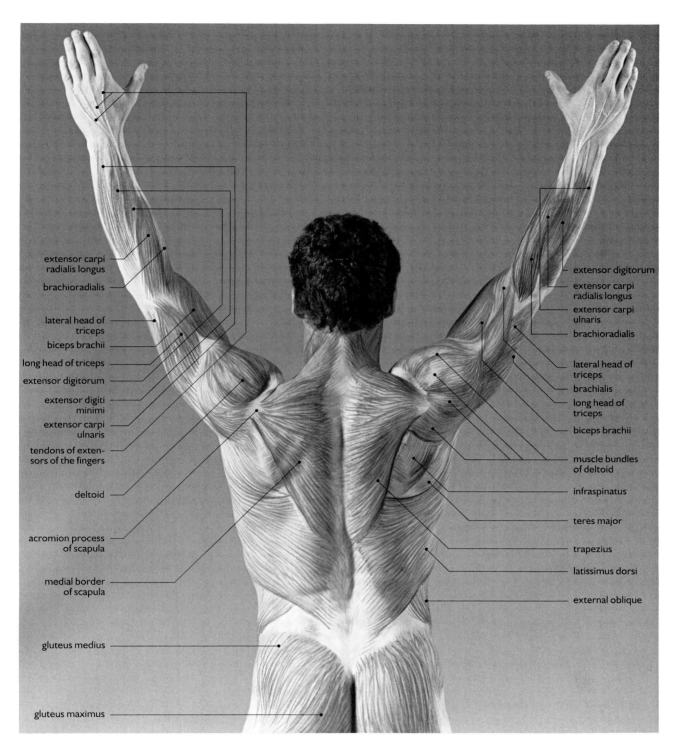

Figure 83.

This pose shows extensors of the forearm, the most medial being *extensor digitorum*, which ends in tendons to all digits but the thumb. Lateral to it (not clearly distinguished) are *extensor digiti minimi* (to the little finger) and *extensor carpi ulnaris* (adductor of the hand). Most lateral is a flexor and adductor, *flexor carpi ulnaris.*

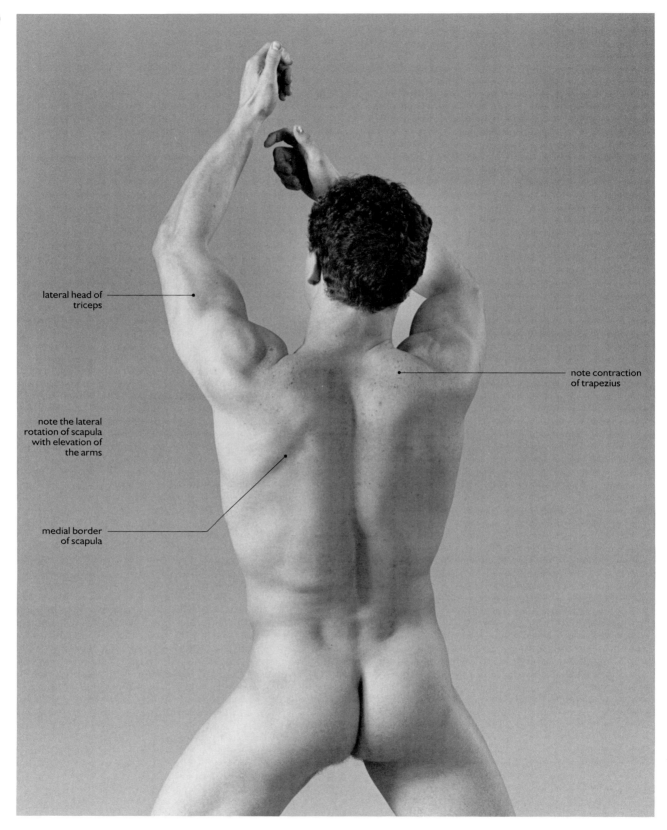

lateral head of
triceps

note contraction
of trapezius

note the lateral
rotation of scapula
with elevation of
the arms

medial border
of scapula

Figure 84.

A variation on the maneuver shown in Fig. 85. In so complex an act, far more than adduction is required. Its bulging shows that the posterior portion of *deltoid* is drawing the arm backward in cooperation with *triceps*. Also, the pelvis and legs are braced, providing the stability essential for effective pulling.

101

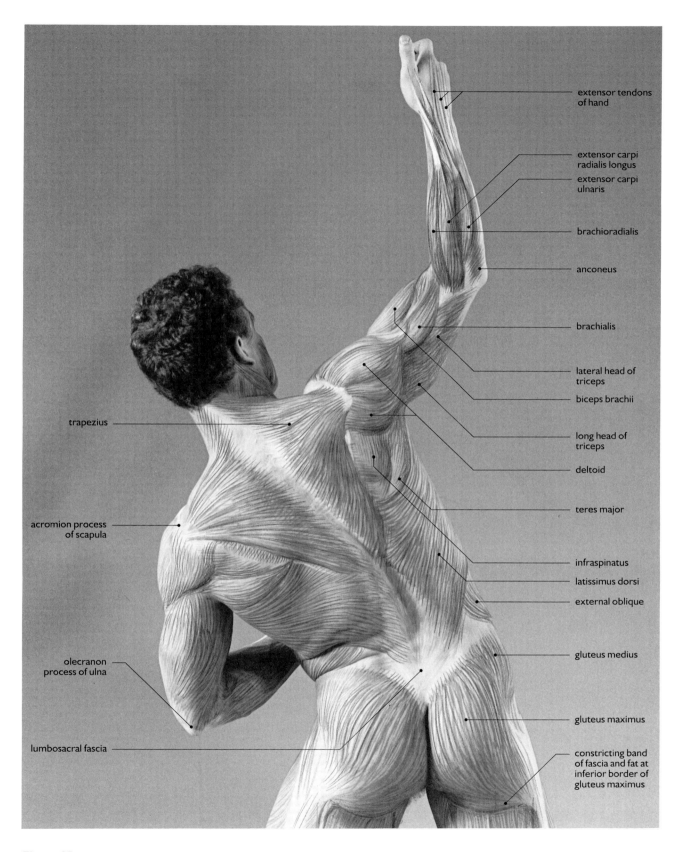

extensor tendons
of hand

extensor carpi
radialis longus

extensor carpi
ulnaris

brachioradialis

anconeus

brachialis

lateral head of
triceps

biceps brachii

long head of
triceps

deltoid

teres major

infraspinatus

latissimus dorsi

external oblique

gluteus medius

gluteus maximus

constricting band
of fascia and fat at
inferior border of
gluteus maximus

trapezius

acromion process
of scapula

olecranon
process of ulna

lumbosacral fascia

Figure 85.
Pulling on a rope involves adduction of the arm, the function of *triceps* (note the contraction of the right arm). It also draws the arm backward, and the three heads together extend it—movements intrinsic to this activity.

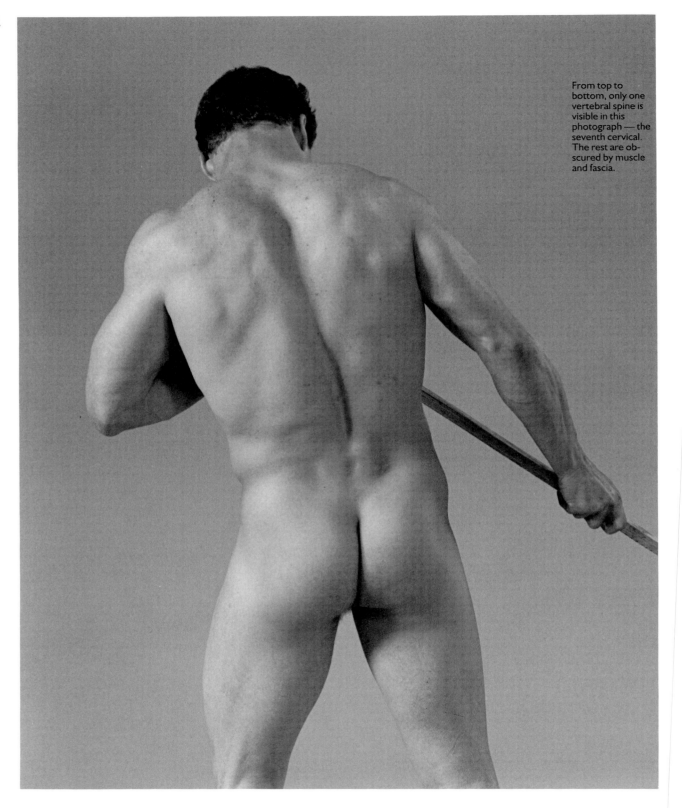

From top to bottom, only one vertebral spine is visible in this photograph — the seventh cervical. The rest are obscured by muscle and fascia.

Figure 86.

The back's congeries of lights and shadows, lumps and hollows, ridges and grooves, are displayed here in all their bewildering intricacy. Knowing the underlying anatomy helps order them into a meaningful pattern.

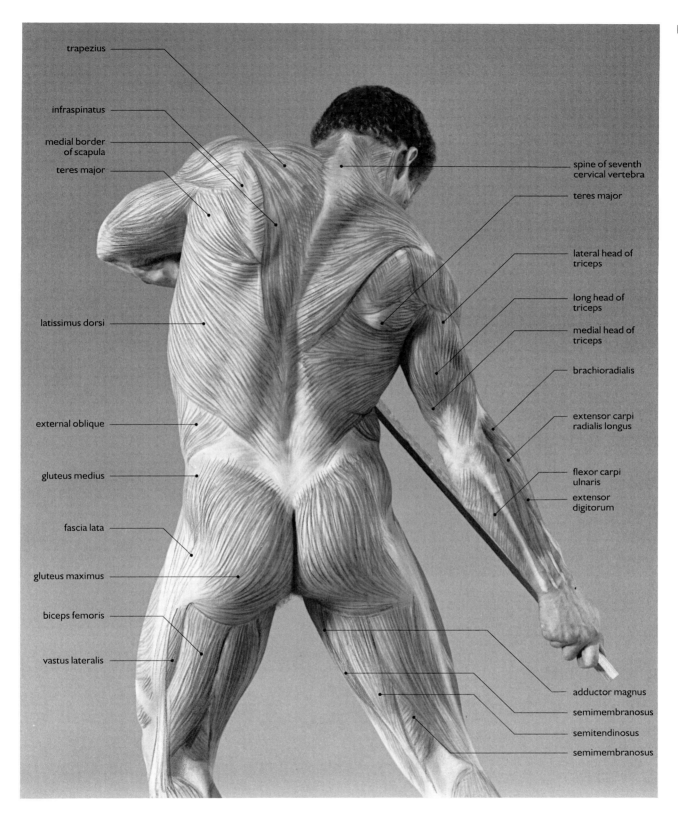

trapezius

infraspinatus

medial border
of scapula

teres major

latissimus dorsi

external oblique

gluteus medius

fascia lata

gluteus maximus

biceps femoris

vastus lateralis

spine of seventh
cervical vertebra

teres major

lateral head of
triceps

long head of
triceps

medial head of
triceps

brachioradialis

extensor carpi
radialis longus

flexor carpi
ulnaris

extensor
digitorum

adductor magnus

semimembranosus

semitendinosus

semimembranosus

Figure 87.
When the arms pull in opposite directions (as in shooting an arrow, for example), the extensors—particularly *triceps*—are the prime movers along with *deltoid*'s secondary exertion. The scapula is stabilized firmly by its strong muscles—*rhomboids, supraspinatus, infraspinatus, teres,* and so on.

good posture à la
West Point

Figure 88.
Trapezius is maximally contracted and fleshy here, occupying roughly half its former area. Its entire outline is distinctly seen on the right as a triangle with the apex at midshoulder and the base extending from occiput to midback.

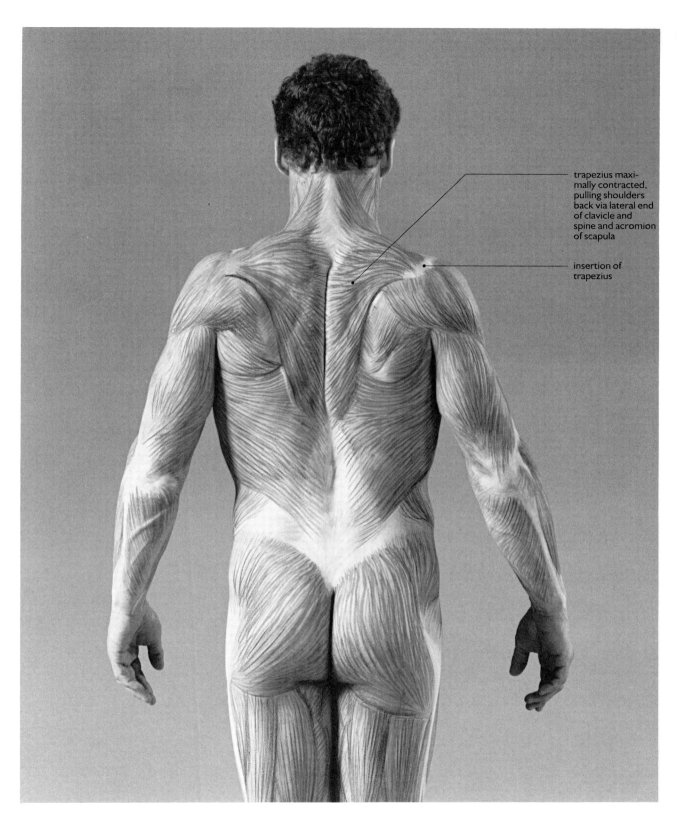

105

trapezius maxi-
mally contracted,
pulling shoulders
back via lateral end
of clavicle and
spine and acromion
of scapula

insertion of
trapezius

Figure 89.
The pose in this figure and the ones in Figs. 88, 90, and 91 demonstrate the extremes of variation in the configuration of the back. The progression is from a position of braced shoulders and extended trunk to one of slight flexion of the trunk with shoulders drawn forward.

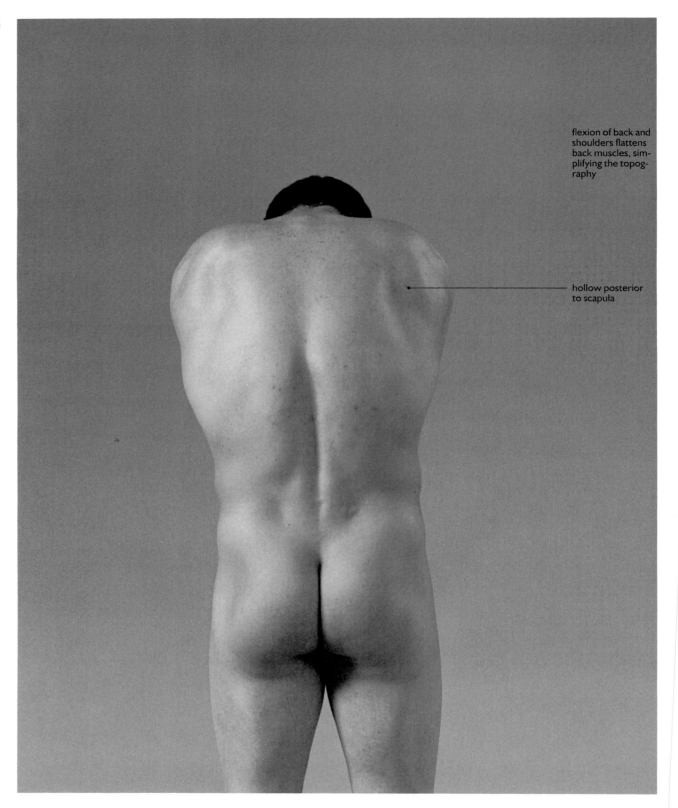

flexion of back and
shoulders flattens
back muscles, sim-
plifying the topog-
raphy

hollow posterior
to scapula

Figure 90.
The appearance of the back's hills and valleys is now entirely altered from that shown in Fig. 86. Except for a thin band at the uppermost outline, *trapezius* has virtually disappeared. The movement of the scapulas laterally and anteriorly has left previously unapparent hollows in their wake.

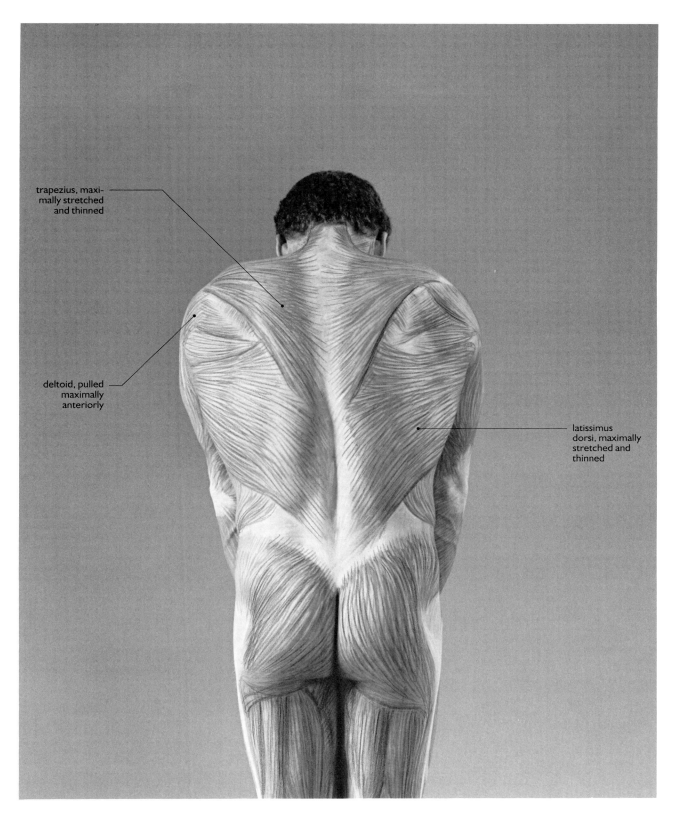

trapezius, maxi-
mally stretched
and thinned

deltoid, pulled
maximally
anteriorly

latissimus
dorsi, maximally
stretched and
thinned

Figure 91.
This pose is the opposite of that in Figs. 88 and 89. Here *trapezius,* a relatively thin muscle, is spread and thinned maximally. *Deltoid,* so conspicuous in the previous position, is almost hidden now. *Latissimus dorsi,* like *trapezius,* is thinned and spread to its utmost limits.

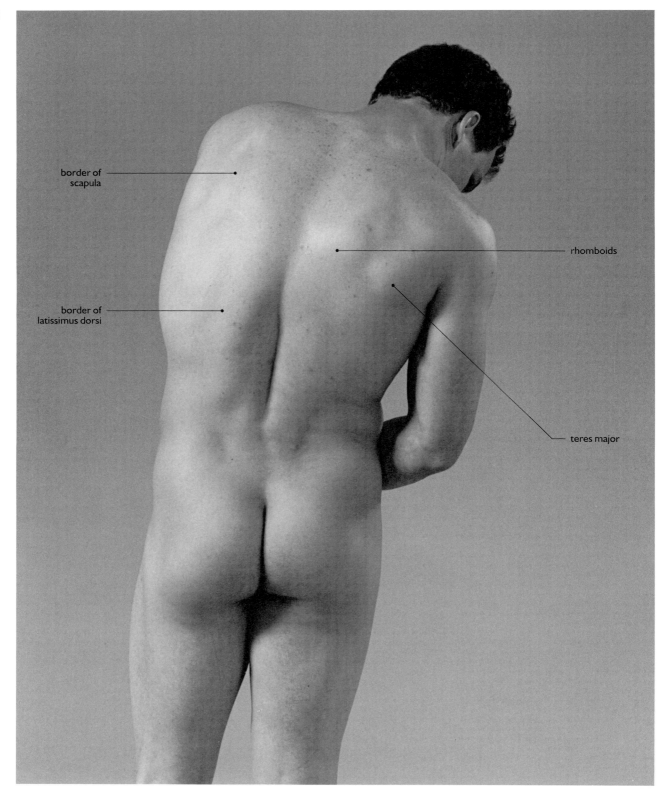

border of
scapula

rhomboids

border of
latissimus dorsi

teres major

Figure 92.
Teres major and underlying *rhomboids* are responsible here for the two prominent mounds on the right midback. The undulations of the left side are exquisitely subtle, yet they too are identifiable, having been faithfully captured in marble and in paint by artists such as Michelangelo and Rubens.

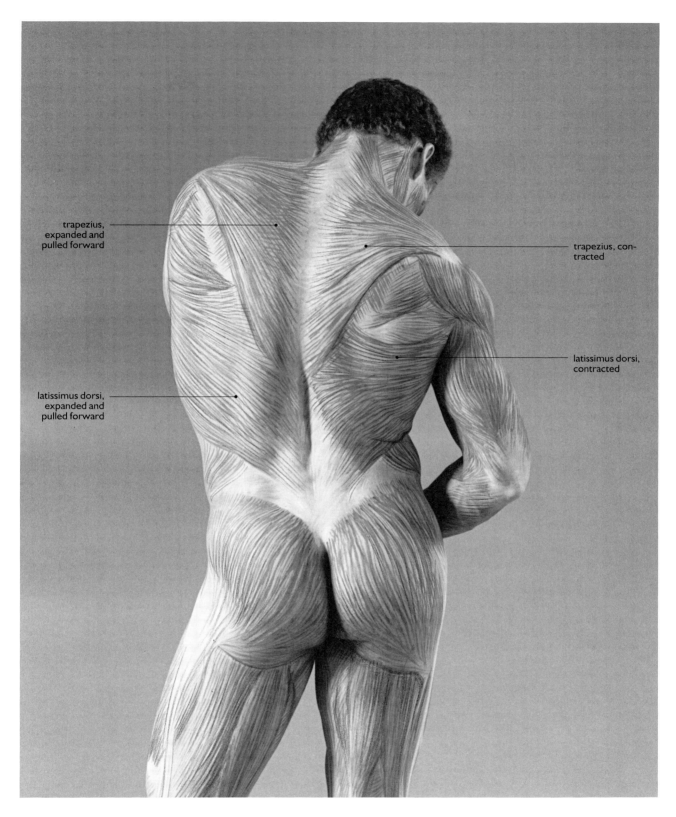

trapezius, expanded and pulled forward

trapezius, contracted

latissimus dorsi, contracted

latissimus dorsi, expanded and pulled forward

Figure 93.

The left side is the same as in Figs. 90 and 91. The right side is now inclined laterally and is slightly flexed. Compare the topography of the two sides first; then compare this pose with those in Figs. 88 and 90. A muscular back's mobility is why it is the most difficult subject to draw and sculpt.

Figure 94.
The beautiful *sternomastoid*, the most prominent surface muscle, would stand out even more if the model were turning his head against resistance. It tends to split in two at its insertion, with the most conspicuous portion going to the sternum and the rest to the clavicle.

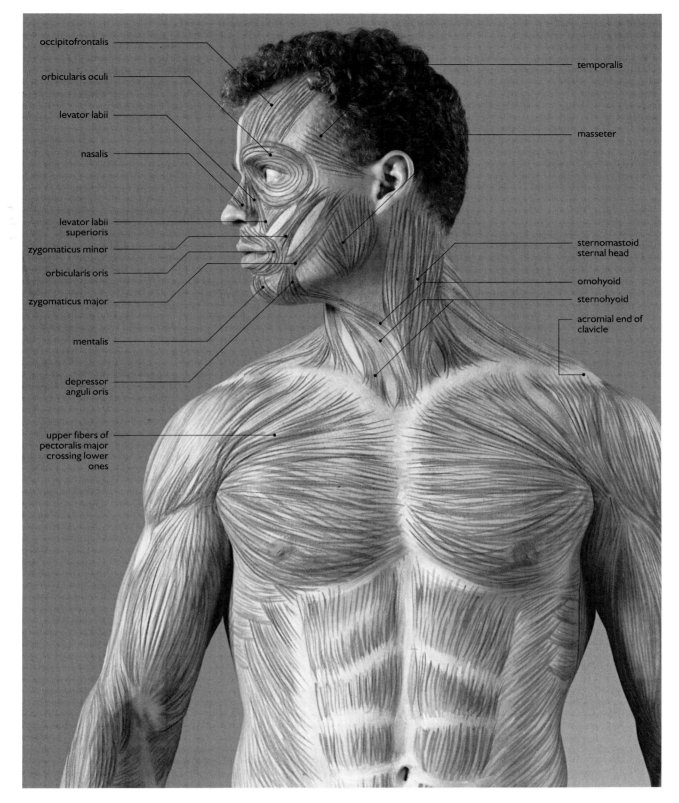

occipitofrontalis

orbicularis oculi

levator labii

nasalis

levator labii
superioris

zygomaticus minor

orbicularis oris

zygomaticus major

mentalis

depressor
anguli oris

upper fibers of
pectoralis major
crossing lower
ones

temporalis

masseter

sternomastoid
sternal head

omohyoid

sternohyoid

acromial end of
clavicle

Figure 95.

The *sternomastoid* forms a rounded strap from the mastoid process behind the ear to the medial end of the clavicle and to the
sternoclavicular articulation.

112

platysma

Figure 96.
Both insertions of the model's right *sternomastoid* are visible here. The faint cordlike form just inside the outer margin of the right *trapezius* is a strand of *platysma,* an inconsequential muscle that draws the lower lip down and laterally, as in expressing revulsion at a worm in one's salad.

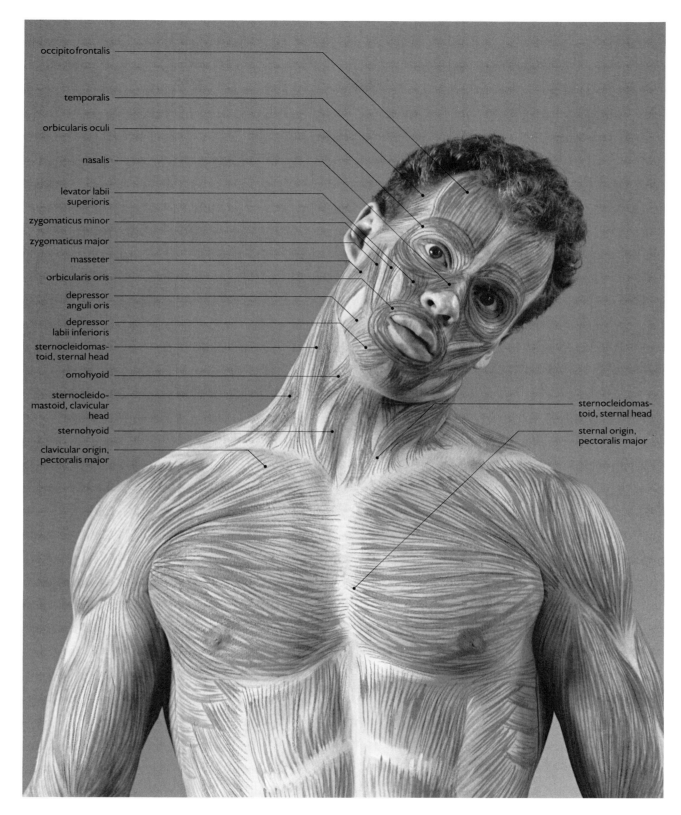

occipitofrontalis

temporalis

orbicularis oculi

nasalis

levator labii superioris

zygomaticus minor

zygomaticus major

masseter

orbicularis oris

depressor anguli oris

depressor labii inferioris

sternocleidomas-toid, sternal head

omohyoid

sternocleido-mastoid, clavicular head

sternohyoid

clavicular origin, pectoralis major

sternocleidomas-toid, sternal head

sternal origin, pectoralis major

Figure 97.

The neck with its vertebrae (seven cervical) is the most flexible portion of the spinal axis. It flexes and extends further than the thoracic and has greater lateral mobility. Extension is facilitated by the shortness of the vertebral spines (except for the prominent seventh) in this area.

trapezius,
contracted

Figure 98.

The left side of *trapezius* is shown in its function of inclining the head to the side; if both upper portions contracted equally, the head would be symmetrically extended. Of course, the left *sternomastoid* is also contributing to the inclination of the head.

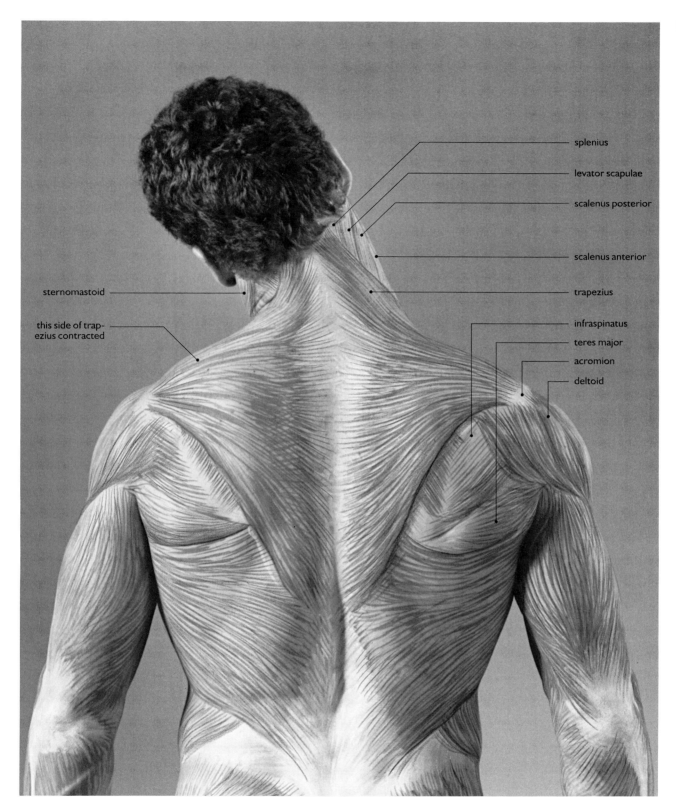

splenius

levator scapulae

scalenus posterior

scalenus anterior

sternomastoid

trapezius

this side of trap-
ezius contracted

infraspinatus

teres major

acromion

deltoid

Figure 99.
The flat straplike muscles just anterior to *trapezius* are *splenius, levator scapulae, scalenus anterior,* and *scalenus posterior*. The *scalenes* bend the cervical spines laterally or, operating together, forward. The *levator* draws the scapula up and medially.

ramus of mandible

Figure 100.
More important in the configuration of the neck, at least in most men, is the laryngeal prominence, or "Adam's apple." Although his voice is normally deep, our model's Adam's apple is not as marked as it is in most men. The depression below the hyoid bone, however, is observable here.

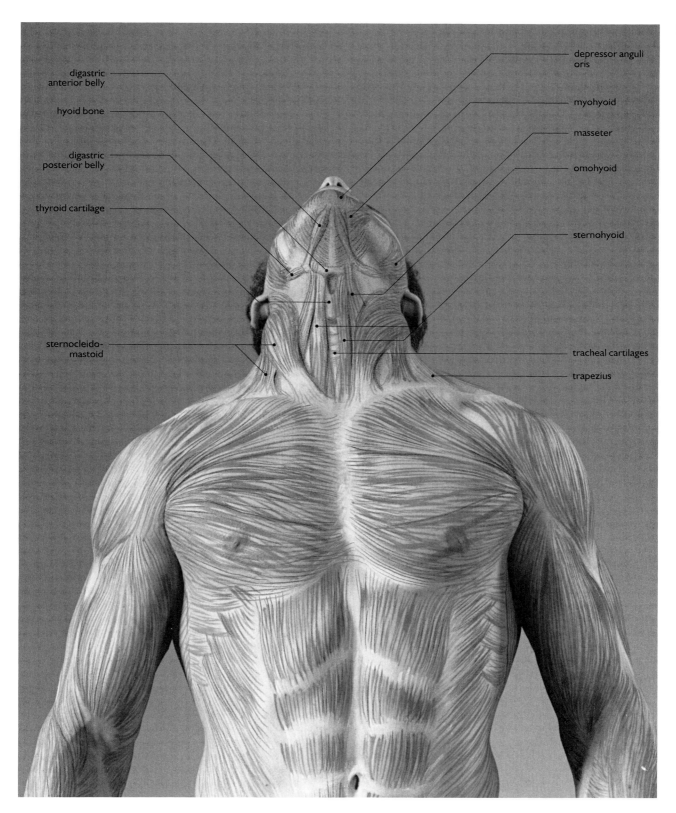

digastric
anterior belly

hyoid bone

digastric
posterior belly

thyroid cartilage

sternocleido-
mastoid

depressor anguli
oris

myohyoid

masseter

omohyoid

sternohyoid

tracheal cartilages

trapezius

Figure 101.

Several smaller neck muscles are shown here. Although important functionally, they do not contribute much beyond a full appearance to the neck. Unless they are unusually developed, their outlines cannot, in fact, be traced on the living subject.

Figure 102.
As the flexors of the neck are all anterior, one need only note that the entire form of the back of the neck is the contribution of *trapezius*. Note again the prominence of the seventh cervical spine.

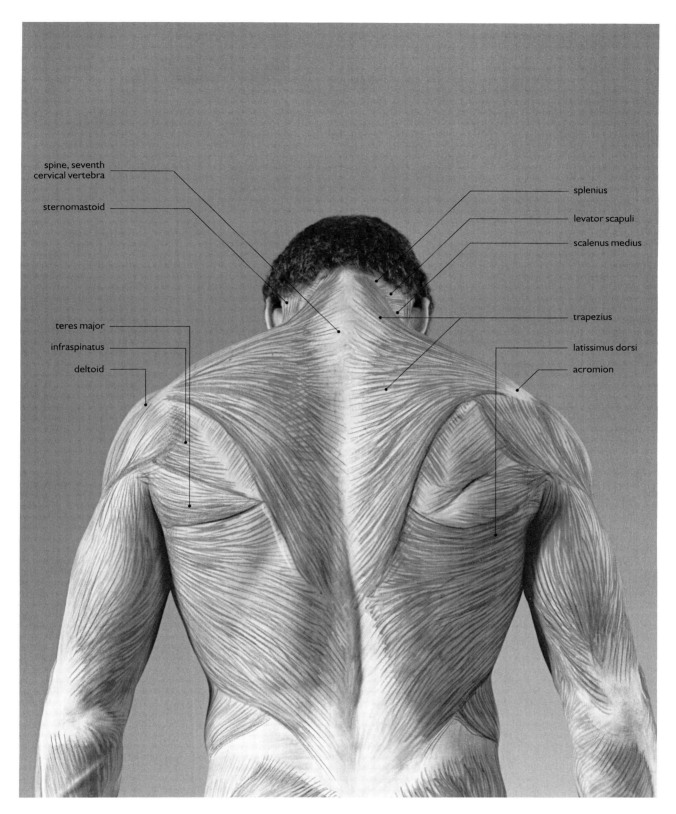

spine, seventh
cervical vertebra

sternomastoid

teres major

infraspinatus

deltoid

splenius

levator scapuli

scalenus medius

trapezius

latissimus dorsi

acromion

Figure 103.
The neck is in flexion. The prominence over the seventh cervical vertebra is very evident here.

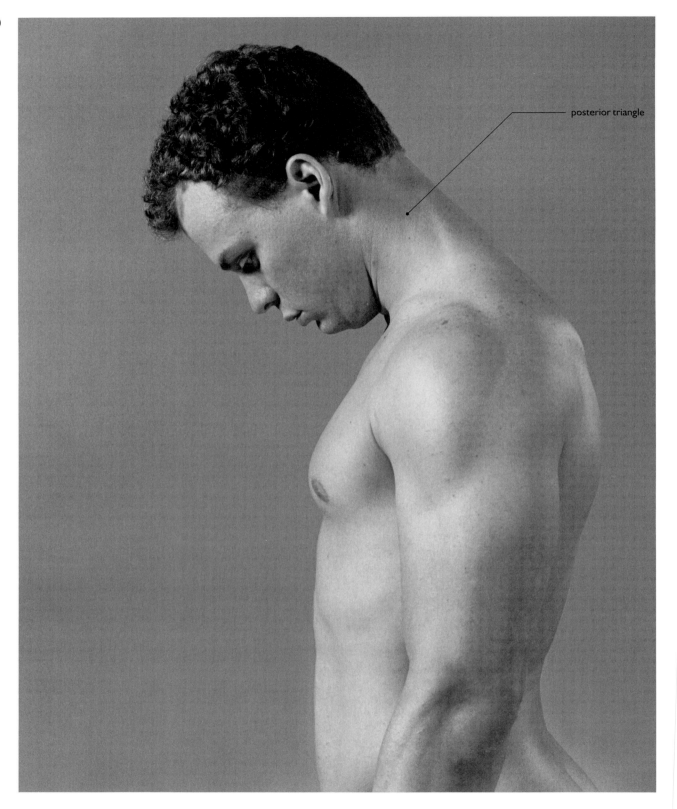

posterior triangle

Figure 104.

The facing borders of *sternomastoid* and *trapezius* can be made out here, but, as mentioned, the flat muscles between them leave no imprint on the surface. They are covered, beneath the skin, with layers of smooth fascia.

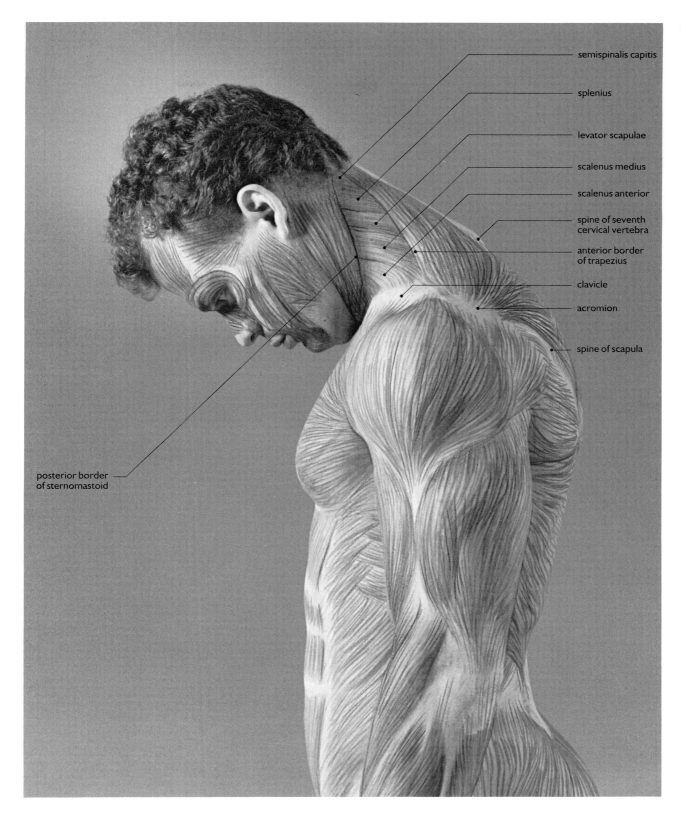

semispinalis capitis

splenius

levator scapulae

scalenus medius

scalenus anterior

spine of seventh
cervical vertebra

anterior border
of trapezius

clavicle

acromion

spine of scapula

posterior border
of sternomastoid

Figure 105.
The neck is fully flexed here. The posterior triangle of the neck is shown. It is formed by the posterior border of *sternomastoid*, the clavicle, and the anterior border of *trapezius*. Within it can be seen *levator scapulae, scalenus* muscles, and, most inferiorly, *omohyoid*.

122

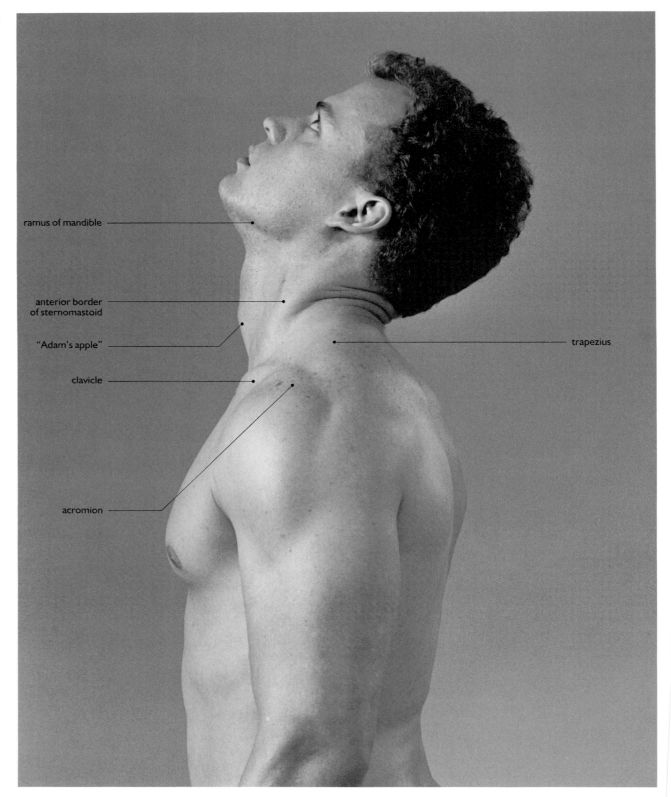

ramus of mandible

anterior border
of sternomastoid

"Adam's apple"

clavicle

acromion

trapezius

Figure 106.
The swelling at the angle (ramus) of the jaw is caused by *masseter*, which becomes most prominent when the teeth are clenched.
Both the clavicle and (just above *deltoid*) the acromion process of the scapula can be discerned here.

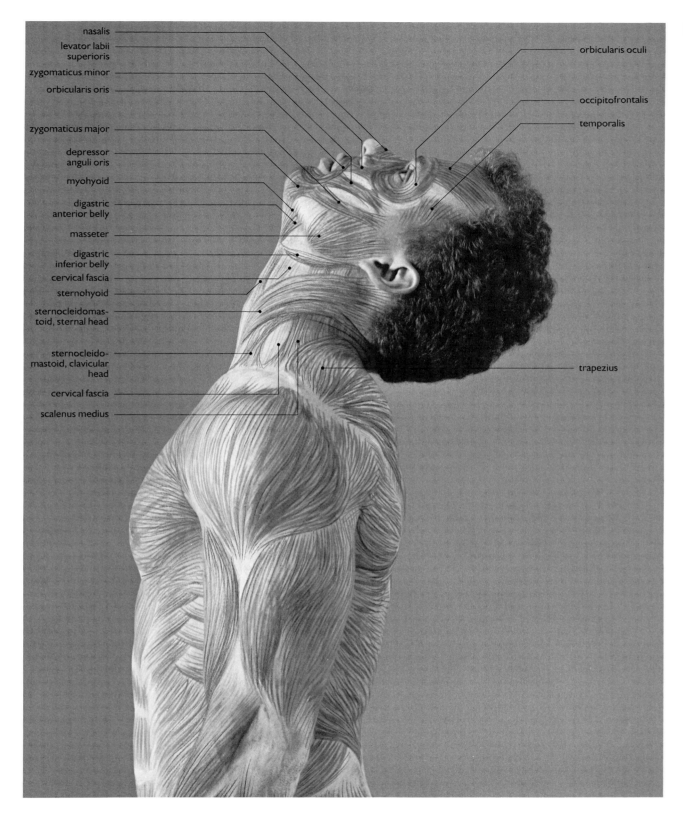

nasalis

levator labii superioris

zygomaticus minor

orbicularis oris

zygomaticus major

depressor anguli oris

myohyoid

digastric anterior belly

masseter

digastric inferior belly

cervical fascia

sternohyoid

sternocleidomas- toid, sternal head

sternocleido- mastoid, clavicular head

cervical fascia

scalenus medius

orbicularis oculi

occipitofrontalis

temporalis

trapezius

Figure 107.

The profile of the male breast is not due solely to *pectoralis major* and *minor*. Although there is no glandular tissue, as in the female, there is usually a deposit of fat near the nipple that rounds the contours. The "Adam's apple" is more discernible in this photograph.

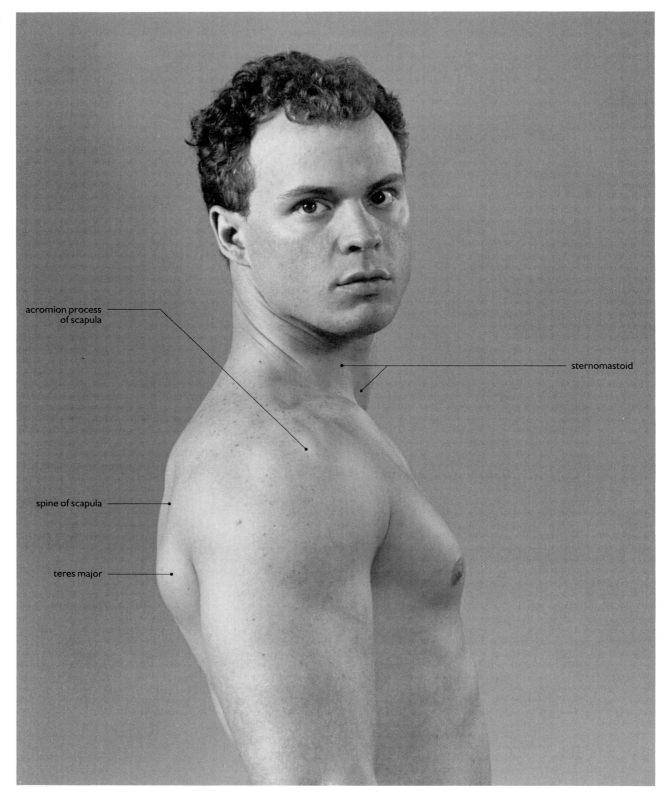

acromion process
of scapula

sternomastoid

spine of scapula

teres major

Figure 108.
The nose can be wrinkled and the nostrils dilated and compressed by muscles that have little influence on surface form beyond filling it out and creating wrinkles. *Occipitofrontalis,* above the eyebrows, wrinkles the forehead and moves the scalp; *risorius* smiles, and *zygomaticus* sneers.

125

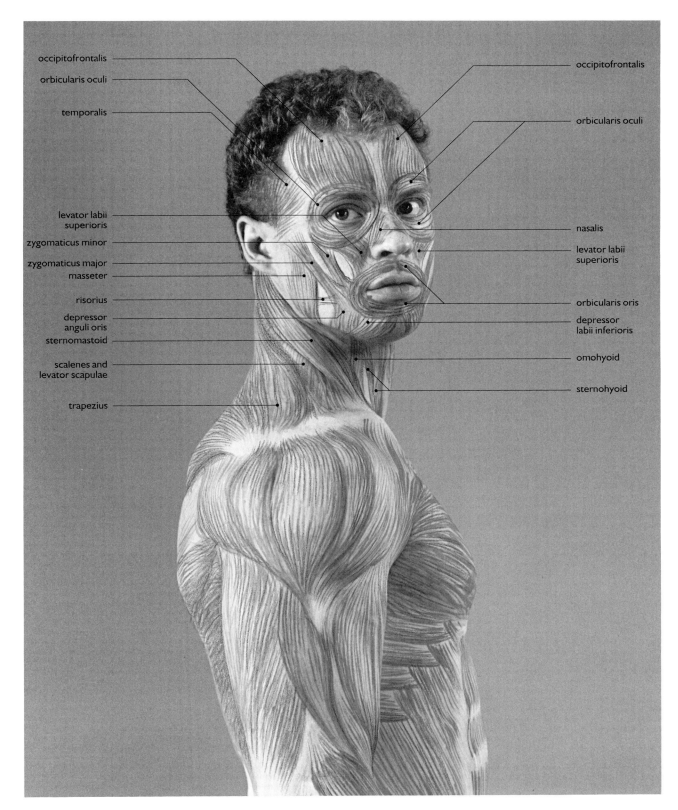

Figure 109.

The facial muscles convey expressions, most of which involve contractions of eye, nose, and mouth muscles. The eyes and mouth are surrounded by the sphincters *orbicularis oculi* and *orbicularis oris*. (A sphincter is an annular muscle surrounding and closing an opening.)

branch of
basilic vein

Figure 110.
Supination. *Supination* is the moving of the forearm from the prone position or an intermediate position into the supine position. *Pronation* is the moving of the forearm from the supine position or an intermediate position into the prone position. (For a mnemonic, see Figs. 134 and 135.)

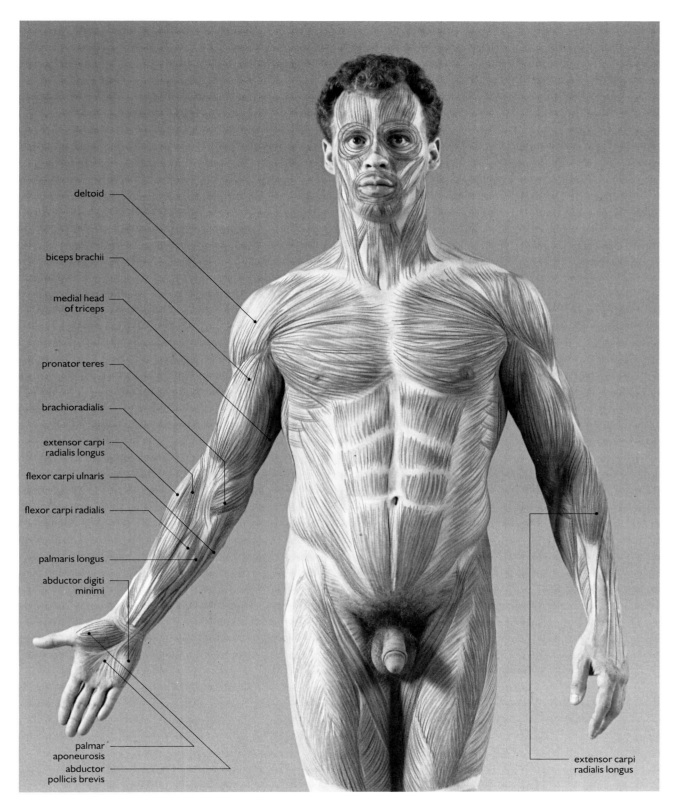

Figure III.

Supination. When *supine,* the two bones of the forearm, ulna and radius, are parallel, and the thumb is directed *away* from the body. When *prone,* the two bones are crossed, the lower end of the radius having moved from the outer side to the inner, thus turning over the hand and bringing the thumb *toward* the body.

128

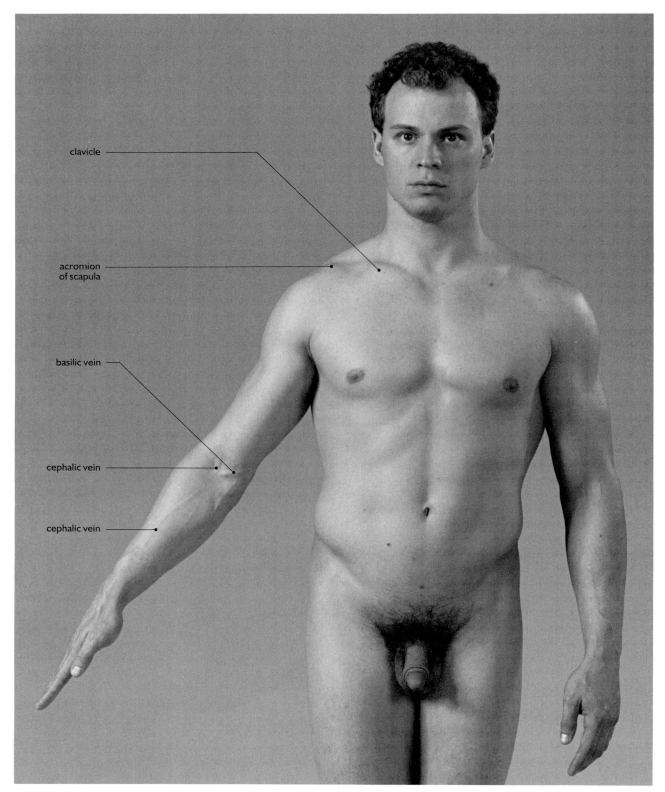

clavicle

acromion
of scapula

basilic vein

cephalic vein

cephalic vein

Figure 112.
Half-pronation. If the arm were relaxed and hanging loosely by the model's side, it would appear to be in roughly this position. Actually, it would be nearer the supine position, because in the natural pendant position the whole limb is rotated medially at the shoulder joint.

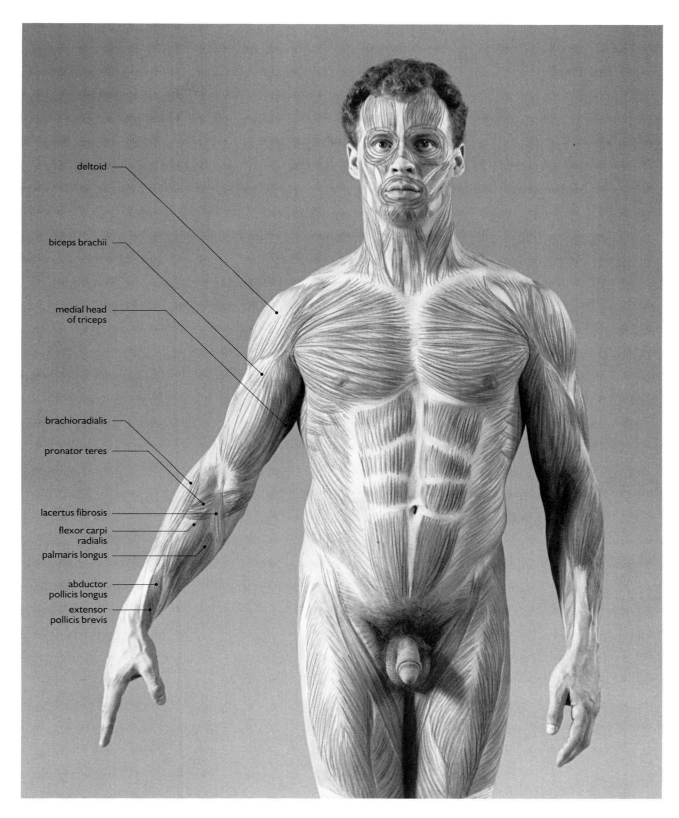

deltoid

biceps brachii

medial head
of triceps

brachioradialis

pronator teres

lacertus fibrosis

flexor carpi
radialis

palmaris longus

abductor
pollicis longus

extensor
pollicis brevis

Figure 113.
Half-pronation. The forearm and hand are halfway to the prone position.

cephalic vein

Figure 114.

Pronation. In the anatomical position, move your hand through the phases shown in Figs. 111–115. Note the impossibility of going further without involving your shoulder. As soon as you attempt more pronation, your *triceps* starts to tense.

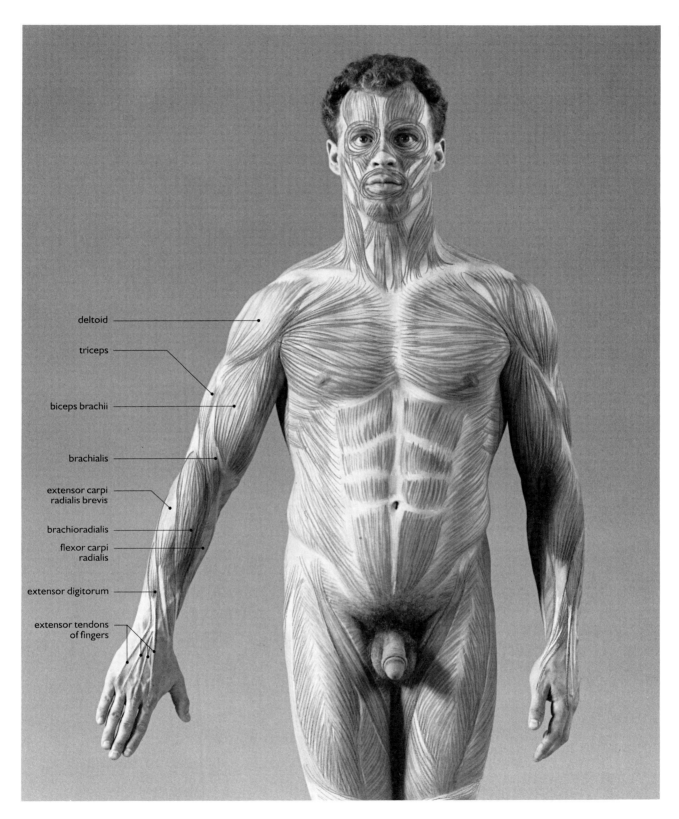

deltoid

triceps

biceps brachii

brachialis

extensor carpi
radialis brevis

brachioradialis

flexor carpi
radialis

extensor digitorum

extensor tendons
of fingers

Figure 115.

Pronation. The thumb has been rotated medially 180 degrees from its position in supination. The radius is much larger at the wrist than is the ulna and has more articulations with the hand. It therefore carries the hand with it as it rotates.

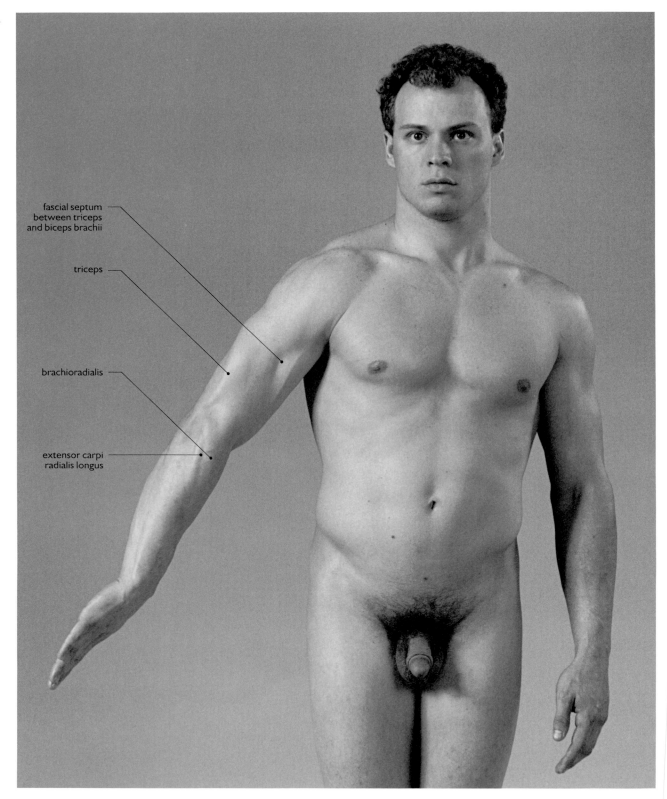

fascial septum
between triceps
and biceps brachii

triceps

brachioradialis

extensor carpi
radialis longus

Figure 116.

Forced pronation. The movement from supination to pronation is stronger than the reverse. For this reason, screws and the tools that turn them are made to be manipulated by supination of the right forearm.

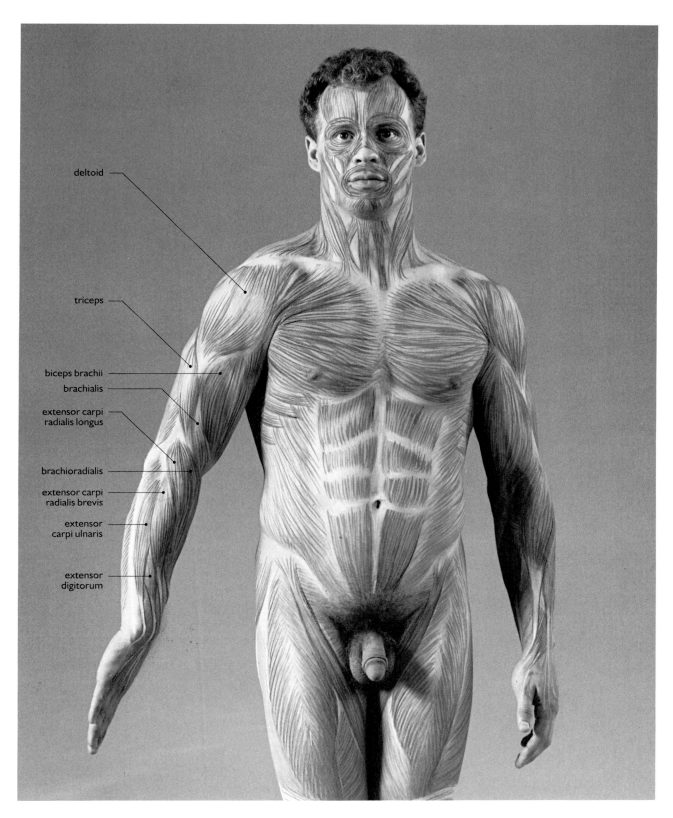

deltoid

triceps

biceps brachii

brachialis

extensor carpi
radialis longus

brachioradialis

extensor carpi
radialis brevis

extensor
carpi ulnaris

extensor
digitorum

Figure 117.

Forced pronation. Comparing the pose in this figure with those in Figs. 114 and 115, one can see how much further forward *deltoid* has come. The shoulder has been rotated medially some 90 degrees. At best, the palm lacks about 45 degrees of coming full circle.

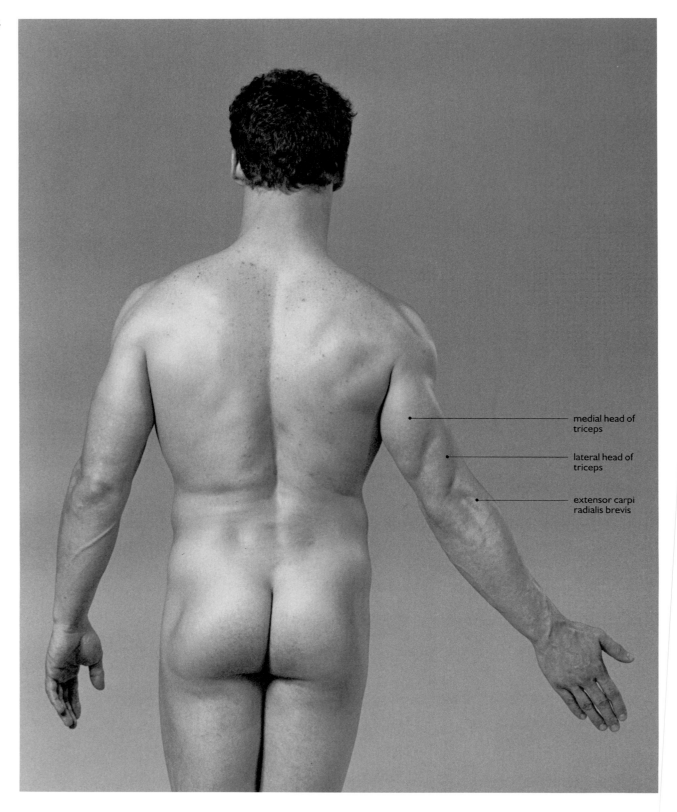

medial head of
triceps

lateral head of
triceps

extensor carpi
radialis brevis

Figure 118.

Supination. The muscle that supinates the forearm is *supinator*. Its action is determined entirely by its proximal and lateral position of insertion on the radius; it pulls that bone to the outer side of the ulna. Covered by other muscles, it cannot be discerned on the surface.

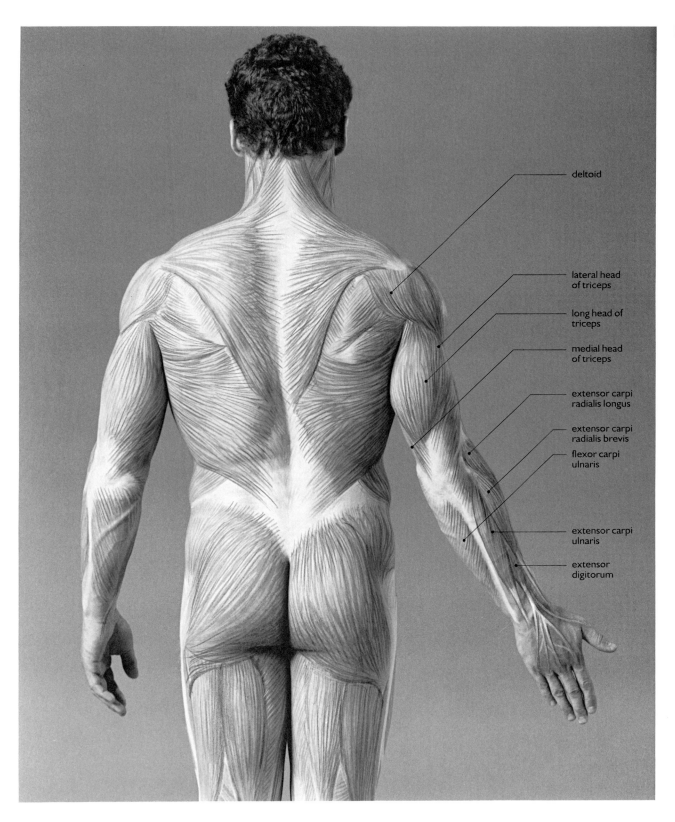

deltoid

lateral head
of triceps

long head of
triceps

medial head
of triceps

extensor carpi
radialis longus

extensor carpi
radialis brevis

flexor carpi
ulnaris

extensor carpi
ulnaris

extensor
digitorum

Figure 119.

Supination. Supination and pronation both refer to the revolving of the distal end of the radius around the distal end of the ulna. Consequently, all muscles of supination and pronation are necessarily inserted in the radius.

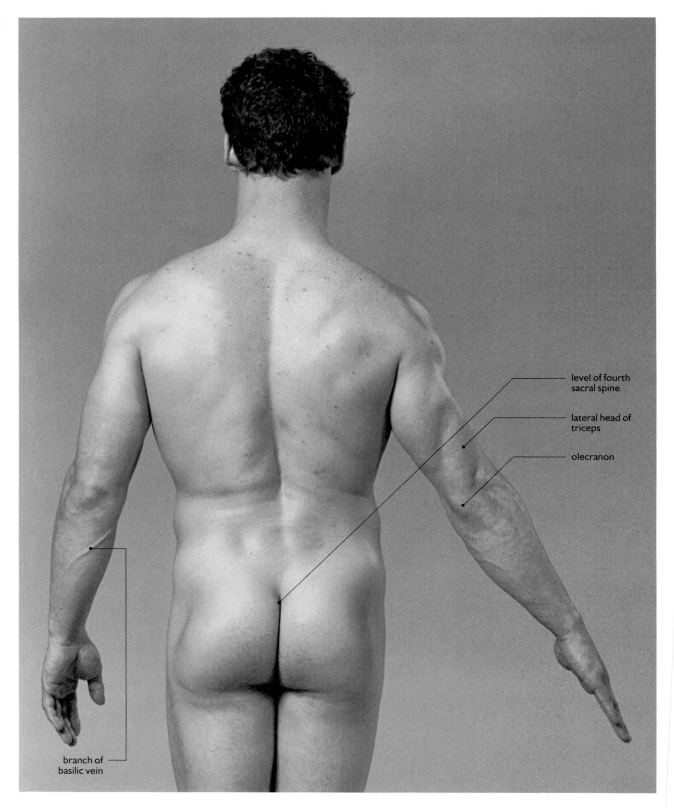

level of fourth
sacral spine

lateral head of
triceps

olecranon

branch of
basilic vein

Figure 120.

Half-pronation. The left arm here shows the relaxed pendant position and how closely it resembles half-pronation. The left shoulder, though, has shifted medially from the anatomical position. The right shoulder remained in that position; the left and right arms and forearms present different contours.

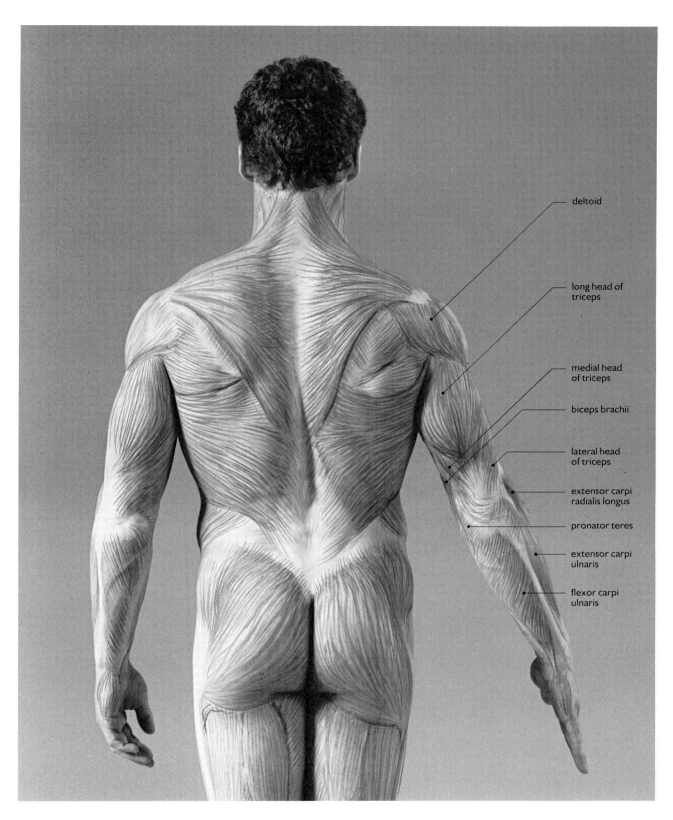

deltoid

long head of
triceps

medial head
of triceps

biceps brachii

lateral head
of triceps

extensor carpi
radialis longus

pronator teres

extensor carpi
ulnaris

flexor carpi
ulnaris

Figure 121.

Half-pronation. The pronators are two: *pronator teres* and *pronator quadratus*. They both insert more distally than *supinator* and in such a way as to pull the radius medially. If sufficiently developed and tensed, they can be detected from the surface.

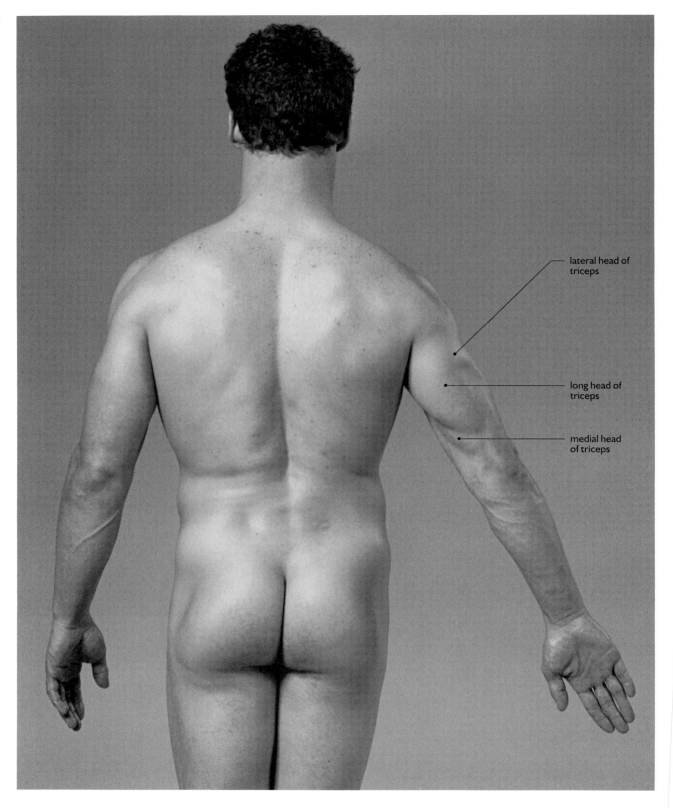

lateral head of
triceps

long head of
triceps

medial head
of triceps

Figure 122.

Pronation. Muscles, from one person to the next, show considerable variation (and not just in bulk), although the general pattern
is similar. One of the cadavers I dissected in medical school had a number of muscles not recognized in the anatomy texts.

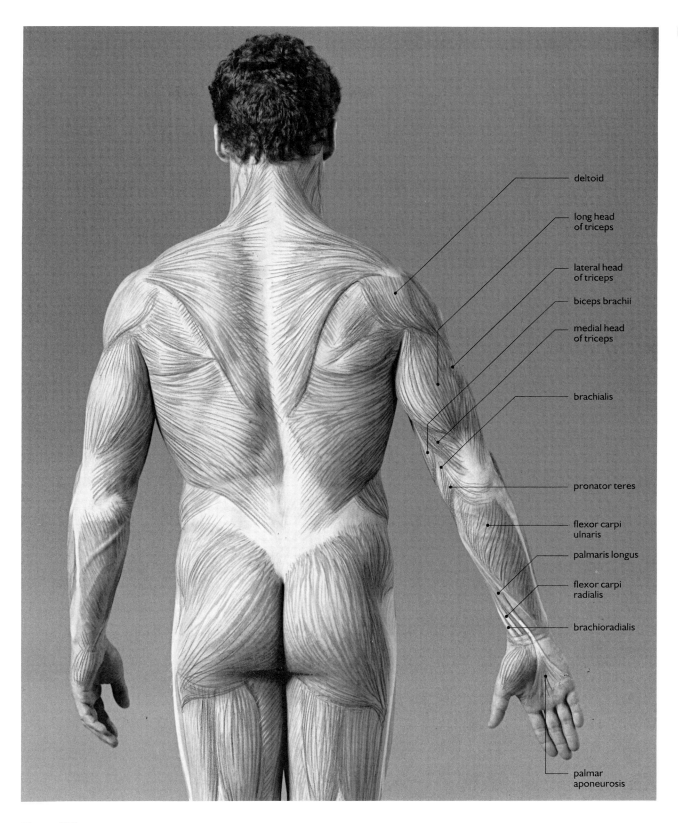

deltoid

long head
of triceps

lateral head
of triceps

biceps brachii

medial head
of triceps

brachialis

pronator teres

flexor carpi
ulnaris

palmaris longus

flexor carpi
radialis

brachioradialis

palmar
aponeurosis

Figure 123.
Pronation. The lateral long and medial heads of *triceps* are clear and easily distinguished in this figure. They can be seen even more clearly in Fig. 122.

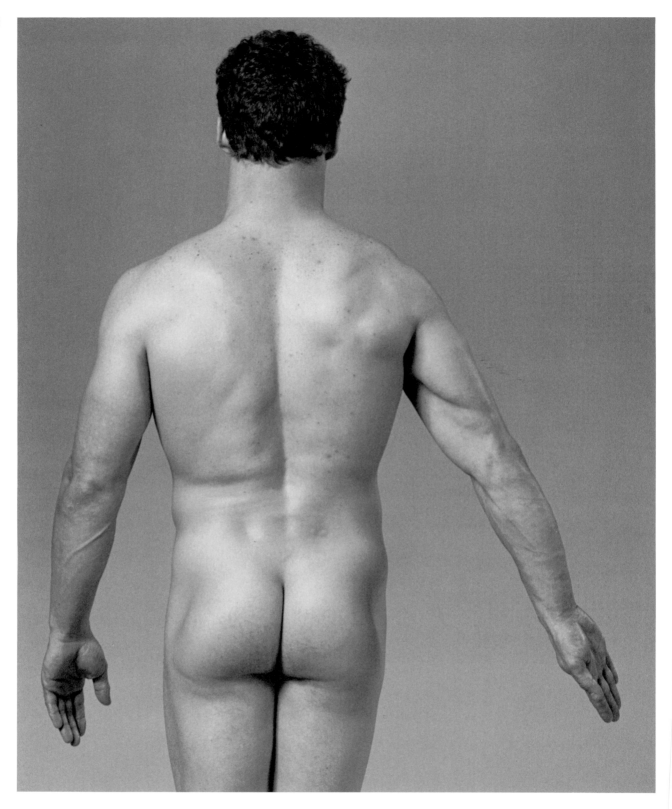

Figure 124.

Forced pronation. This photograph shows a strained position, not frequent in everyday activity. It is used to push something away, though it would seem more natural and effective to employ the back of the hand. It does, however, provide for greater latitude in twisting the arm without injury.

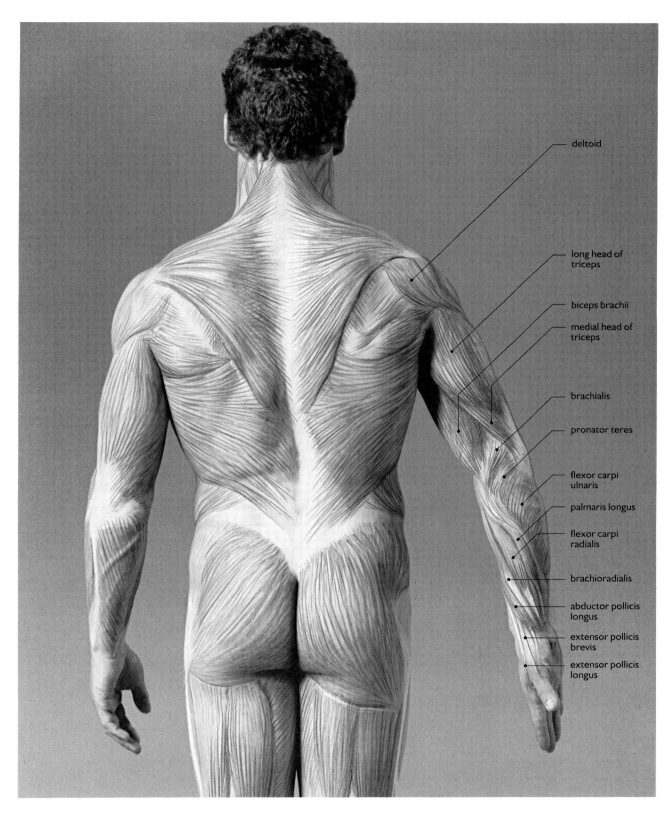

deltoid

long head of
triceps

biceps brachii

medial head of
triceps

brachialis

pronator teres

flexor carpi
ulnaris

palmaris longus

flexor carpi
radialis

brachioradialis

abductor pollicis
longus

extensor pollicis
brevis

extensor pollicis
longus

Figure 125.

Forced pronation. Again, the long and medial heads of *triceps* are unmistakable. The long head of *triceps* stretches much nearer the elbow in this subject than in many similarly built men. The *biceps*, a strong supinator, is at maximum stretch here.

142

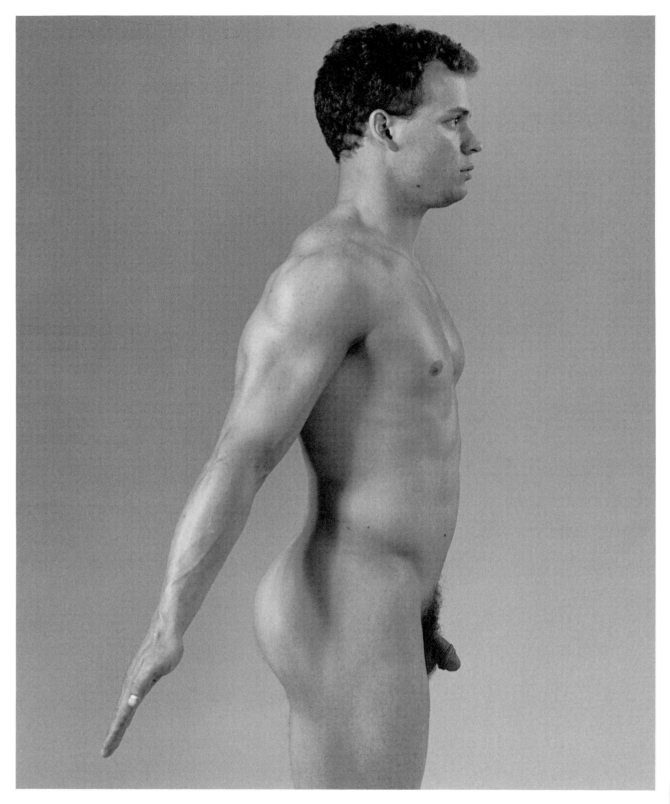

Figure 126.
Supination. The joints of the arm are rigidly extended here to demonstrate supination in its clearest form. In normal activity, however, supination is part of a stream of movement, ebbing and flowing imperceptibly as one action merges into the next.



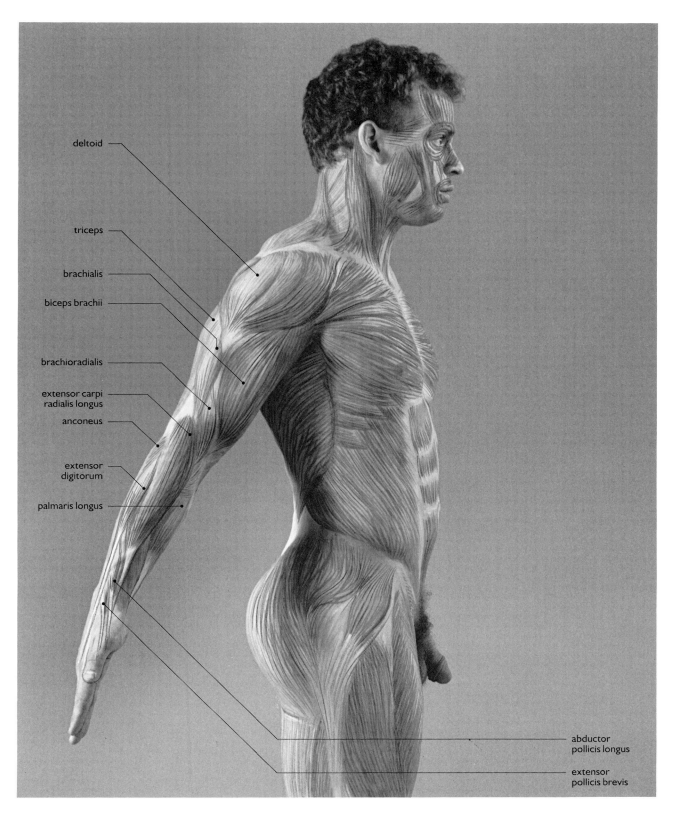

Figure 127.

Supination. The lateral head of *triceps* is standing out clearly here. Also evident is the *extensor carpi radialis longus*.

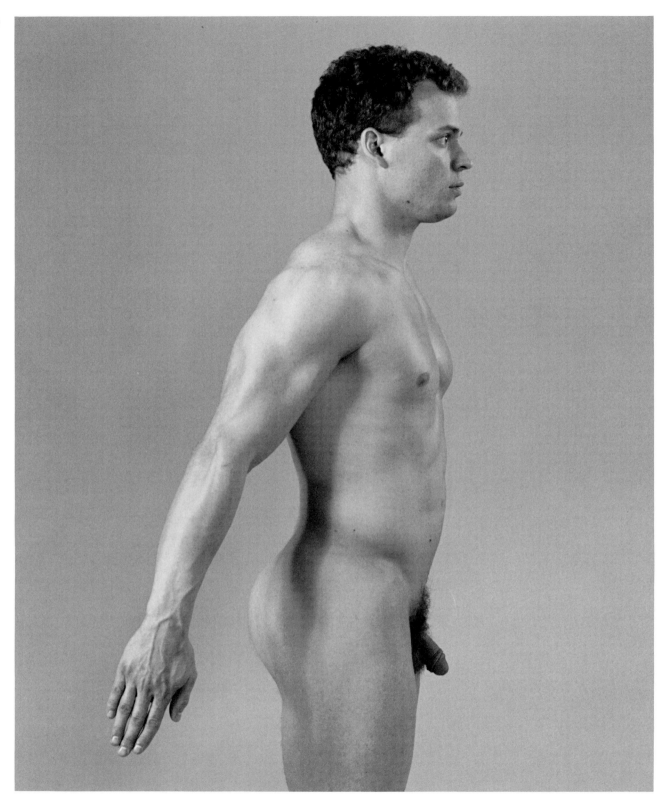

Figure 128.
Half-pronation. Four features that tend to confuse surface anatomy are hair, veins, and fat depots and other contours of deep structures (bony projections and deep muscles) that conflict with surface detail. Of these, veins are the least predictable in pattern.

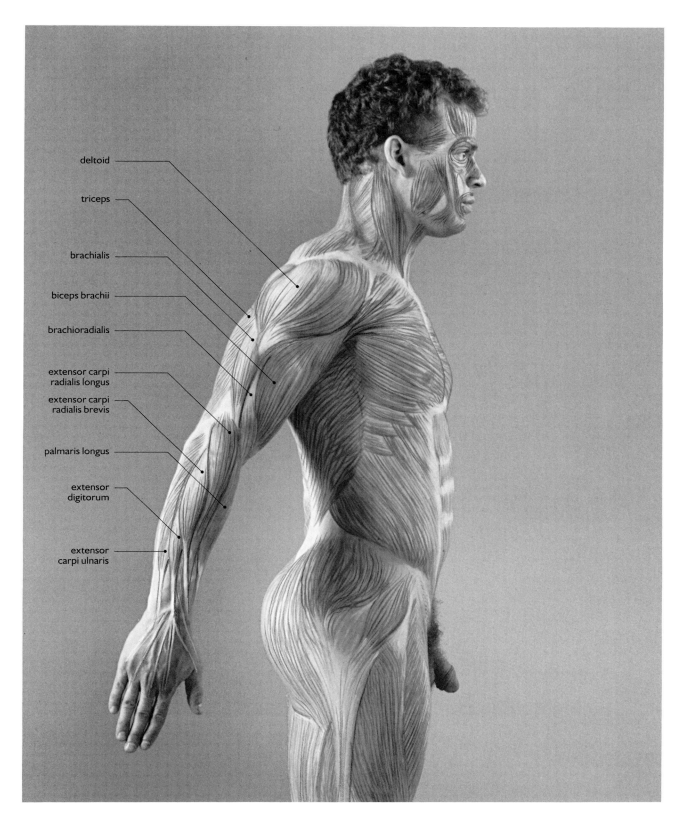

deltoid

triceps

brachialis

biceps brachii

brachioradialis

extensor carpi
radialis longus

extensor carpi
radialis brevis

palmaris longus

extensor
digitorum

extensor
carpi ulnaris

Figure 129.

Half-pronation. Long arms are a simian characteristic. Perhaps for this reason, artists in the past have preferred models with relatively short arms, because the effect was more pleasing. Another reason: Women's arms, in proportion to their trunks, are shorter than men's.

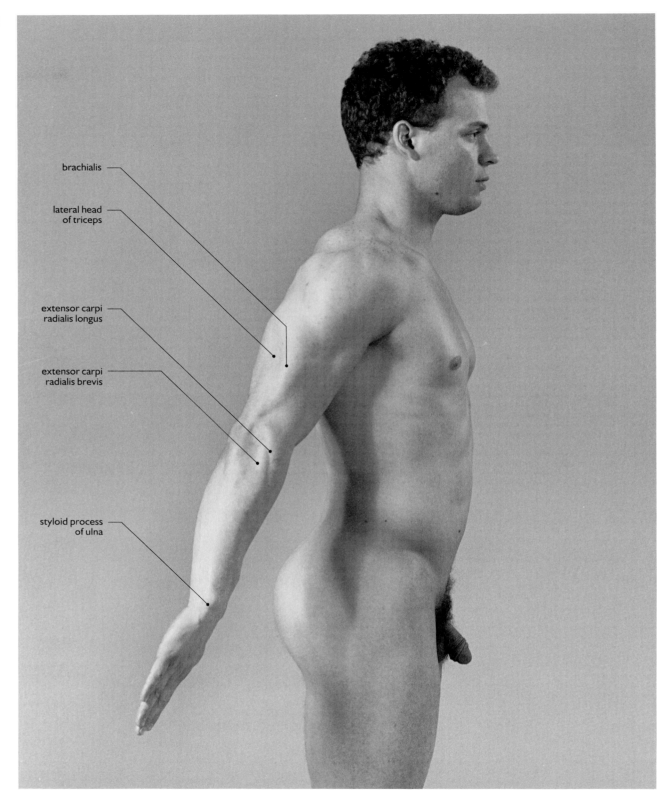

brachialis

lateral head
of triceps

extensor carpi
radialis longus

extensor carpi
radialis brevis

styloid process
of ulna

Figure 130.
Pronation. The hands, taken together, have access to every part of the body. Considering the limitations of the forelimbs of most other mammals, this is a remarkable capacity that humans share with only certain other primates.

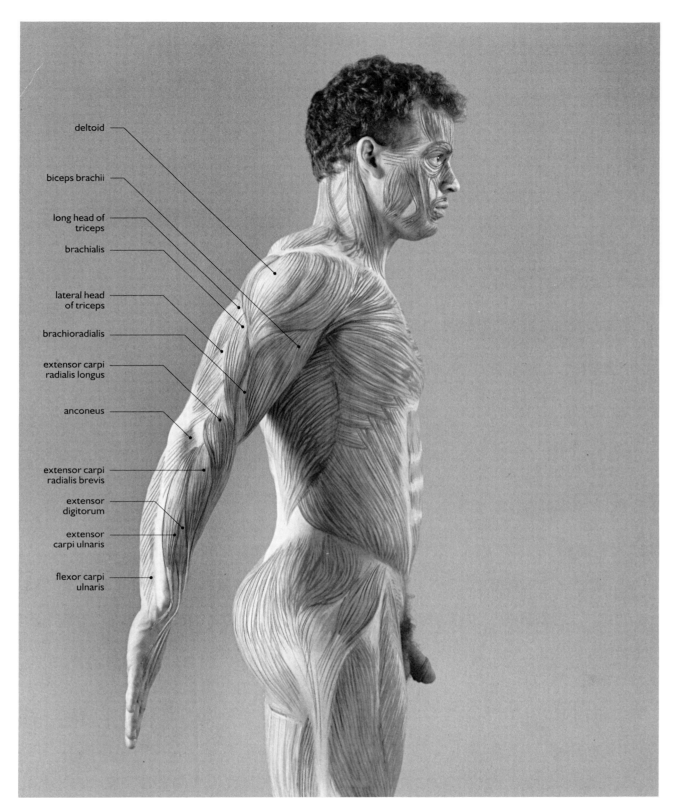

deltoid

biceps brachii

long head of
triceps

brachialis

lateral head
of triceps

brachioradialis

extensor carpi
radialis longus

anconeus

extensor carpi
radialis brevis

extensor
digitorum

extensor
carpi ulnaris

flexor carpi
ulnaris

Figure 131.

Pronation. Although the elbow is a simple hinge joint with mobility in only one plane (unlike the knee, which is capable of some rotation as well as flexion and extension), the shoulder and wrist together afford the hand an extraordinary maneuverability.

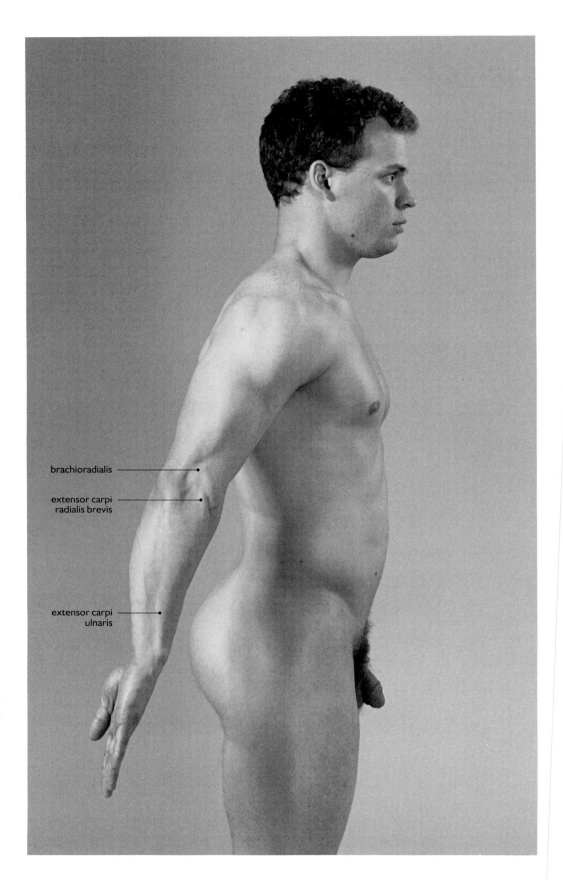

brachioradialis ——————

extensor carpi
radialis brevis ——————

extensor carpi
ulnaris ——————

Figure 132.
Forced pronation.
Both *brachioradialis*
and *extensor carpi
radialis brevis* can be
seen here as parallel
curving ridges
medial to the elbow.
The swelling on the
forearm adjacent to
the model's buttock
is *palmaris longus*,
which pronates and
flexes the hand.

149

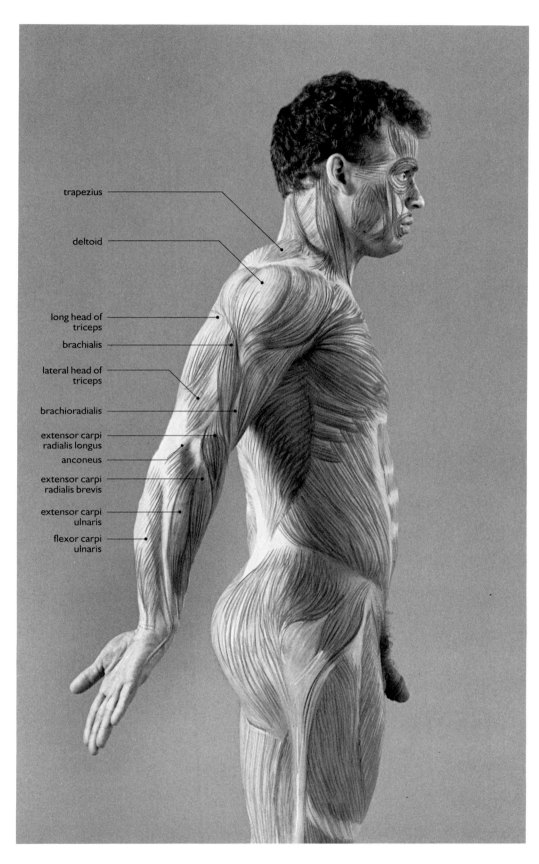

trapezius

deltoid

long head of
triceps

brachialis

lateral head of
triceps

brachioradialis

extensor carpi
radialis longus

anconeus

extensor carpi
radialis brevis

extensor carpi
ulnaris

flexor carpi
ulnaris

Figure 133.
Forced pronation.
Many people can
force pronation
further—in fact, to a
point at which the
palm would face the
viewer. There is
great variation in
joint flexibility in an
individual and from
one person to
another. Women
tend to be more
flexible than men.

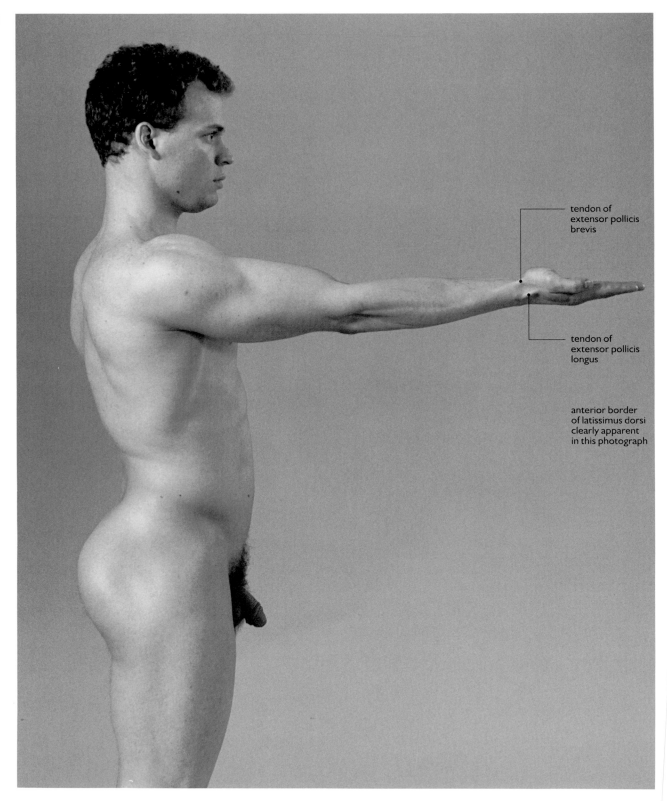

tendon of
extensor pollicis
brevis

tendon of
extensor pollicis
longus

anterior border
of latissimus dorsi
clearly apparent
in this photograph

Figure 134.

Supination. Mnemonic: A bowl of soup could be placed in this man's s(o)upine hand. The bowl would not be secure if placed on his prone (palm down) hand. A man lying s(o)upine (that is, flat on his back) is able to drink soup from a cup. A man lying prone (that is, face down on his belly) is not.

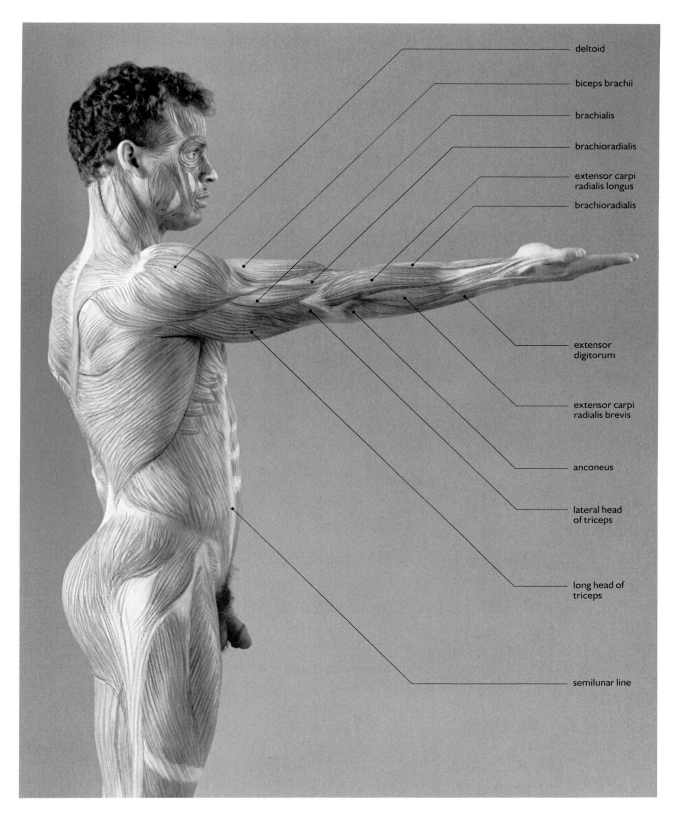

deltoid

biceps brachii

brachialis

brachioradialis

extensor carpi
radialis longus

brachioradialis

extensor
digitorum

extensor carpi
radialis brevis

anconeus

lateral head
of triceps

long head of
triceps

semilunar line

Figure 135.
Supination. The pale band of fascia running from *pectoralis major* to the inguinal area is the semilunar line, so called because of its crescentic shape as it curves anteriorly on the lower abdomen.

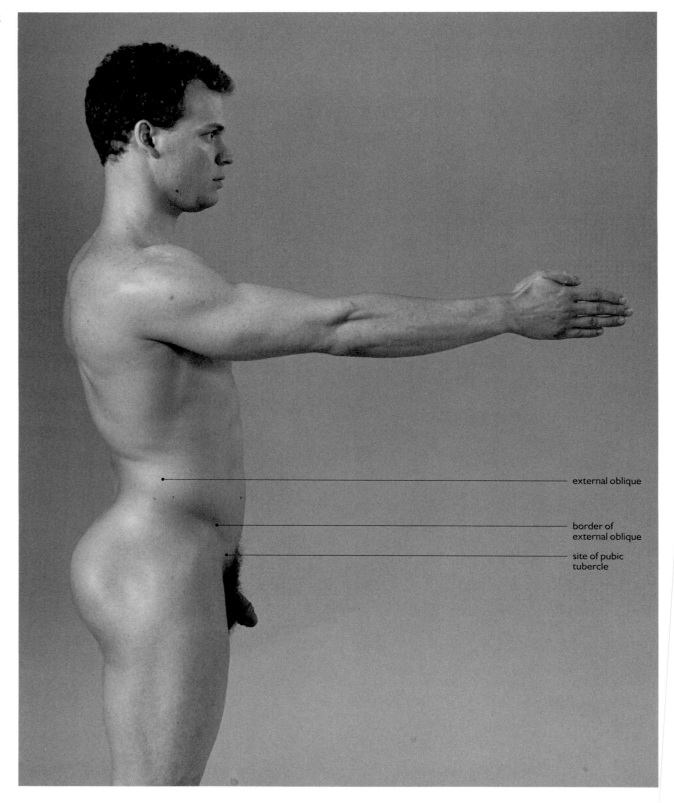

external oblique

border of
external oblique

site of pubic
tubercle

Figure 136.

Half-pronation. The aponeurosis of *external oblique* splits just above the tubercle of the pubis. Through this opening—or subcutaneous inguinal ring—the spermatic cord exits from the abdomen and descends to the testicle. The ring is located at the junction of the thigh and abdomen (groin).

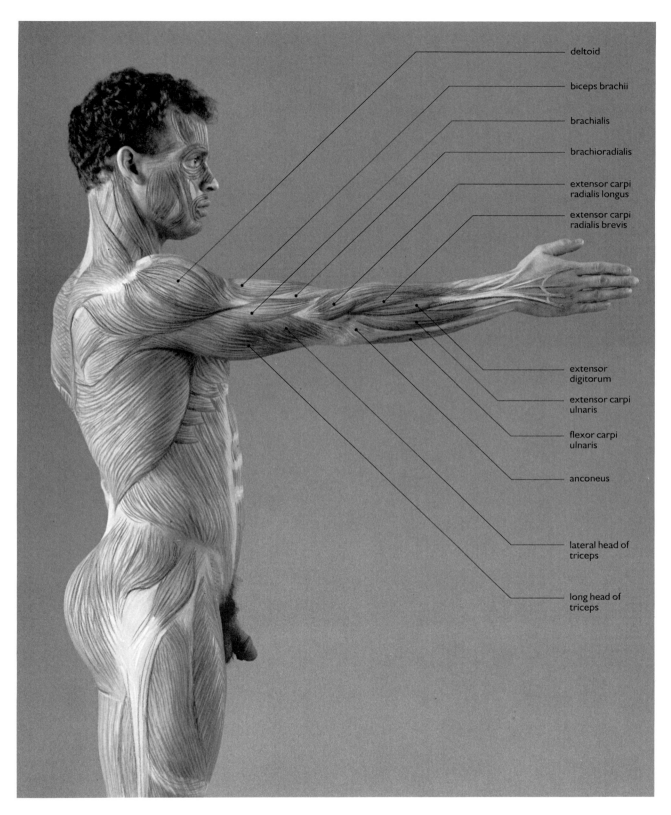

deltoid

biceps brachii

brachialis

brachioradialis

extensor carpi
radialis longus

extensor carpi
radialis brevis

extensor
digitorum

extensor carpi
ulnaris

flexor carpi
ulnaris

anconeus

lateral head of
triceps

long head of
triceps

Figure 137.
Half-pronation. The separation of abdomen from thigh is marked by the inguinal, or Poupart's ligament. It is an aponeurotic band, the inferior portion of the fascia of *external oblique*, extending from the anterior superior iliac spine to the tubercle of the pubis bone at the front of the pelvis.

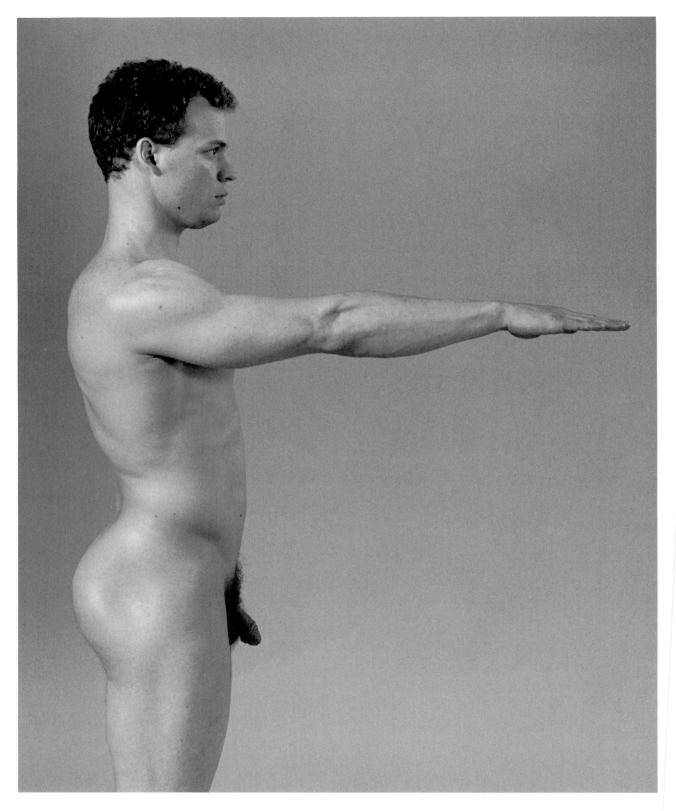

Figure 138.
Pronation. *Serratus anterior* can be seen here and in Fig. 139. It passes over the ribs and behind the scapula to insert on its margin. When it contracts, it draws the scapula forward and to the side. A couple of its "fingers" can be seen here just anterior to the edge of *latissimus dorsi*.

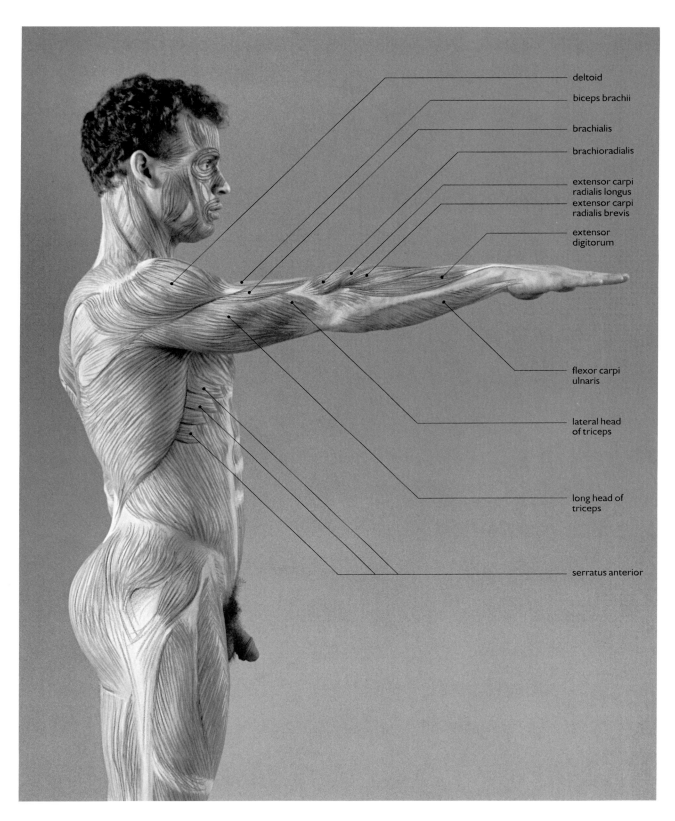

deltoid

biceps brachii

brachialis

brachioradialis

extensor carpi
radialis longus

extensor carpi
radialis brevis

extensor
digitorum

flexor carpi
ulnaris

lateral head
of triceps

long head of
triceps

serratus anterior

Figure 139.

Pronation. *Serratus anterior* originates from the eight or nine uppermost ribs, spreads fanlike, and interdigitates with *latissimus dorsi.* "Serratus" means "sawlike."

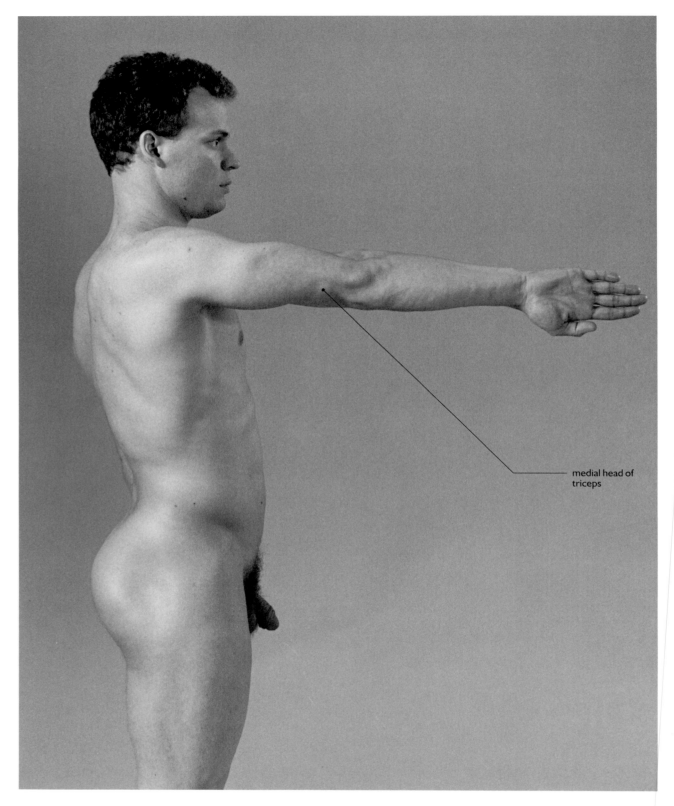

medial head of
triceps

Figure 140.
Forced pronation. *Palmaris longus* pronates and flexes the hand.

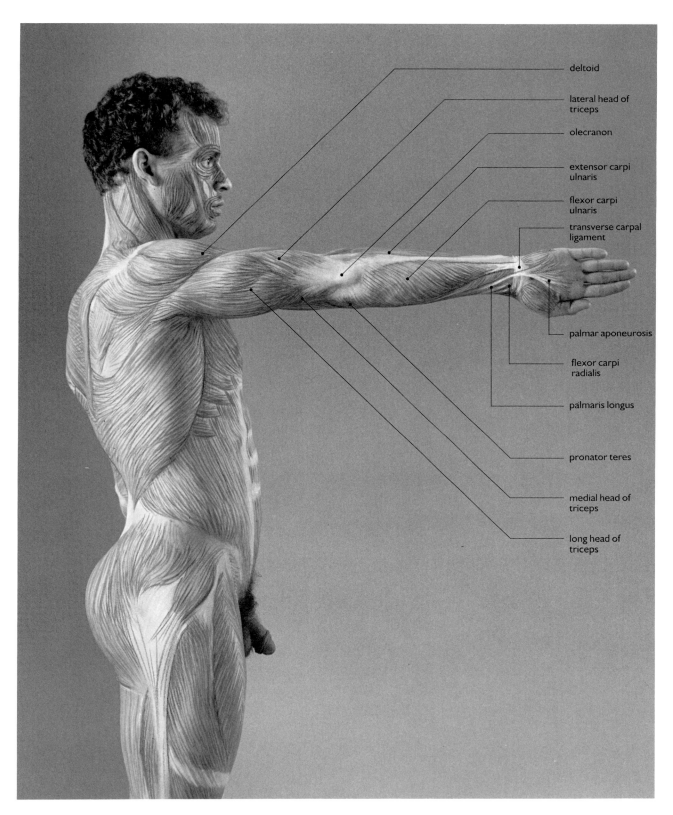

deltoid

lateral head of triceps

olecranon

extensor carpi ulnaris

flexor carpi ulnaris

transverse carpal ligament

palmar aponeurosis

flexor carpi radialis

palmaris longus

pronator teres

medial head of triceps

long head of triceps

Figure 141.

Forced pronation. The web in the palm of the hand is the palmar aponeurosis. It is a thick triangular membrane that at its apex joins the transverse carpal ligament (the band across the wrist). It is the final termination of the tendon of *palmaris longus*.

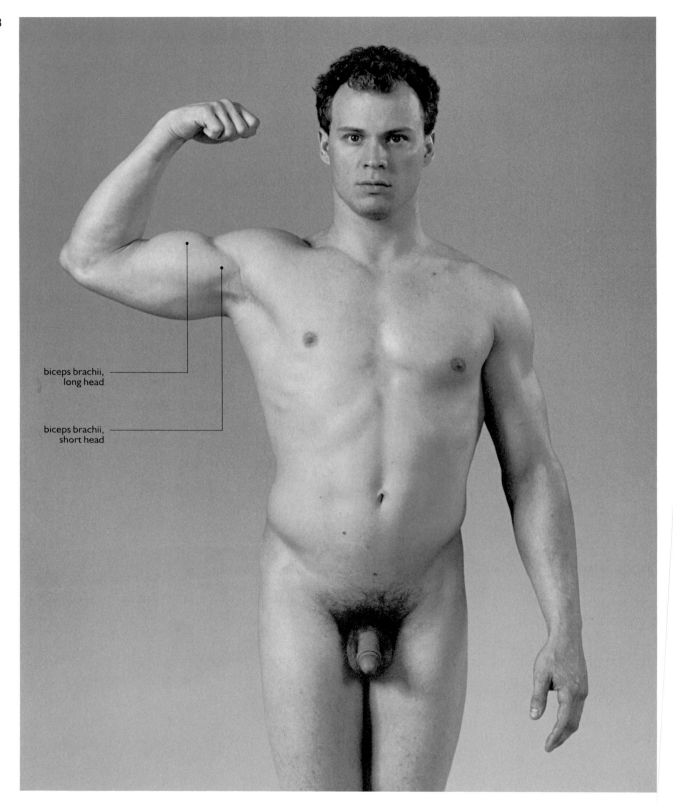

biceps brachii,
long head

biceps brachii,
short head

Figure 142.
Flexion of the arms at acute angle. "Biceps" means "two-headed," and both heads can be seen here. At the upper margin of the bulge is the long head, so called because its tendon, which inserts on the tuberosity above the glenoid fossa of the scapula, is longer than that of the short head, the bulge just below it.

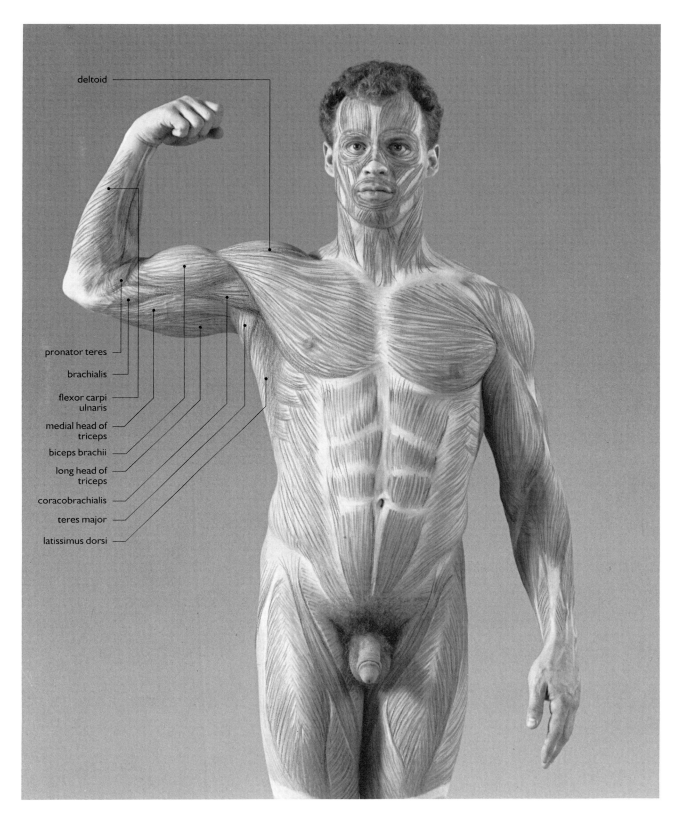

deltoid

pronator teres

brachialis

flexor carpi
ulnaris

medial head of
triceps

biceps brachii

long head of
triceps

coracobrachialis

teres major

latissimus dorsi

Figure 143.

Flexion of the arms at acute angle. This is the traditional "making a muscle" pose. Besides flexing the arm, *biceps* also raises it forward, rotates it slightly inward, and supinates the forearm. Just below it is *coracobrachialis*, which raises the arm forward and adducts it.

160

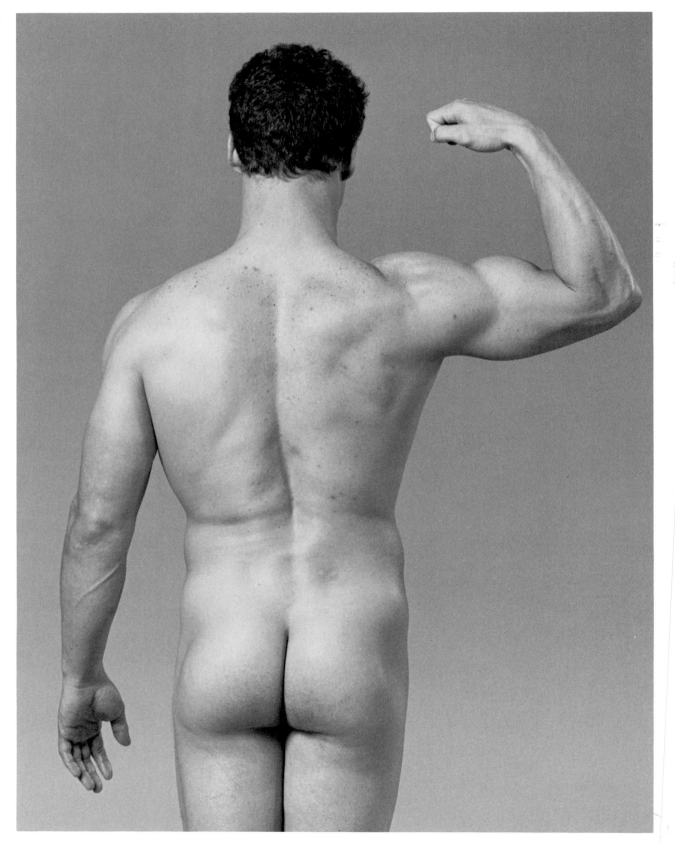

Figure 144.

Flexion of the arms at acute angle. The various bundles of *deltoid* are clear here. *Deltoid* might be considered the *gluteus maximus* of the arm. Both form a kind of hood over the joint, both are powerful elevators of the limbs, and both are made up of bundles of coarse fibers.

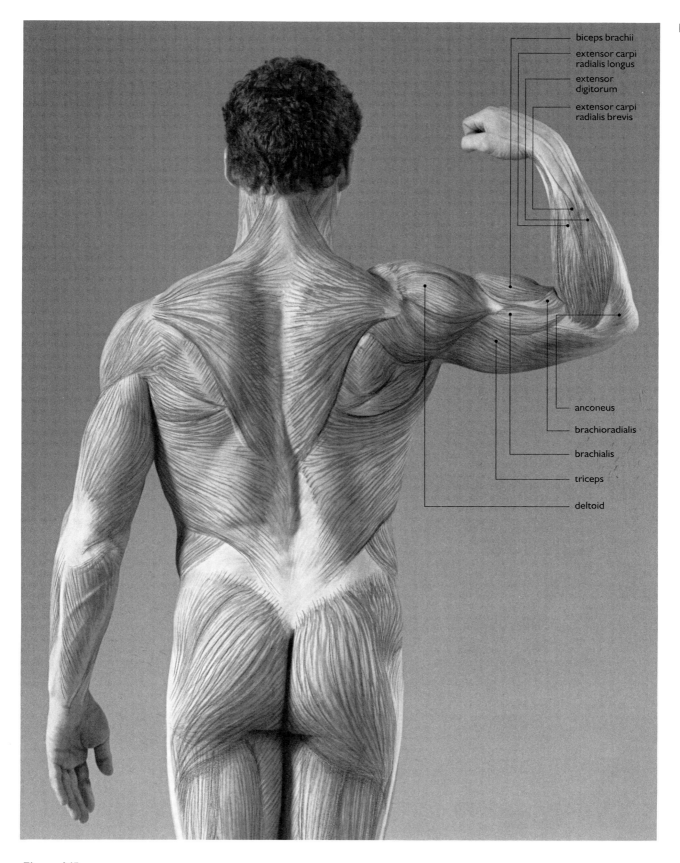

biceps brachii

extensor carpi radialis longus

extensor digitorum

extensor carpi radialis brevis

anconeus

brachioradialis

brachialis

triceps

deltoid

Figure 145.

Flexion of the arms at acute angle. Contrary to what one might expect, *biceps*, in the middle of the arm, has no connection with the humerus. One head arises from the scapula just above the socket of the humerus, the other from the scapula's coracoid process. It inserts on the radius.

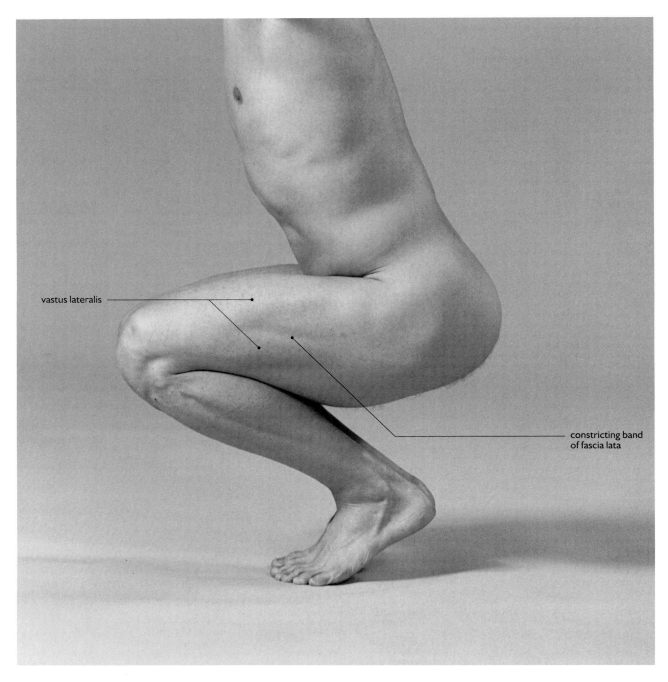

vastus lateralis

constricting band
of fascia lata

Figure 146.

Flexion of the legs at acute angle, both feet on the ground. Evident here is the longitudinal dent caused by *vastus lateralis* bulging out on either side of the constricting *fascia lata*.

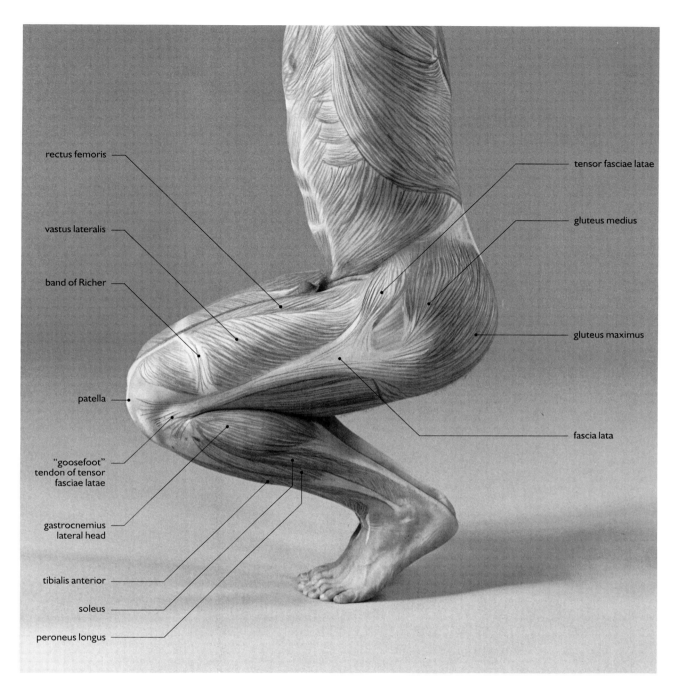

rectus femoris

vastus lateralis

band of Richer

patella

"goosefoot"
tendon of tensor
fasciae latae

gastrocnemius
lateral head

tibialis anterior

soleus

peroneus longus

tensor fasciae latae

gluteus medius

gluteus maximus

fascia lata

163

Figure 147.

Flexion of the legs at acute angle, both feet on the ground. *Biceps femoris* and *gluteus maximus* do not form one but rather two smooth curves, one following on the other. This is because the lower portion of *gluteus maximus* is bound by the gluteal fascia, which forms a constricting band.

164

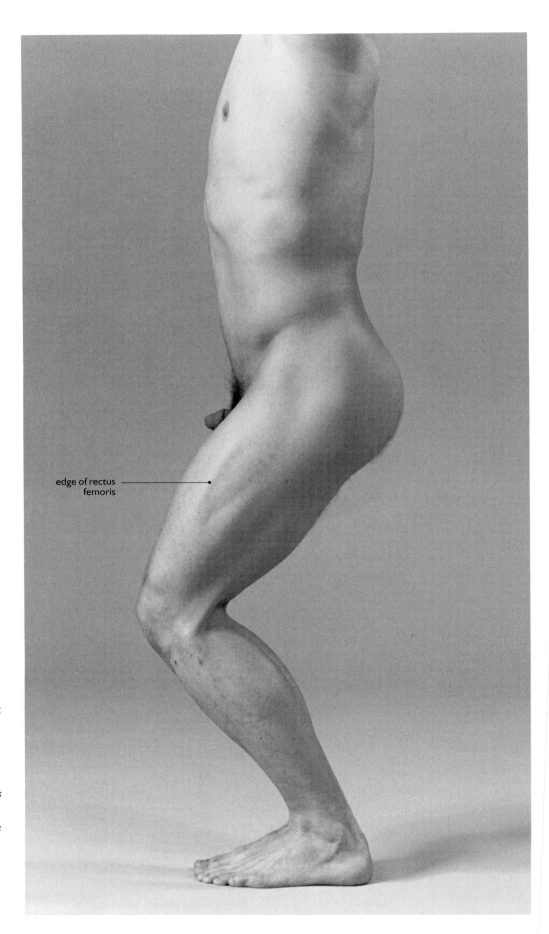

edge of rectus femoris

Figure 148.
Flexion of the legs at right angle, feet on the ground. The lateral edge of *rectus femoris* forms a ridge just anterior to *vastus lateralis*. Posterior to the latter is the tense anterior border of the ilio-tibial band, which also forms a sharp-edged cord at the rear of the knee.

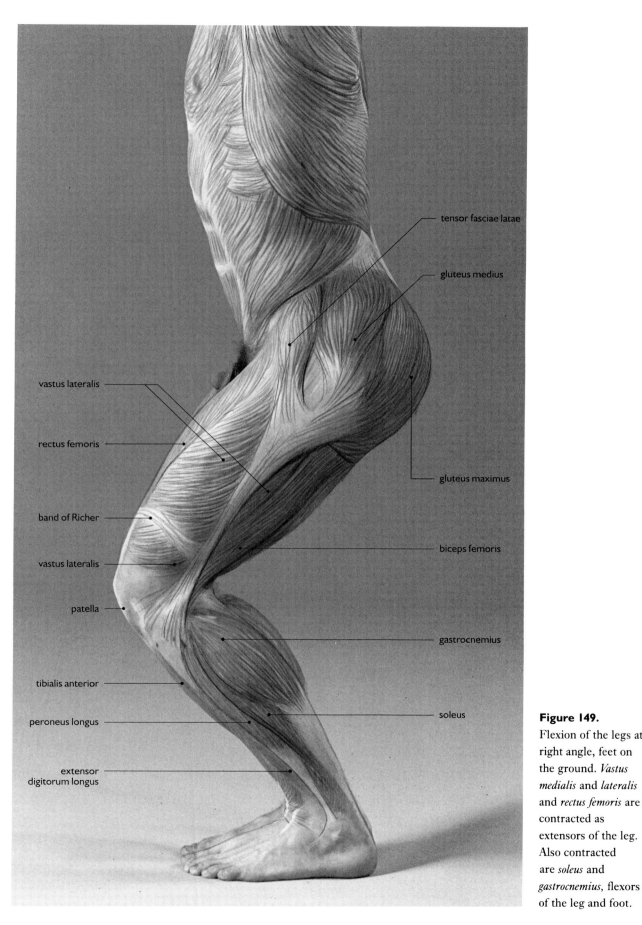

tensor fasciae latae

gluteus medius

gluteus maximus

vastus lateralis

rectus femoris

band of Richer

vastus lateralis

patella

tibialis anterior

peroneus longus

extensor
digitorum longus

biceps femoris

gastrocnemius

soleus

Figure 149.
Flexion of the legs at
right angle, feet on
the ground. *Vastus
medialis* and *lateralis*
and *rectus femoris* are
contracted as
extensors of the leg.
Also contracted
are *soleus* and
gastrocnemius, flexors
of the leg and foot.

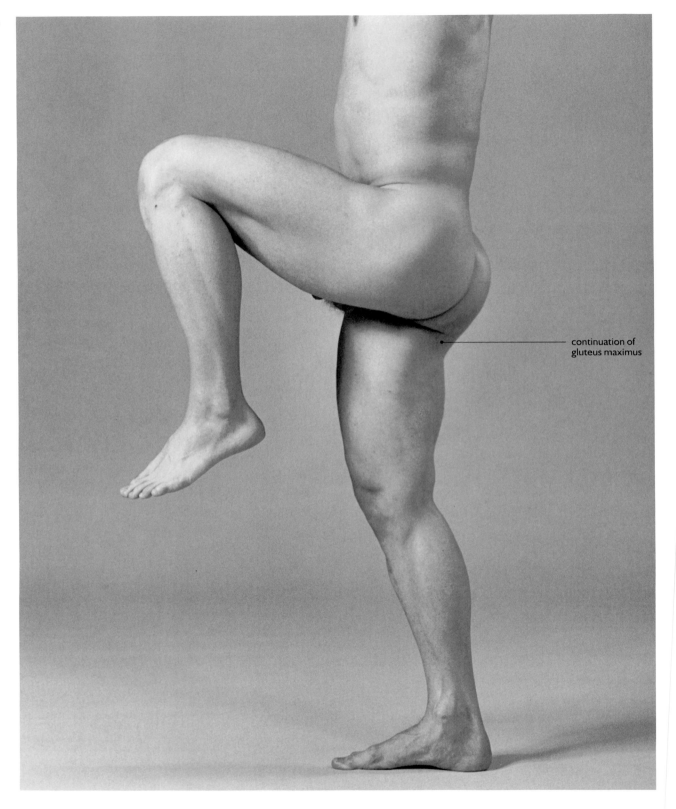

continuation of
gluteus maximus

Figure 150.
Flexion of the legs at acute angle. *Gluteus maximus* (right) is contracted and bulging as it braces the pelvis. Its downward curve does not flow into the fold but proceeds to join the thigh at an obtuse angle. The area between the fold to the back of the thigh represents the muscle's true contour.

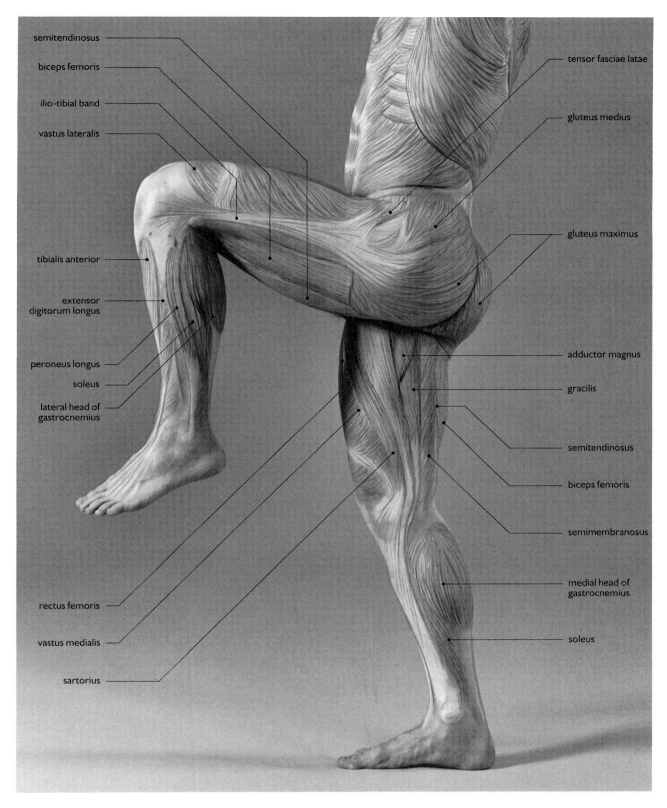

semitendinosus

biceps femoris

ilio-tibial band

vastus lateralis

tibialis anterior

extensor digitorum longus

peroneus longus

soleus

lateral head of gastrocnemius

rectus femoris

vastus medialis

sartorius

tensor fasciae latae

gluteus medius

gluteus maximus

adductor magnus

gracilis

semitendinosus

biceps femoris

semimembranosus

medial head of gastrocnemius

soleus

Figure 151.

Flexion of the legs at acute angle. The deepest indentation proximal to the left knee is the edge of *vastus lateralis*. On the right, *biceps femoris, semimembranosus, semitendinosus,* and *gracilis* are contracted, bracing the leg.

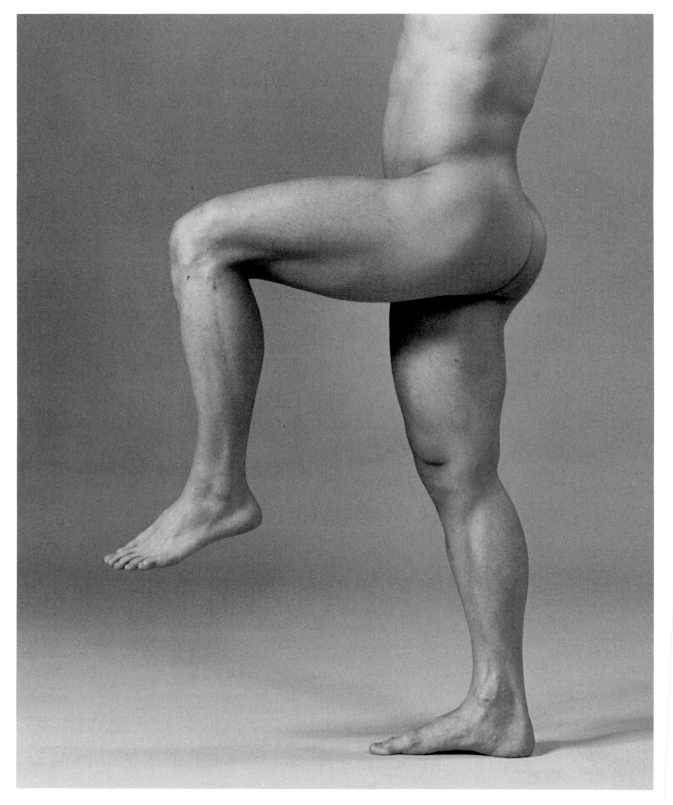

Figure 152.
Flexion of the legs at right angle. The adductor muscles of the inner thigh tend to be straplike. Such elongated muscles are efficient, for muscle fibers contract to half their length; thus they exert their effect over some distance. But, lacking bulk, they are relatively weak.

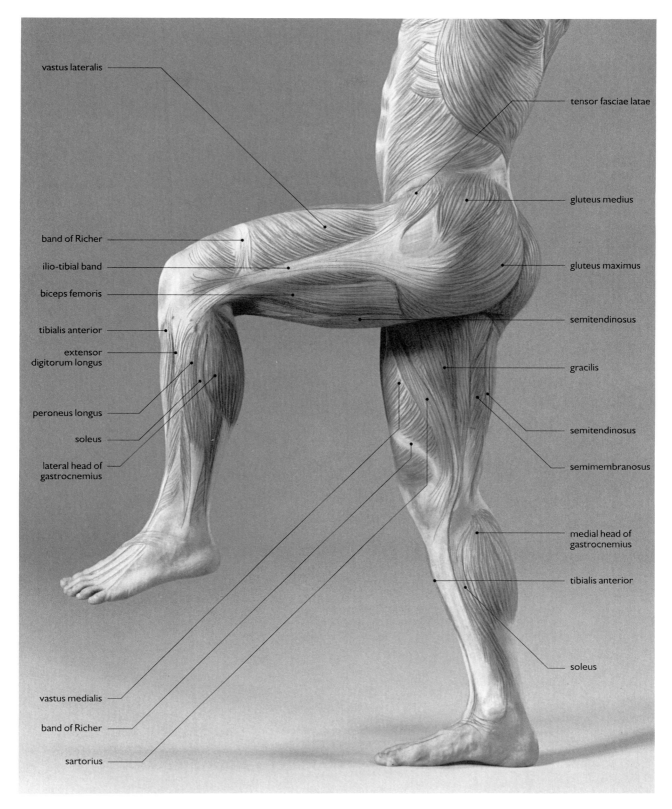

vastus lateralis

tensor fasciae latae

gluteus medius

band of Richer

gluteus maximus

ilio-tibial band

biceps femoris

semitendinosus

tibialis anterior

extensor
digitorum longus

gracilis

peroneus longus

semitendinosus

soleus

semimembranosus

lateral head of
gastrocnemius

medial head of
gastrocnemius

tibialis anterior

soleus

vastus medialis

band of Richer

sartorius

Figure 153.

Flexion of the legs at right angle. The constricting effect of the band of Richer on *vastus medialis* can be appreciated in this figure as well as in Fig. 152, where the inferior portion creates an additional bulge.

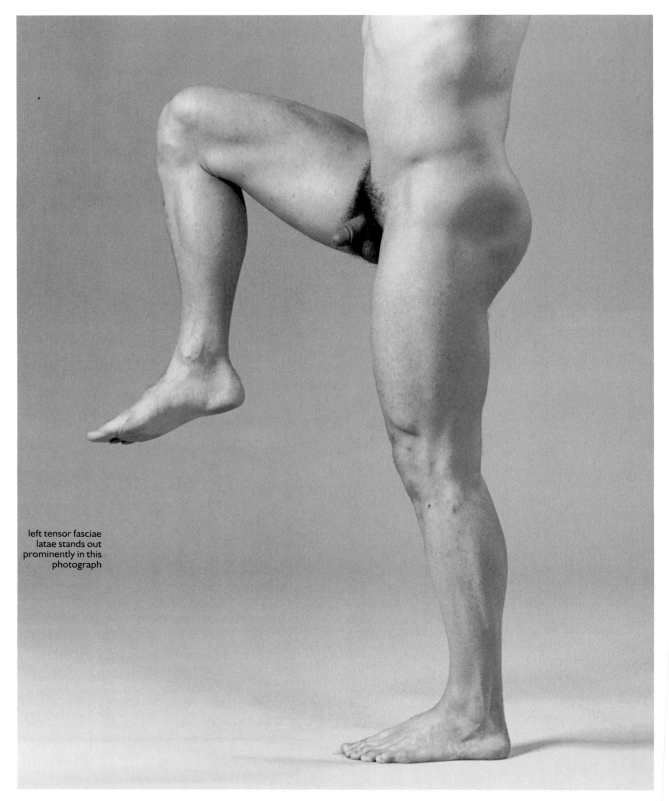

left tensor fasciae latae stands out prominently in this photograph

Figure 154.

Flexion of the legs at acute angle. The contracted right *sartorius* is obviously bulging and can be clearly seen for three-quarters of its length. *Sartorius*, a flexor and abductor of the thigh, is the body's longest muscle. "Sartor" is Latin for "tailor," referring to a cross-legged sitting posture.

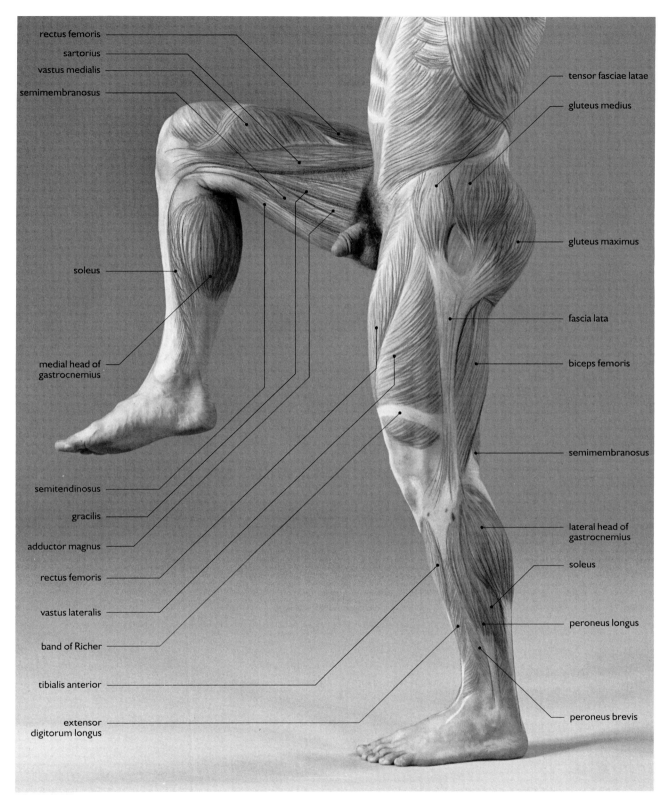

rectus femoris

sartorius

vastus medialis

semimembranosus

tensor fasciae latae

gluteus medius

gluteus maximus

soleus

fascia lata

biceps femoris

medial head of gastrocnemius

semimembranosus

semitendinosus

gracilis

adductor magnus

lateral head of gastrocnemius

rectus femoris

soleus

vastus lateralis

peroneus longus

band of Richer

tibialis anterior

extensor digitorum longus

peroneus brevis

Figure 155.

Flexion of the legs at acute angle. The adductors and extensors of the right thigh are relatively passive here, playing out gradually to control the vigorous contractions of the flexors. Note the extreme contraction of *gluteus medius* and *tensor fasciae latae*.

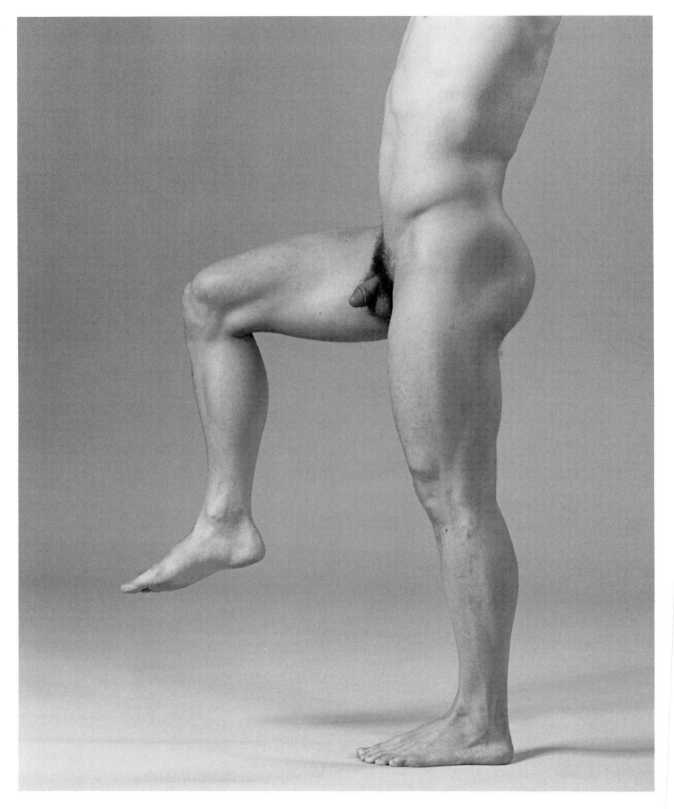

Figure 156.

Flexion of the legs at right angle. *Soleus,* as a distinct bulge just posterior to the right shin, is visible. It points the foot and inclines the sole down, hence its name, *sol*eus. In other words, it flexes the foot plantar-ward.

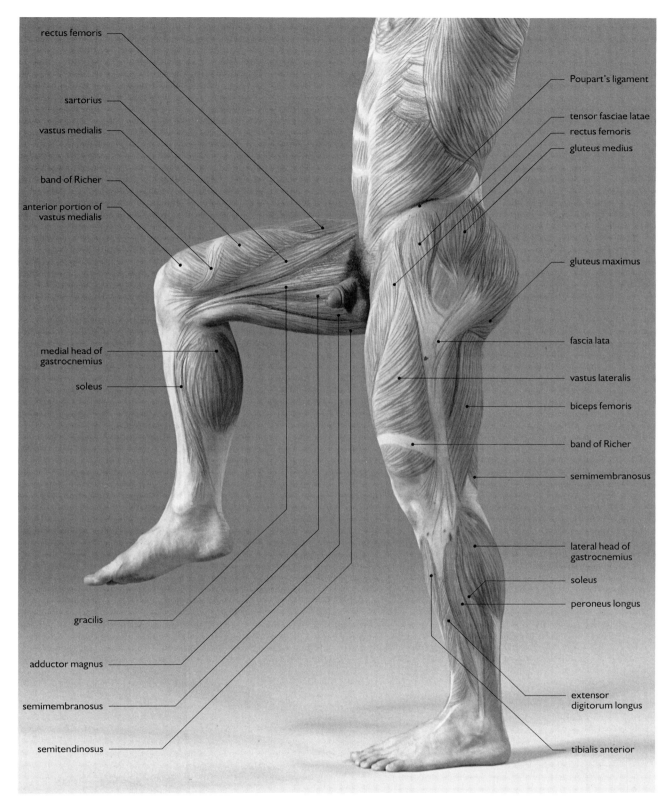

rectus femoris

sartorius

vastus medialis

band of Richer

anterior portion of
vastus medialis

medial head of
gastrocnemius

soleus

gracilis

adductor magnus

semimembranosus

semitendinosus

Poupart's ligament

tensor fasciae latae

rectus femoris

gluteus medius

gluteus maximus

fascia lata

vastus lateralis

biceps femoris

band of Richer

semimembranosus

lateral head of
gastrocnemius

soleus

peroneus longus

extensor
digitorum longus

tibialis anterior

Figure 157.

Flexion of the legs at right angle. *Sartorius* forms a boundary between the extensors (anterior) and the adductors (medial). When the knee is bent, it acts as an internal rotator of the leg. Its insertion, as a fanned tendon, is discernible here (right knee), where it attaches to the upper part of the tibial shaft.

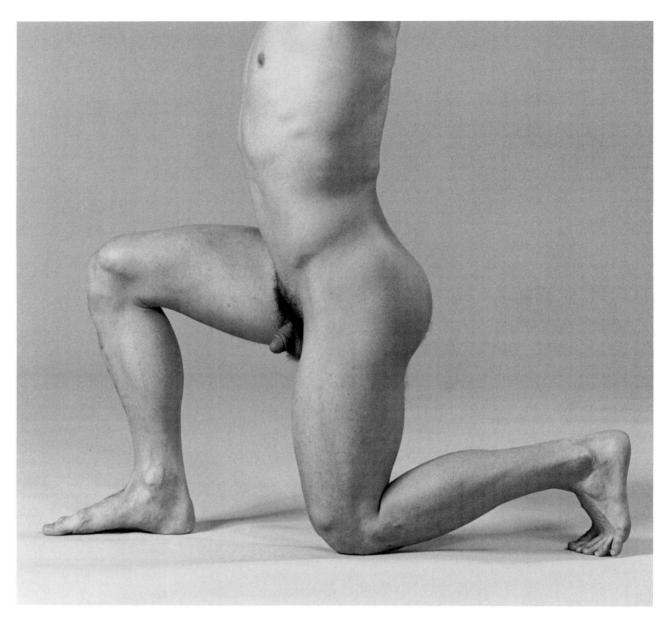

Figure 158.
Genuflection, left knee, lateral view. One does not kneel on the patella (knee cap), which, in that posture, moves up into a groove between the condyles of the femur. One kneels on its ligament (*ligamentum patellae*) and on the two condyles at the end of the tibia.

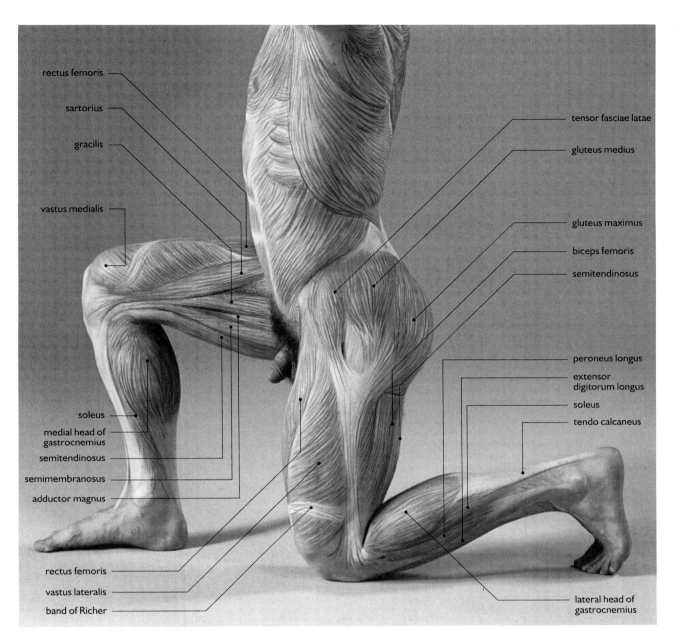

rectus femoris

sartorius

gracilis

vastus medialis

tensor fasciae latae

gluteus medius

gluteus maximus

biceps femoris

semitendinosus

soleus

medial head of
gastrocnemius

semitendinosus

semimembranosus

adductor magnus

peroneus longus

extensor
digitorum longus

soleus

tendo calcaneus

rectus femoris

vastus lateralis

band of Richer

lateral head of
gastrocnemius

Figure 159.

Genuflection, left knee, lateral view. "Genu" is Latin for "knee"; the word is more precisely anatomical than churchly. The knee is necessarily the largest joint in the body, as the weight of the trunk must be transmitted through it.

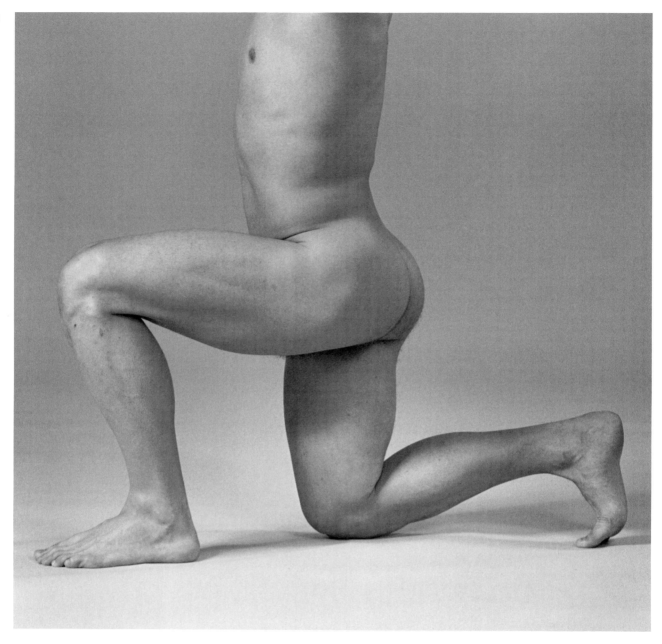

Figure 160.

Genuflection, right knee, medial view. To equalize weight on the two main supports (right thigh, left leg), the pelvis is tilted forward, increasing the lumbar curve. The line of gravity is thereby shifted closer to a point midway between the supporting structures.

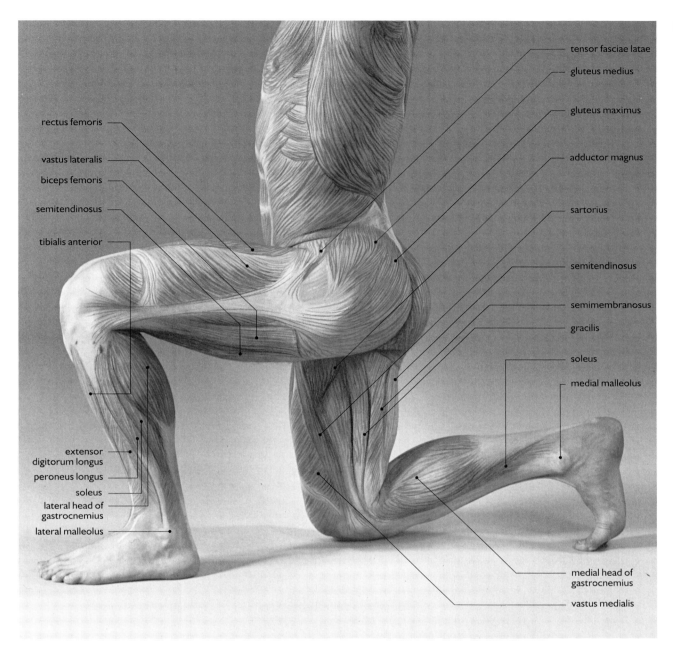

rectus femoris

vastus lateralis

biceps femoris

semitendinosus

tibialis anterior

extensor
digitorum longus

peroneus longus

soleus

lateral head of
gastrocnemius

lateral malleolus

tensor fasciae latae

gluteus medius

gluteus maximus

adductor magnus

sartorius

semitendinosus

semimembranosus

gracilis

soleus

medial malleolus

medial head of
gastrocnemius

vastus medialis

Figure 161.

Genuflection, right knee, medial view. Three-point balance (tripod) looks more stable than two-point (feet). Actually, finer cerebellar "tuning" is necessary. Try it; notice the muscles constantly shifting weight, uneasy in their effort to maintain balance.

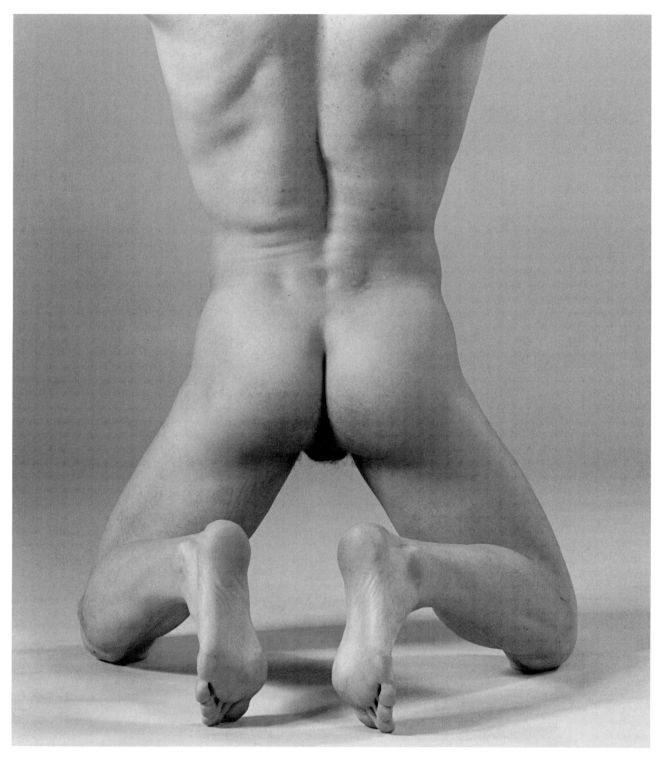

Figure 162.

Kneeling, posterior view. To balance his shoulder breadth and upper trunk weight, a man spaces his knees widely. A woman, with her wider pelvis and lower center of gravity, kneels more easily and comfortably. With her knees and feet together, she does not require a tripodal alignment.

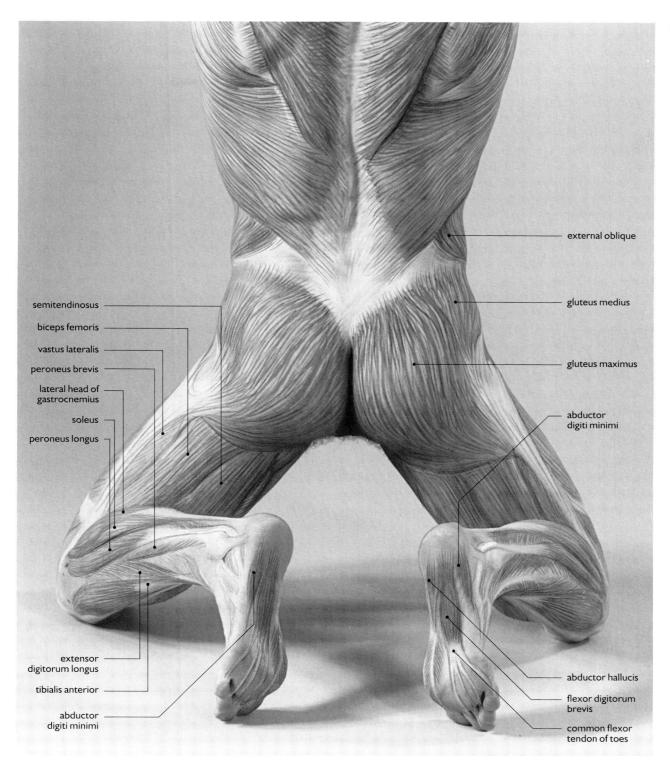

179

semitendinosus

biceps femoris

vastus lateralis

peroneus brevis

lateral head of
gastrocnemius

soleus

peroneus longus

extensor
digitorum longus

tibialis anterior

abductor
digiti minimi

external oblique

gluteus medius

gluteus maximus

abductor
digiti minimi

abductor hallucis

flexor digitorum
brevis

common flexor
tendon of toes

Figure 163.

Kneeling, posterior view. Note that the muscles of the sole of the foot are protected and away from the major weight-bearing areas. In standing, weight is on the calcaneus (heel bone) and the balls of the toes, both areas cushioned by fat pads bound up in connective tissue.

180

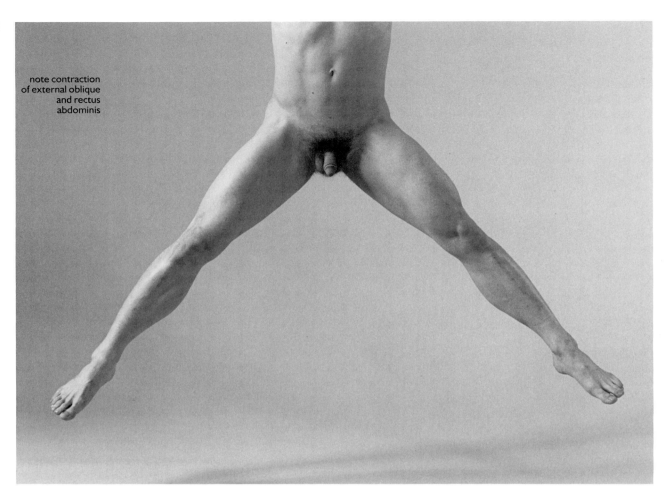

note contraction
of external oblique
and rectus
abdominis

Figure 164.

Extreme abduction of the thighs, anterior view. A bit of highly contracted *gluteus medius* is seen here (the convex portion of the silhouette just below the indentation caused by Poupart's ligament). The origin of *sartorius* on the anterior superior iliac spine also stands out (model's right thigh).

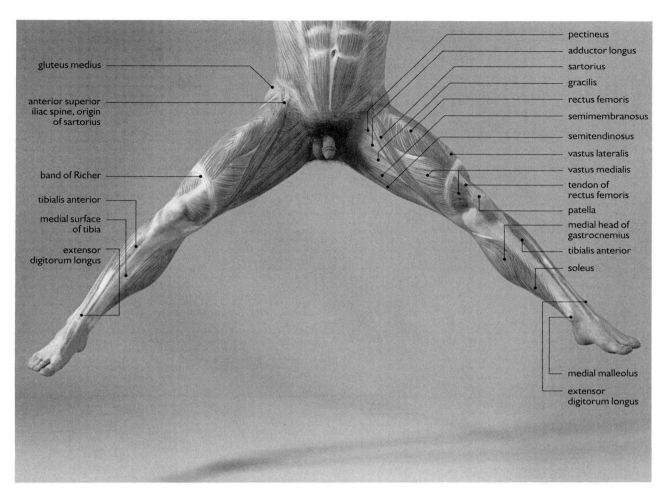

gluteus medius

anterior superior
iliac spine, origin
of sartorius

band of Richer

tibialis anterior

medial surface
of tibia

extensor
digitorum longus

pectineus

adductor longus

sartorius

gracilis

rectus femoris

semimembranosus

semitendinosus

vastus lateralis

vastus medialis

tendon of
rectus femoris

patella

medial head of
gastrocnemius

tibialis anterior

soleus

medial malleolus

extensor
digitorum longus

Figure 165.

Extreme abduction of the thighs, anterior view. *Rectus femoris,* an abductor of the thigh, is contracted here, as is *sartorius,* for the same reason. The *vastus* group (*quadriceps*) as extensors are in maximum contraction.

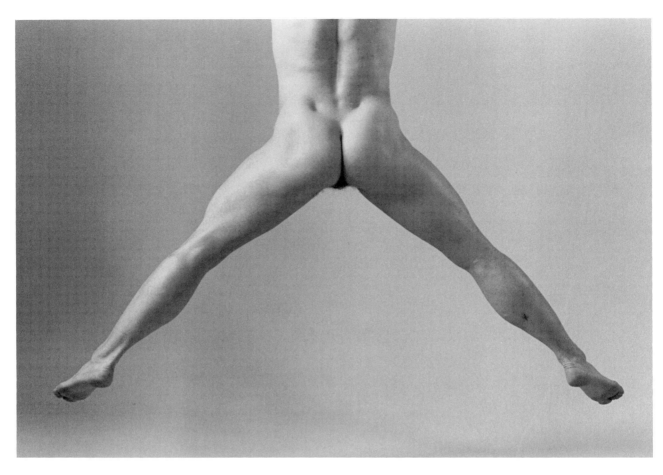

Figure 166.
Extreme abduction of the thighs, posterior view. The gluteal folds are obliterated; thus the true configuration of *gluteus maximus* can be perceived. *Vastus lateralis* is bulging hugely, especially in the left thigh. *Gluteus medius,* the main abductor, is contracted right up to the iliac crest.

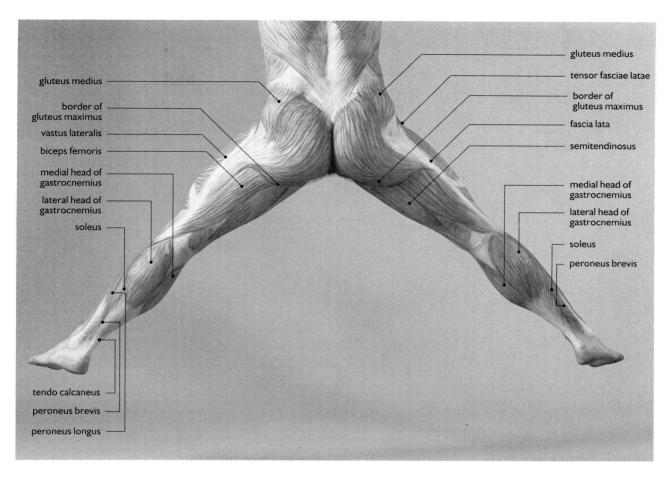

gluteus medius

border of
gluteus maximus

vastus lateralis

biceps femoris

medial head of
gastrocnemius

lateral head of
gastrocnemius

soleus

tendo calcaneus

peroneus brevis

peroneus longus

gluteus medius

tensor fasciae latae

border of
gluteus maximus

fascia lata

semitendinosus

medial head of
gastrocnemius

lateral head of
gastrocnemius

soleus

peroneus brevis

Figure 167.

Extreme abduction of the thighs, posterior view. *Gluteus medius,* a powerful abductor stretching from the iliac wall to the great trochanter, is maximally contracted, deepening the concavity at the buttock's lateral surface. Its contraction has also exaggerated the dimples over the posterior superior iliac spines.

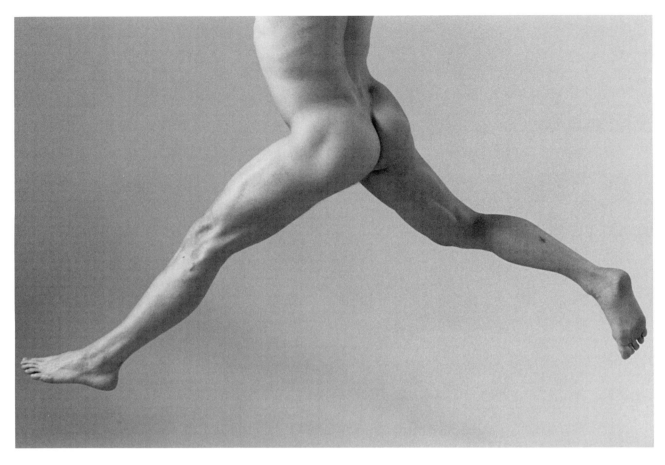

Figure 168.
Scissors kick, three-quarter posterior view. Unlike the right and left shoulders, which are generally thought of as separate parts, the buttocks are regarded by the layperson as an entity. Here they are exhibiting opposite functions: The left is more or less passively supporting the activity of the extensors of the lower leg; the right is violently extending the thigh.

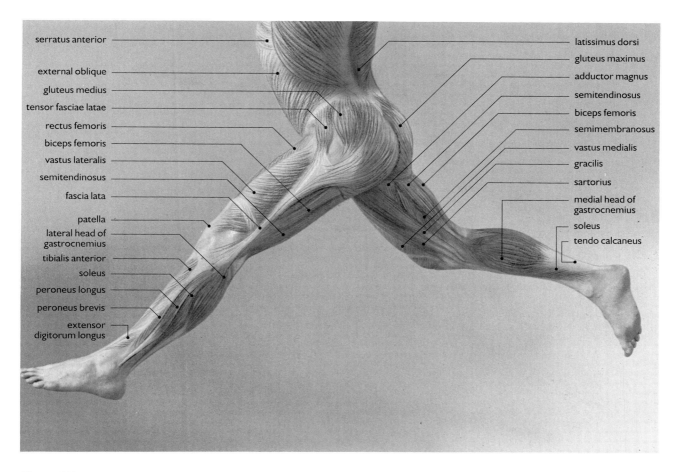

serratus anterior

external oblique

gluteus medius

tensor fasciae latae

rectus femoris

biceps femoris

vastus lateralis

semitendinosus

fascia lata

patella

lateral head of gastrocnemius

tibialis anterior

soleus

peroneus longus

peroneus brevis

extensor digitorum longus

latissimus dorsi

gluteus maximus

adductor magnus

semitendinosus

biceps femoris

semimembranosus

vastus medialis

gracilis

sartorius

medial head of gastrocnemius

soleus

tendo calcaneus

Figure 169.

Scissors kick, three-quarter posterior view. In this photograph, the left thigh is flexed, the right one extended. On the left, the quadriceps are doing the main work in pulling the thigh up. On the right, *biceps femoris* and other hamstrings are pulling the thigh back. The hamstrings are less strong than the quadriceps muscles.

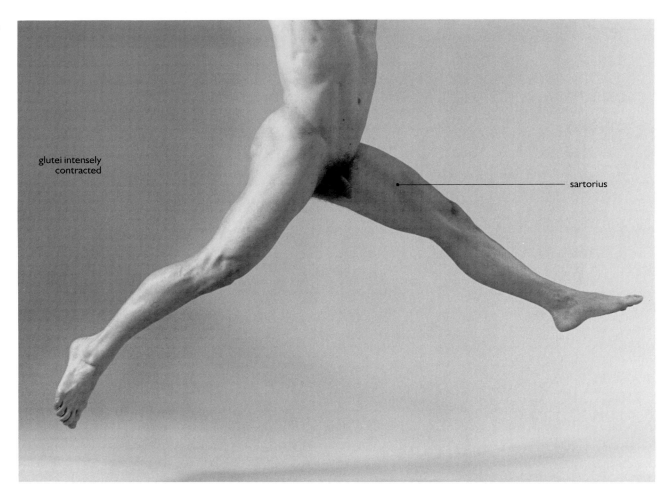

glutei intensely
contracted

sartorius

Figure 170.

Scissors kick, antero-lateral view. The model's right leg is less flexed than in Fig. 171, hence there is greater tension in the hamstring group. *Sartorius*, because it flexes both the thigh and the leg, is under great stress here (left), with the thigh flexed and the leg extended. Consequently, it is remarkably patent for its entire length.

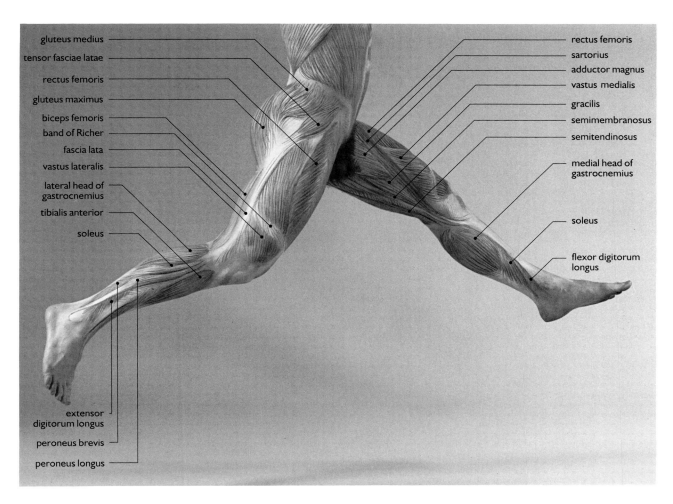

gluteus medius
tensor fasciae latae
rectus femoris
gluteus maximus
biceps femoris
band of Richer
fascia lata
vastus lateralis
lateral head of gastrocnemius
tibialis anterior
soleus

extensor digitorum longus
peroneus brevis
peroneus longus

rectus femoris
sartorius
adductor magnus
vastus medialis
gracilis
semimembranosus
semitendinosus
medial head of gastrocnemius

soleus

flexor digitorum longus

Figure 171.

Scissors kick, antero-lateral view. The model's right thigh is maximally extended, mainly the work of *gluteus maximus,* and tightly bunched in contraction. The hamstrings, the flexors of the leg, also extend the thigh in cooperation with *gluteus maximus.*

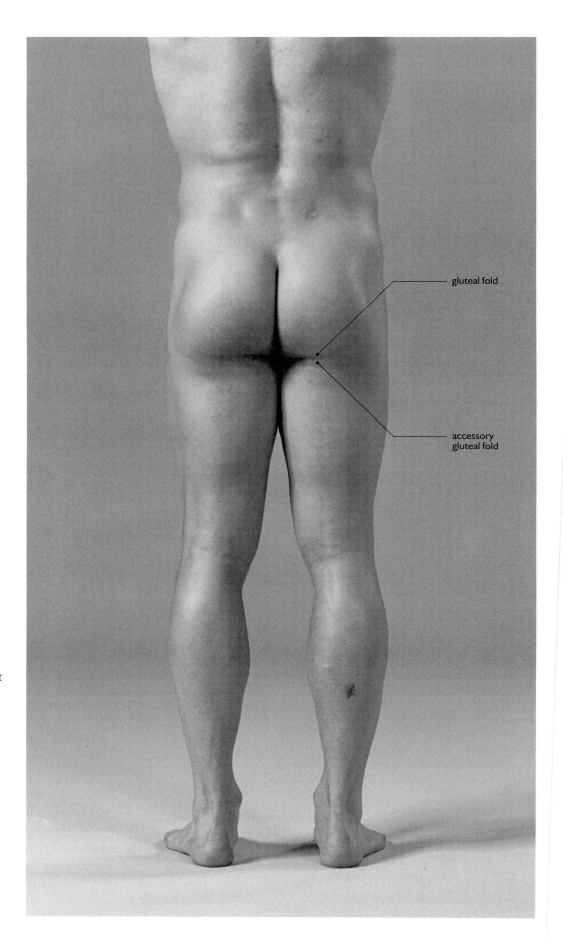

gluteal fold

accessory
gluteal fold

Figure 172.
Gluteal folds, weight
on both legs. In
sitting, the folds
serve to pad and
protect the muscles
and, to a certain
extent, the ischial
tuberosities. Their
structure and
function are similar
to the pads of fat
and fascia padding
the heel, the only
other area subject to
constant pressure.

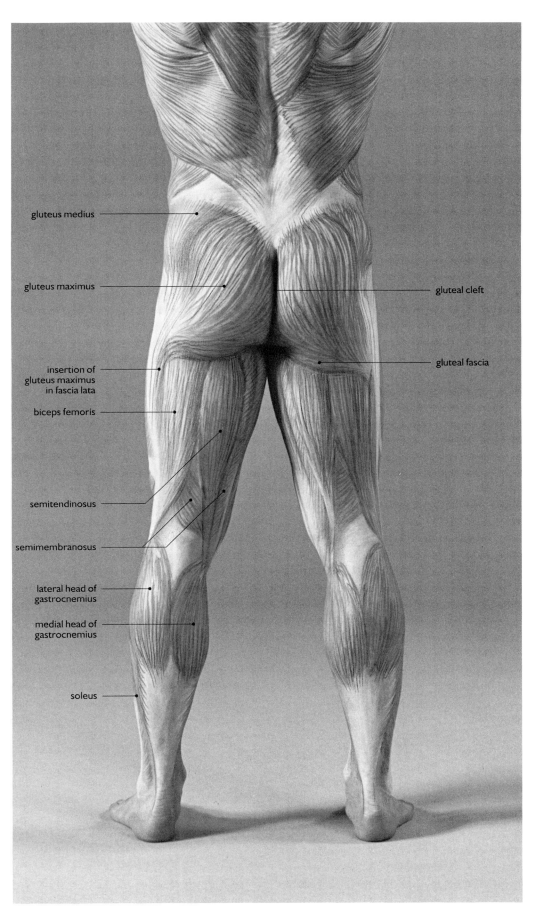

gluteus medius

gluteus maximus

gluteal cleft

insertion of
gluteus maximus
in fascia lata

gluteal fascia

biceps femoris

semitendinosus

semimembranosus

lateral head of
gastrocnemius

medial head of
gastrocnemius

soleus

Figure 173.
Gluteal folds, weight
on both legs. The
lower, inner angle of
the buttock is not
gluteal muscle but
fat packaged in
tough fascia. One
does not sit on one's
gluteal muscles; no
muscle could
withstand such
abuse. The
tuberosities of the
pelvis' ischium bone
bear the pressure in
sitting.

190

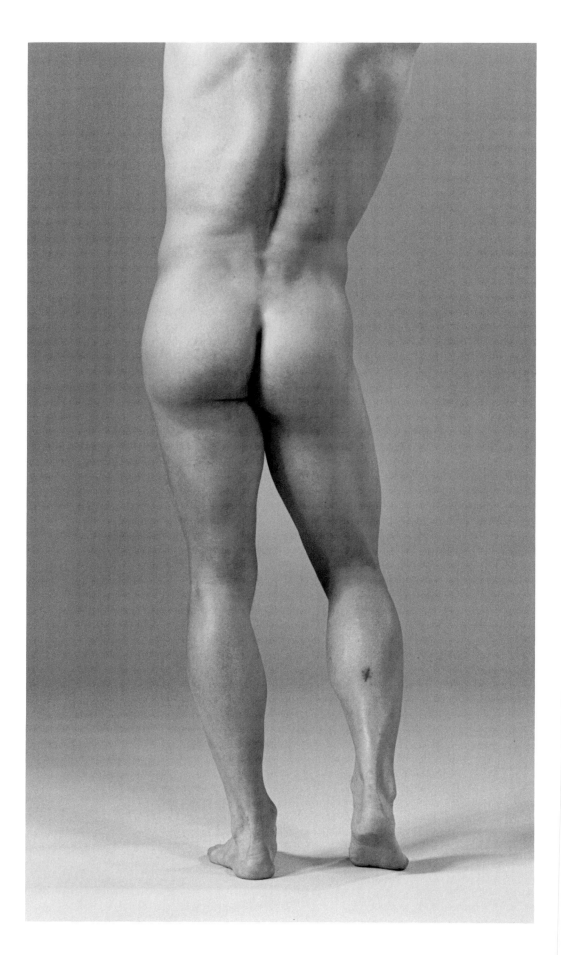

Figure 174.
Gluteal fold, left,
weight on the left
leg. This stance is
familiar from Greek
and Roman
sculpture—for
example, the figure
of Hermes with
Dionysus as a boy
(possibly by
Praxiteles) and the
two bronze youths
found in the sea
near Anticythera
and Marathon.
Other examples
include
Michelangelo's
David and Rodin's
Age of Brass.

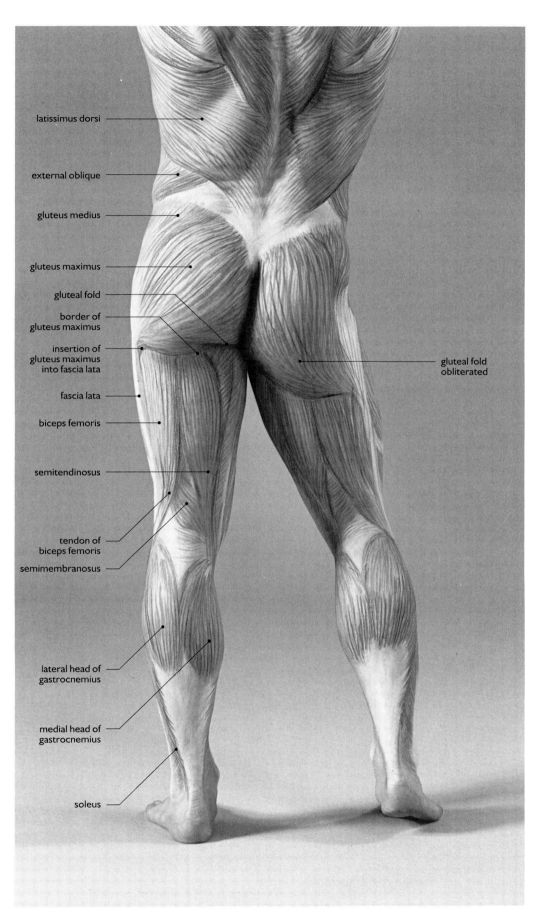

latissimus dorsi

external oblique

gluteus medius

gluteus maximus

gluteal fold

border of
gluteus maximus

insertion of
gluteus maximus
into fascia lata

fascia lata

biceps femoris

semitendinosus

tendon of
biceps femoris

semimembranosus

lateral head of
gastrocnemius

medial head of
gastrocnemius

soleus

gluteal fold
obliterated

Figure 175.
Gluteal fold, left,
weight on the left
leg. With the weight
on one leg and the
other thigh and leg
somewhat flexed,
the pelvis tilts,
exaggerating the fold
on the weight-
bearing side and
diminishing it on the
other.

192

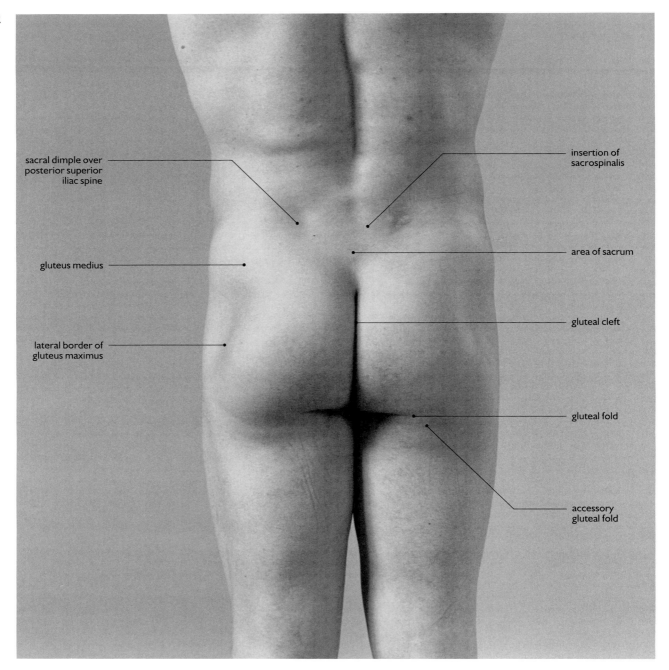

sacral dimple over
posterior superior
iliac spine

insertion of
sacrospinalis

gluteus medius

area of sacrum

lateral border of
gluteus maximus

gluteal cleft

gluteal fold

accessory
gluteal fold

Figure 176.
Gluteal area, standing. In this photograph, the iliac crests are quite visible on either side of the sacral dimples. In some men, the gluteal folds are double; there is a suggestion of that here. The secondary folds are observed only when the thigh is fully extended.

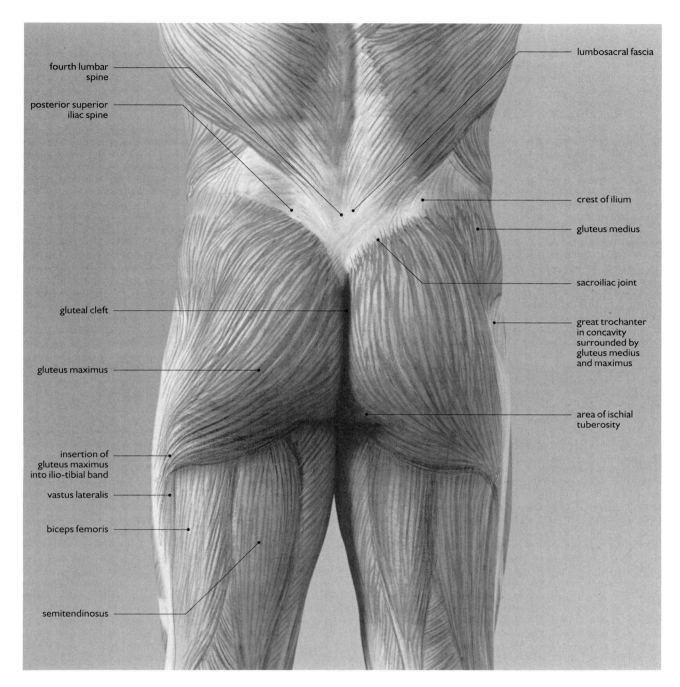

fourth lumbar spine

posterior superior iliac spine

lumbosacral fascia

crest of ilium

gluteus medius

sacroiliac joint

gluteal cleft

great trochanter in concavity surrounded by gluteus medius and maximus

gluteus maximus

area of ischial tuberosity

insertion of gluteus maximus into ilio-tibial band

vastus lateralis

biceps femoris

semitendinosus

Figure 177.
Gluteal area, standing. The iliac crests, evident in men, are rarely so in women. In women, a layer of fat covers the crests and forms a smooth, unbroken curve up the back and over the flanks, creating a beautiful line. It is this superficial fat layer that produces the aesthetically pleasing roundness of normal-weight women.

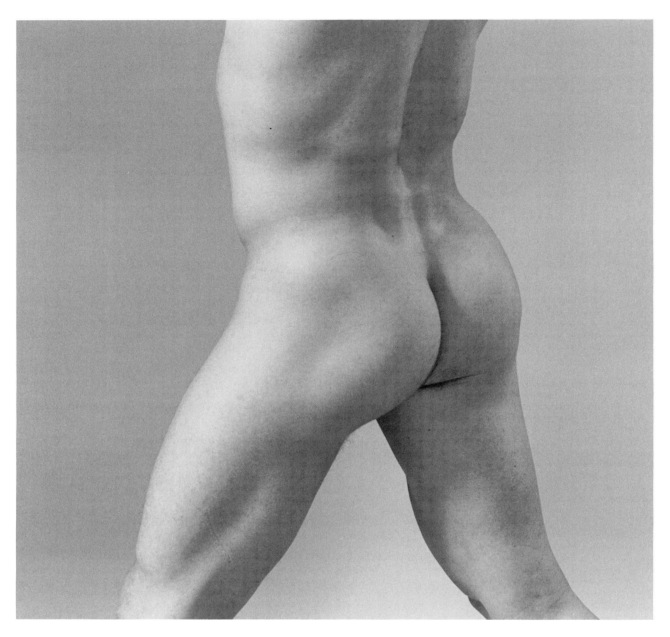

Figure 178.

Gluteal area, walking. Another view of the fold (right) and its disappearance (left). The cords of *sacrospinalis* are evident here, as well as the longitudinal groove between them that marks the lumbo-sacral fascia where it is adjacent to the fascia of the sacrum.

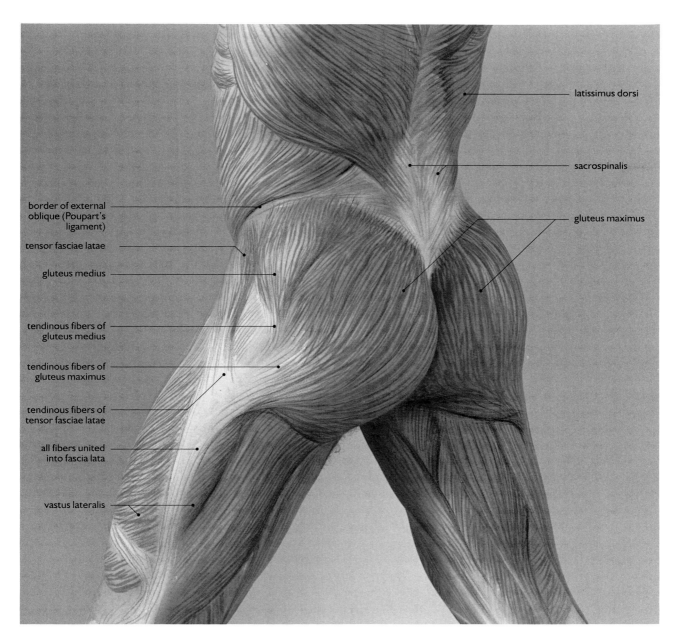

latissimus dorsi

sacrospinalis

gluteus maximus

border of external
oblique (Poupart's
ligament)

tensor fasciae latae

gluteus medius

tendinous fibers of
gluteus medius

tendinous fibers of
gluteus maximus

tendinous fibers of
tensor fasciae latae

all fibers united
into fascia lata

vastus lateralis

Figure 179.

Gluteal area, walking. *Gluteus maximus*, the heaviest muscle in the body, is built for hard labor. It is not exercised much in walking, but in running and climbing it is powerfully active in straightening the leg. It also strongly extends the trunk when one rises from a sitting or stooping position or goes up stairs.

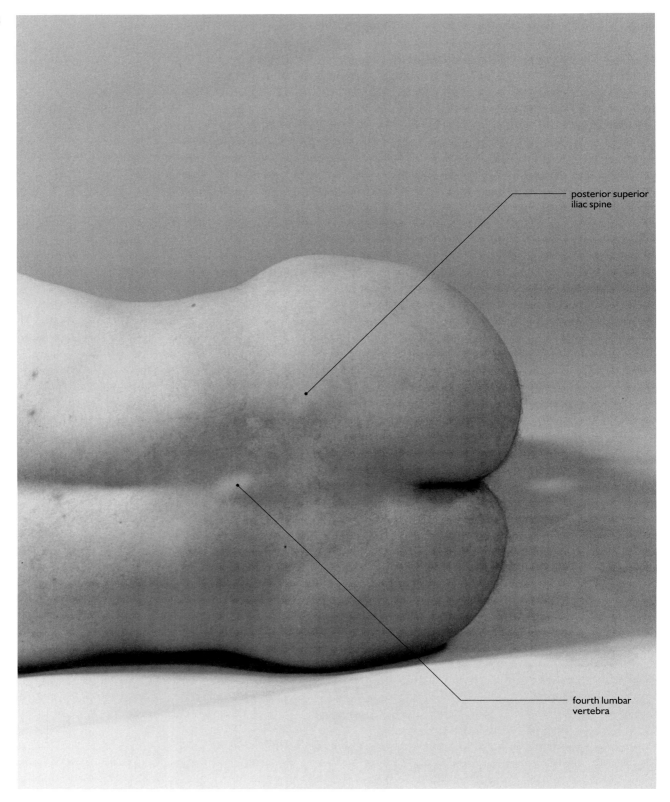

posterior superior
iliac spine

fourth lumbar
vertebra

Figure 180.

Gluteal area, thighs flexed. The prominent midline projection is the spine of the fourth lumbar vertebra. It is located on an imaginary transverse line drawn from the height of one iliac crest to the other. A useful landmark medically, it indicates the site for lumbar puncture (between third and fourth lumbar vertebrae).

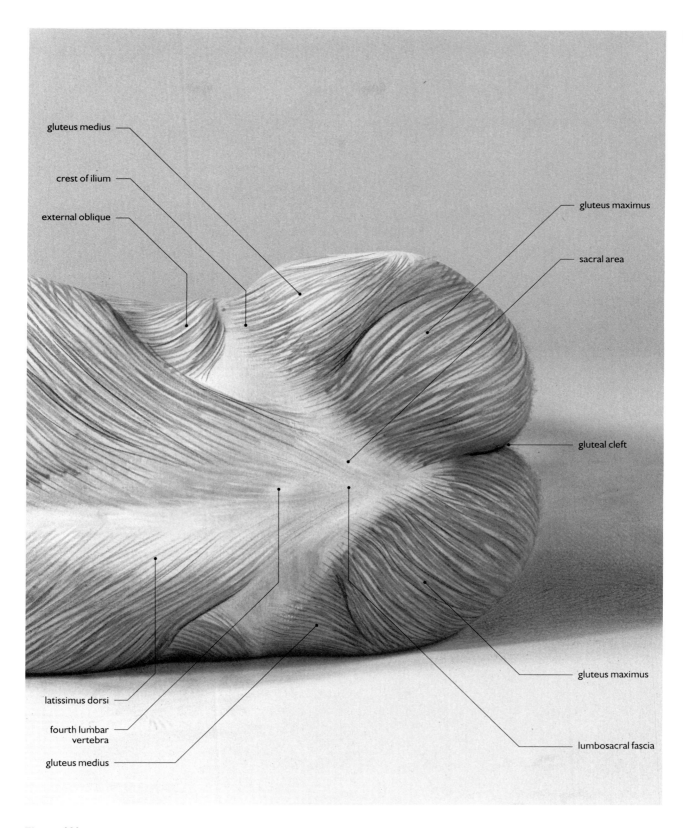

gluteus medius

crest of ilium

external oblique

gluteus maximus

sacral area

gluteal cleft

gluteus maximus

latissimus dorsi

fourth lumbar
vertebra

gluteus medius

lumbosacral fascia

Figure 181.

Gluteal area, thighs flexed. The spines of the lumbar vertebrae are not deep beneath the skin, and the lumbo-sacral fascia and aponeurosis of *latissimus dorsi*, though exceedingly tough, are thin.

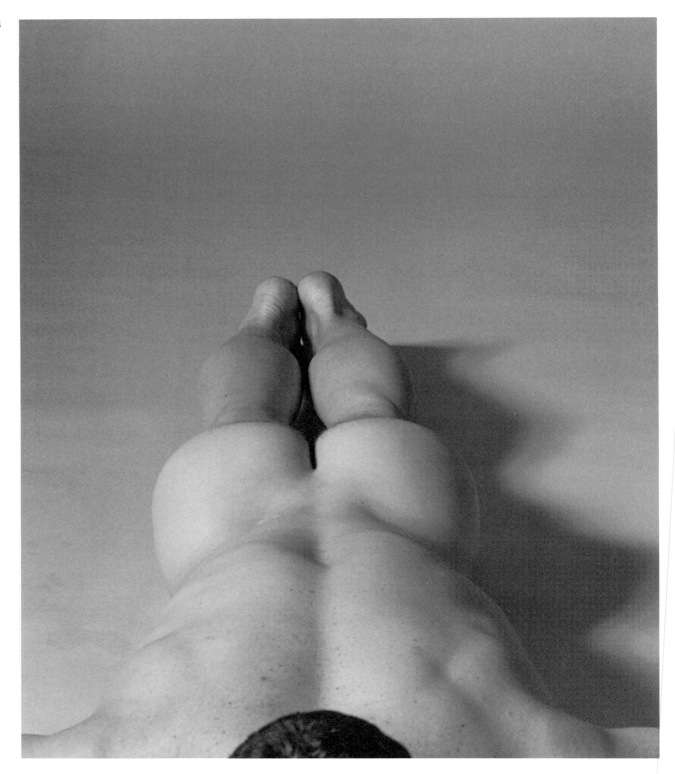

Figure 182.
Gluteal area, looking caudad. The model is lying prone (see Fig. 134). The gluteal cleft is shallower superiorly, deepening as it curves down and under. Although the buttocks are relaxed, normal tone keeps them pressed together.

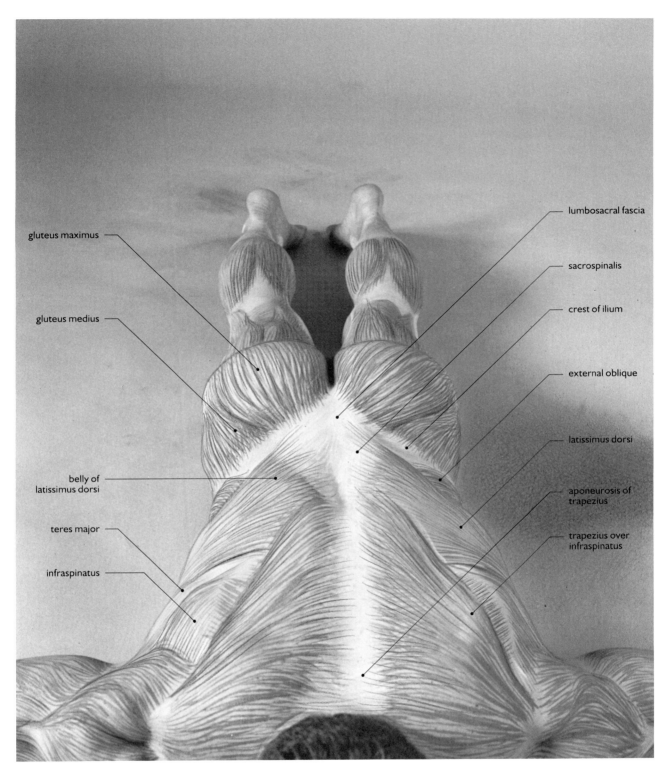

gluteus maximus

gluteus medius

belly of
latissimus dorsi

teres major

infraspinatus

lumbosacral fascia

sacrospinalis

crest of ilium

external oblique

latissimus dorsi

aponeurosis of
trapezius

trapezius over
infraspinatus

Figure 183.

Gluteal area, looking caudad. The model is again prone. Because the lumbar spine is relatively extended, the spine of the fourth vertebra is no longer prominent. (The spine is inclined caudad; the overlying fascia are stretched less tightly.) It is most prominent when the spine is maximally flexed.

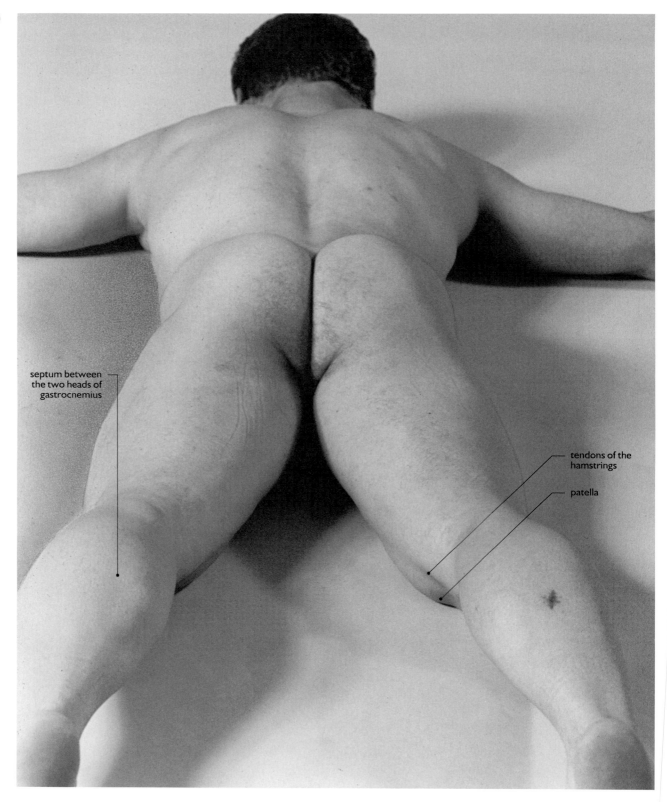

septum between
the two heads of
gastrocnemius

tendons of the
hamstrings

patella

Figure 184.

Gluteal area, looking cephalad. With the buttocks more tensed than in Fig. 185, the dividing line between *gluteus maximus* and *medius* is more apparent. *Medius* is seen as the somewhat crescentic areas capping the lateral portions of the buttocks.

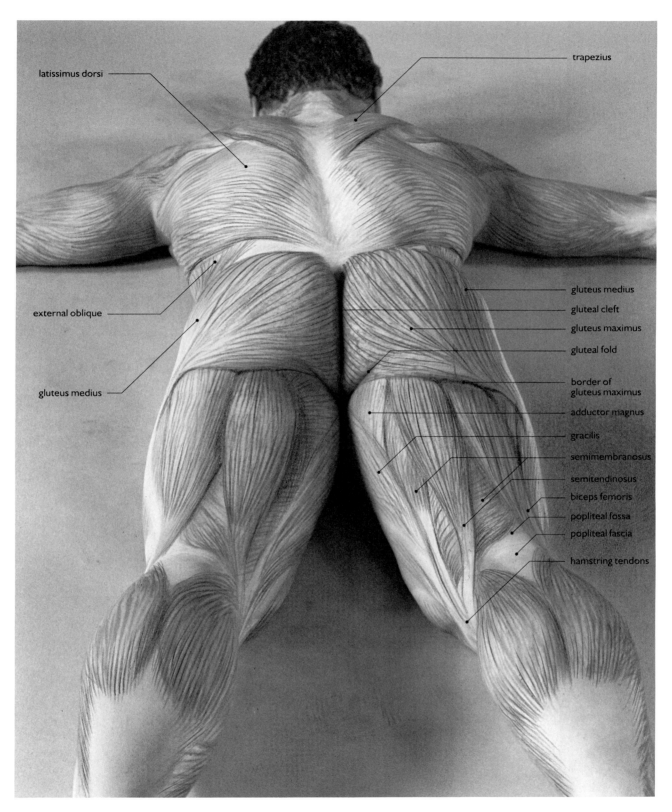

latissimus dorsi

trapezius

external oblique

gluteus medius

gluteus medius
gluteal cleft
gluteus maximus
gluteal fold
border of
gluteus maximus
adductor magnus
gracilis
semimembranosus
semitendinosus
biceps femoris
popliteal fossa
popliteal fascia
hamstring tendons

Figure 185.
Gluteal area, looking cephalad. The gluteal cleft deepens inferiorly, and just superior to the folds it merges into the perineum, the area most proximate to the pelvic outlet. The downward and outward slant of the fibers of *gluteus maximus* is unmistakable here.

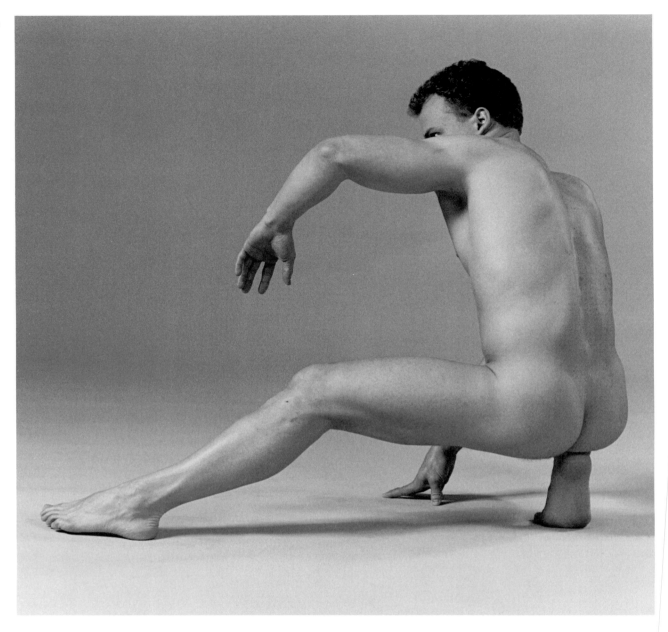

Figure 186.
The conformation of the armpit is well visualized here. It is surely a beautiful structure, perfectly organized for its function and made up of wonderfully varied, integrated shapes.

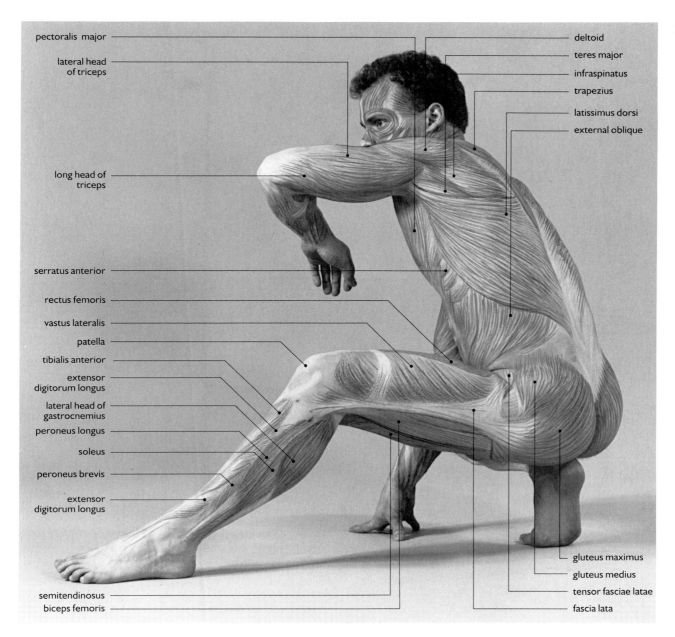

pectoralis major

lateral head
of triceps

long head of
triceps

serratus anterior

rectus femoris

vastus lateralis

patella

tibialis anterior

extensor
digitorum longus

lateral head of
gastrocnemius

peroneus longus

soleus

peroneus brevis

extensor
digitorum longus

semitendinosus

biceps femoris

deltoid

teres major

infraspinatus

trapezius

latissimus dorsi

external oblique

gluteus maximus

gluteus medius

tensor fasciae latae

fascia lata

Figure 187.

This and the following fourteen poses diverge radically from standard medical and anatomical positions. They are sculptural, corresponding to the atelier rather than the anatomy lab. Nevertheless, they reveal the bodily structure just as effectively, if not more so.

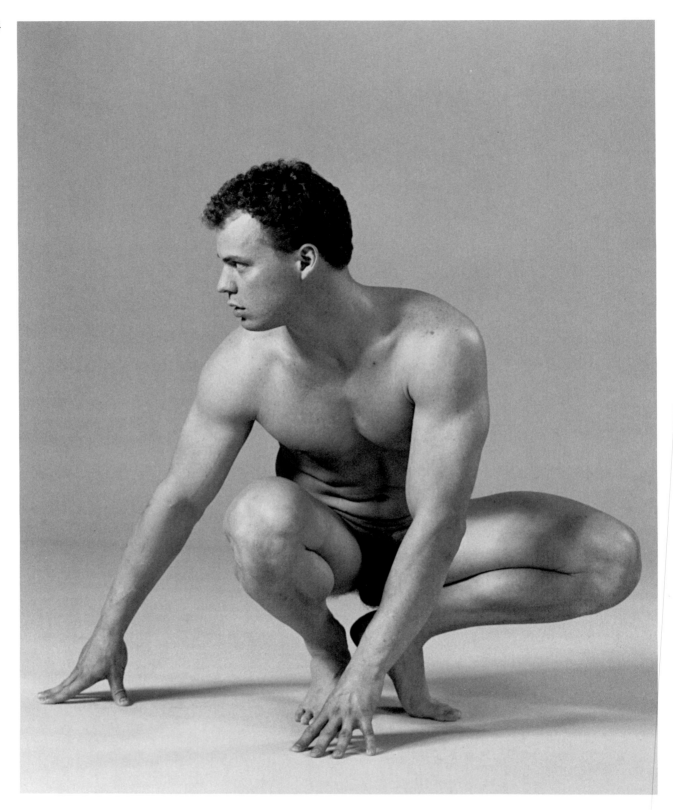

Figure 188.

The umbilicus, or navel, is located at the junction of two fascial bands and, on flexion of the trunk, is included in one of the creases. The transverse band is the interrupting tendon of (usually) the lowest segment of *rectus abdominis*. The vertical band, separating the two *rectus* muscles, is the *linea alba*.

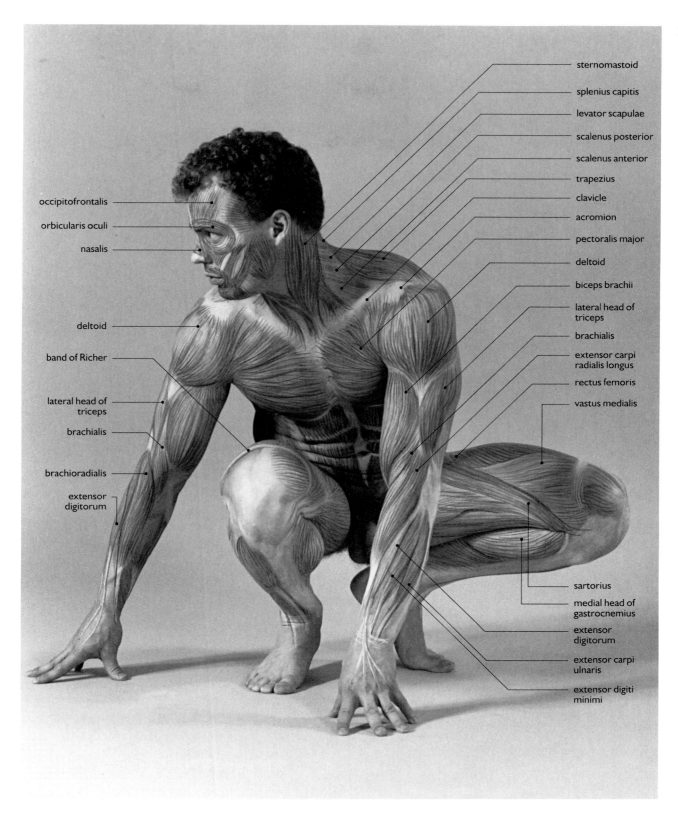

sternomastoid

splenius capitis

levator scapulae

scalenus posterior

scalenus anterior

trapezius

clavicle

acromion

pectoralis major

deltoid

biceps brachii

lateral head of triceps

brachialis

extensor carpi radialis longus

rectus femoris

vastus medialis

occipitofrontalis

orbicularis oculi

nasalis

deltoid

band of Richer

lateral head of triceps

brachialis

brachioradialis

extensor digitorum

sartorius

medial head of gastrocnemius

extensor digitorum

extensor carpi ulnaris

extensor digiti minimi

Figure 189.

This crouching, *contrapposto* pose suggests movement from right to left. Note that when the abdomen is compressed, the abdominal creases occur precisely at *rectus abdominis'* tendinous intersections, with the muscle bellying out only between the creases.

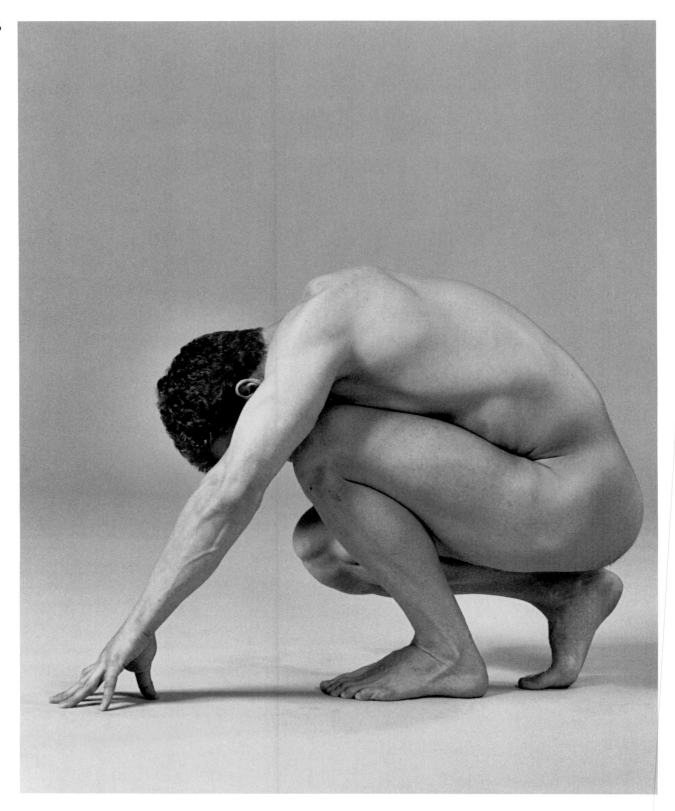

Figure 190.

The compact pose suggests a telamon or atlas, the male equivalent of a caryatid, a sculptured figure incorporated in a column that, in a Greek or Roman temple, supports an entablature.

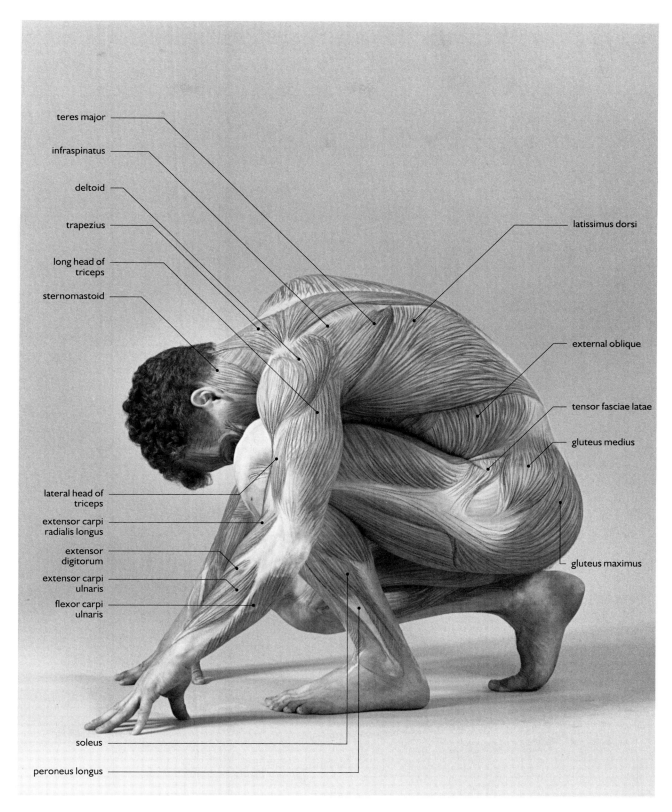

teres major

infraspinatus

deltoid

trapezius

long head of triceps

sternomastoid

latissimus dorsi

external oblique

tensor fasciae latae

gluteus medius

lateral head of triceps

extensor carpi radialis longus

extensor digitorum

extensor carpi ulnaris

flexor carpi ulnaris

gluteus maximus

soleus

peroneus longus

Figure 191.

This interesting view of *trapezius* suggests why it is sometimes called a cowl or hood muscle. Its origin and insertion are obvious here.

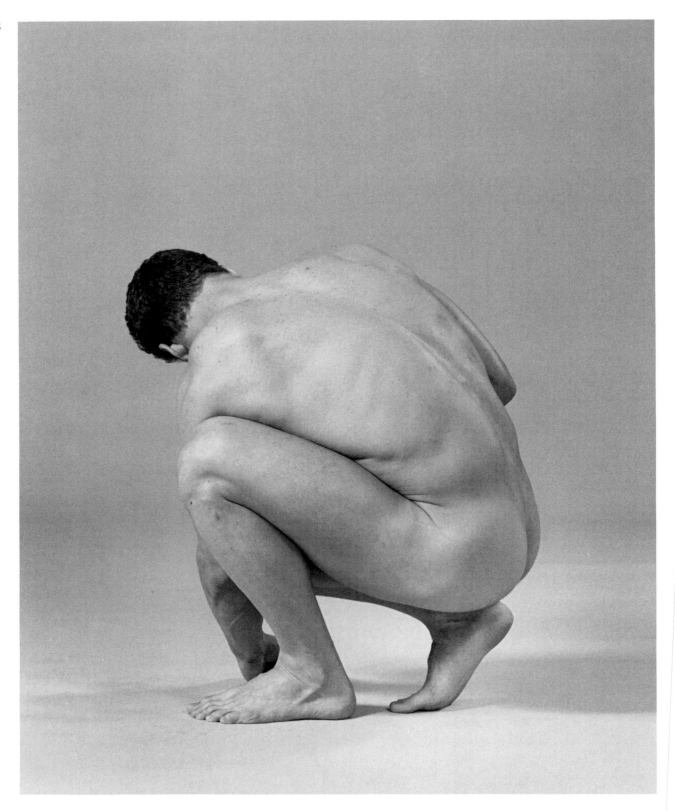

Figure 192.
Another compact telamon pose. Excepting the relatively fragile ankles, it would fulfill Michelangelo's test of good sculpture: It could be rolled down a hill without anything breaking off. Note that with the back flexed, the vertebral spines are visible.

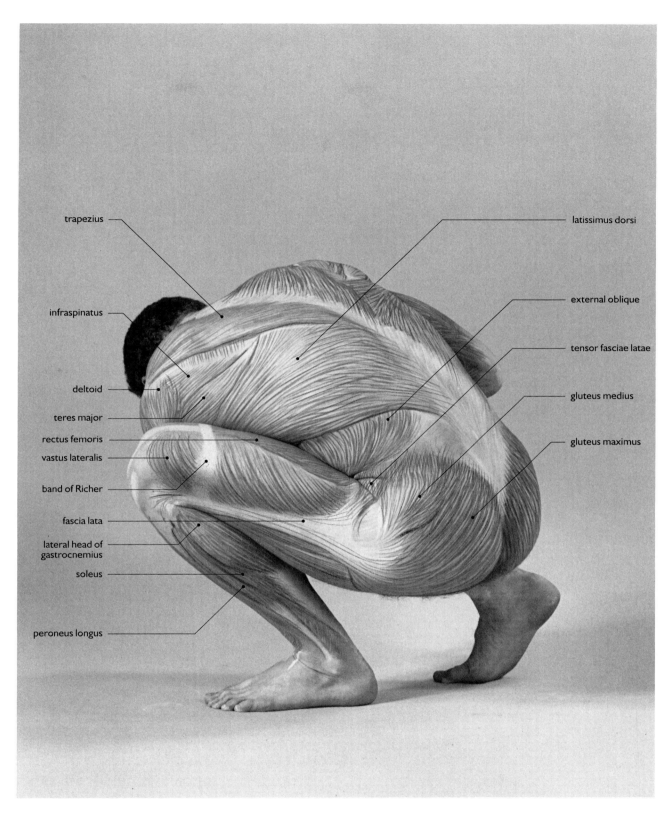

trapezius

latissimus dorsi

infraspinatus

external oblique

tensor fasciae latae

deltoid

gluteus medius

teres major

rectus femoris

gluteus maximus

vastus lateralis

band of Richer

fascia lata

lateral head of
gastrocnemius

soleus

peroneus longus

Figure 193.

The impressive sweep of *latissimus dorsi* is striking in this pose. Also apparent is the tension exerted on the *fascia lata* by the gluteals.

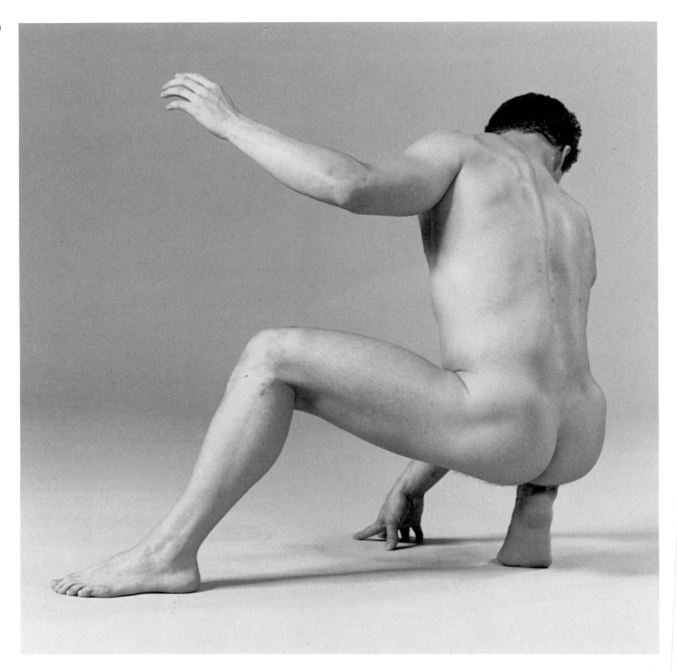

Figure 194.
This *contrapposto* pose suggests that the subject has been facing left and is now turning right. It is remarkable that in this position almost the entire left scapula is visible, from its spine and acromion process, throughout its dorsal surface, to its lower angle.

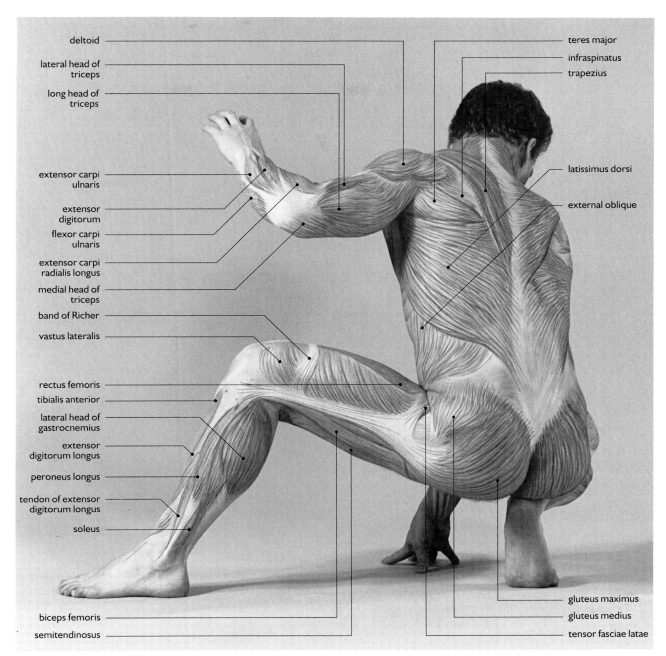

deltoid

lateral head of triceps

long head of triceps

extensor carpi ulnaris

extensor digitorum

flexor carpi ulnaris

extensor carpi radialis longus

medial head of triceps

band of Richer

vastus lateralis

rectus femoris

tibialis anterior

lateral head of gastrocnemius

extensor digitorum longus

peroneus longus

tendon of extensor digitorum longus

soleus

biceps femoris

semitendinosus

teres major

infraspinatus

trapezius

latissimus dorsi

external oblique

gluteus maximus

gluteus medius

tensor fasciae latae

Figure 195.

Vastus lateralis and *rectus femoris* are contracted here showing the function of the band of Richer: In preventing excessive bulging of the muscles (which wastes their contractile power), the band allows strength to be reserved for the work at hand—in this case, supporting the leg.

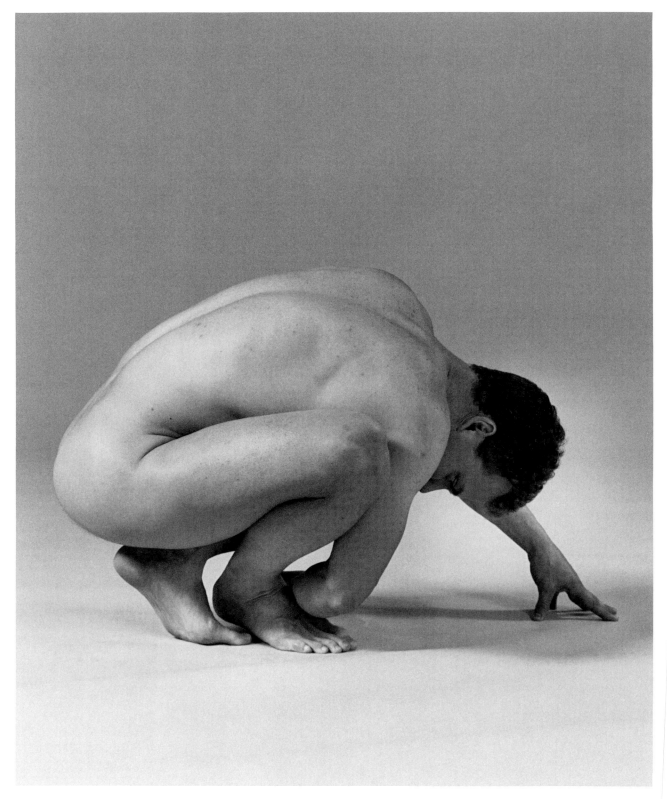

Figure 196.

In this telamon pose, the model seems to retain a lumbar concavity, even though the entire back is strongly flexed. This is an illusion, however. The well-developed *sacrospinalis* muscles above and *glutei* below merely cause the nonelevated area between them to appear concave.

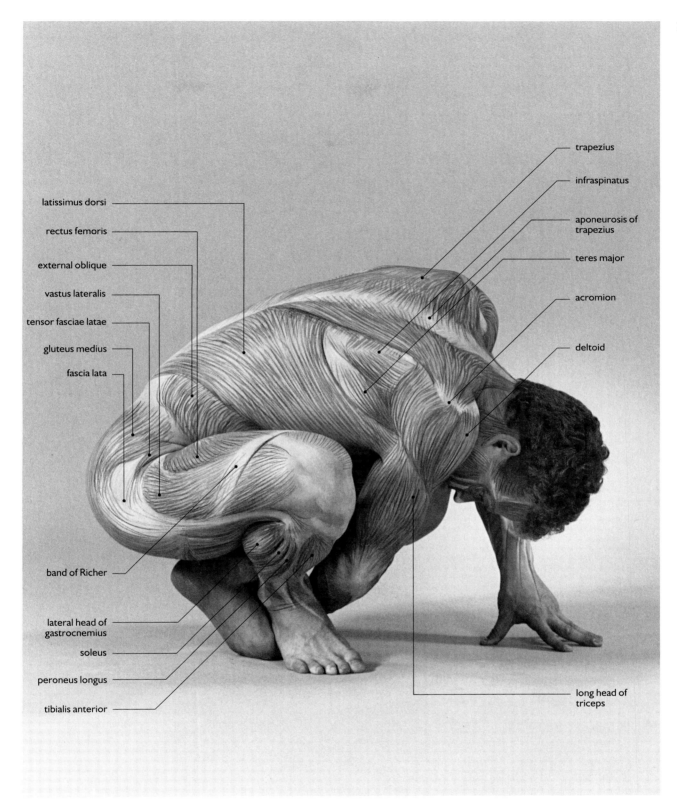

trapezius

infraspinatus

aponeurosis of
trapezius

teres major

acromion

deltoid

long head of
triceps

latissimus dorsi

rectus femoris

external oblique

vastus lateralis

tensor fasciae latae

gluteus medius

fascia lata

band of Richer

lateral head of
gastrocnemius

soleus

peroneus longus

tibialis anterior

Figure 197.
Teres major is a strong, bulky muscle, though always partly hidden by *latissimus dorsi*. The latter is often mistakenly credited with the increasing width of a weightlifter's chest. In fact, it is the bulging *teres major* underneath that is mostly responsible.

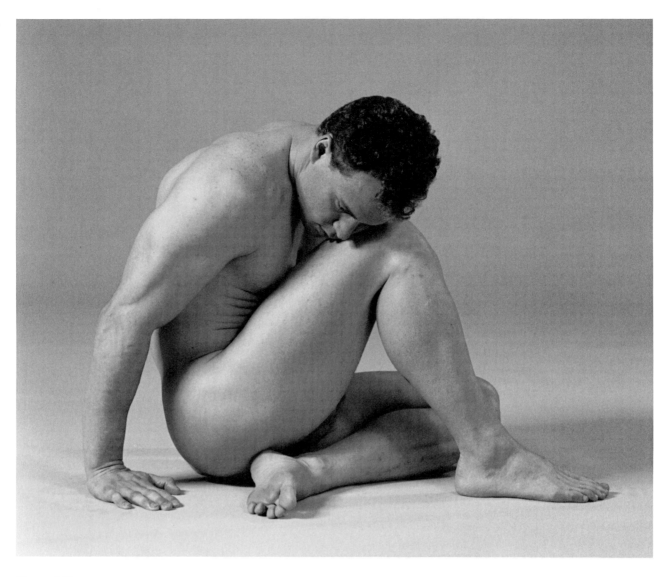

Figure 198.
A broad-based, pyramidal pose such as this offers the utmost in stability, and it would take much to tip the model over. Obviously, that is why the Greeks used it, in the form of telamones and caryatids, in the construction of their temples.

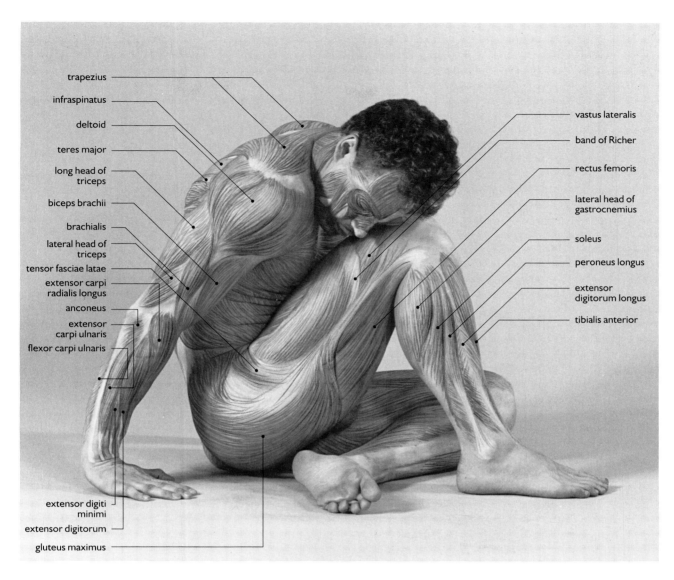

trapezius

infraspinatus

deltoid

teres major

long head of
triceps

biceps brachii

brachialis

lateral head of
triceps

tensor fasciae latae

extensor carpi
radialis longus

anconeus

extensor
carpi ulnaris

flexor carpi ulnaris

extensor digiti
minimi

extensor digitorum

gluteus maximus

vastus lateralis

band of Richer

rectus femoris

lateral head of
gastrocnemius

soleus

peroneus longus

extensor
digitorum longus

tibialis anterior

Figure 199.

The bulge to the left of *deltoid* is *teres major,* more clearly seen, perhaps, in Fig. 198.

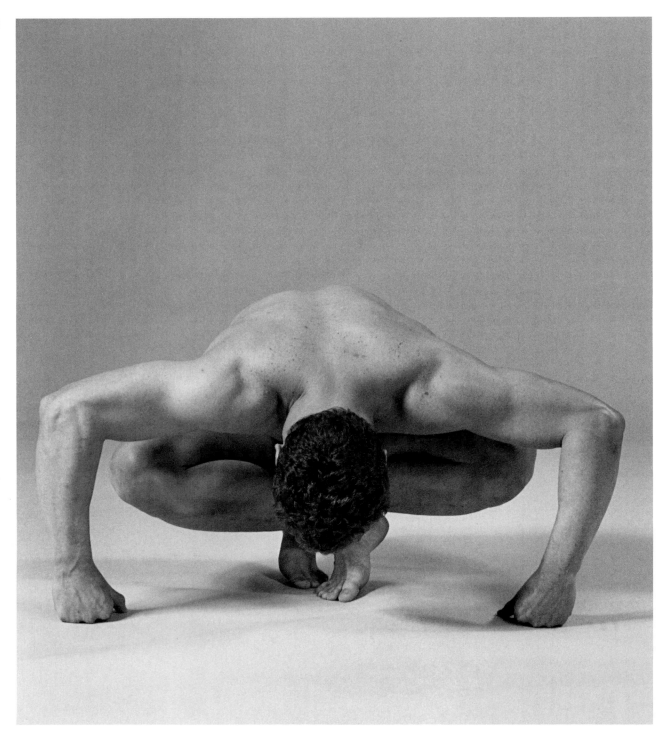

Figure 200.
Here is another telamon pose demonstrating the stability of such positions. The dorsal muscles are seen in perspective from *deltoid* to *teres major* to *latissimus dorsi* to *sacrospinalis* as a series of subtle swellings that would inevitably appear arbitrary without anatomical knowledge.

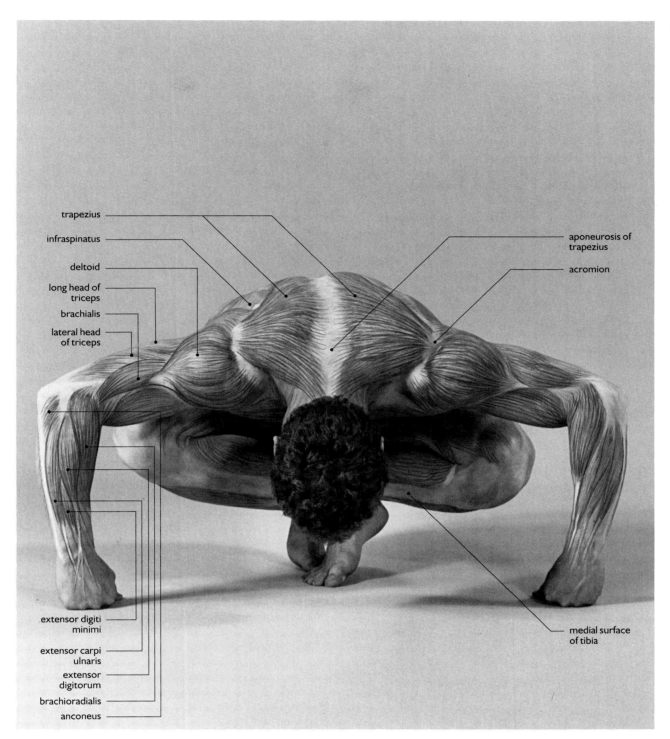

Figure 201.

Although this is not a standard anatomical demonstration position, it perhaps ought to be, as it displays the relation of the shoulders to the upper back to advantage. Why the trapezoidal form gave *trapezius* its name is evident, as well as that muscle's origins and insertions.

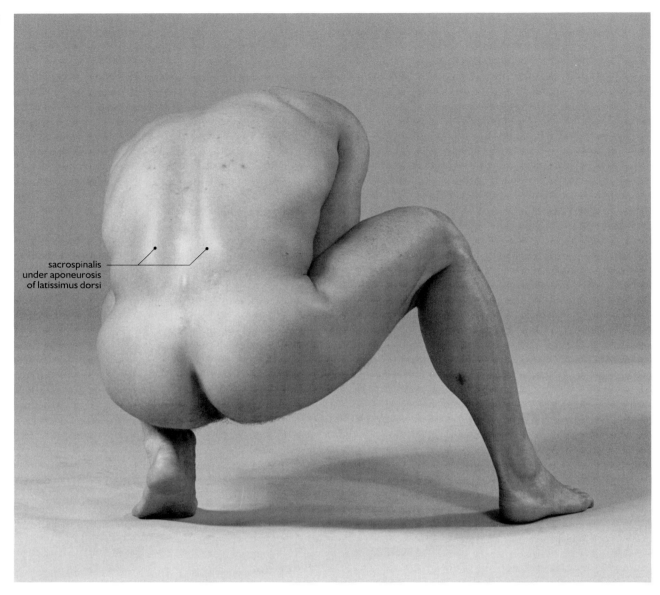

sacrospinalis
under aponeurosis
of latissimus dorsi

Figure 202.

The parallel columns of the paravertebral muscles and the tips of the vertebral spines between them, including the prominent fourth lumbar, are revealed in high relief in this photograph. The tendon of *tensor fasciae latae* is evident at the underside of the knee.

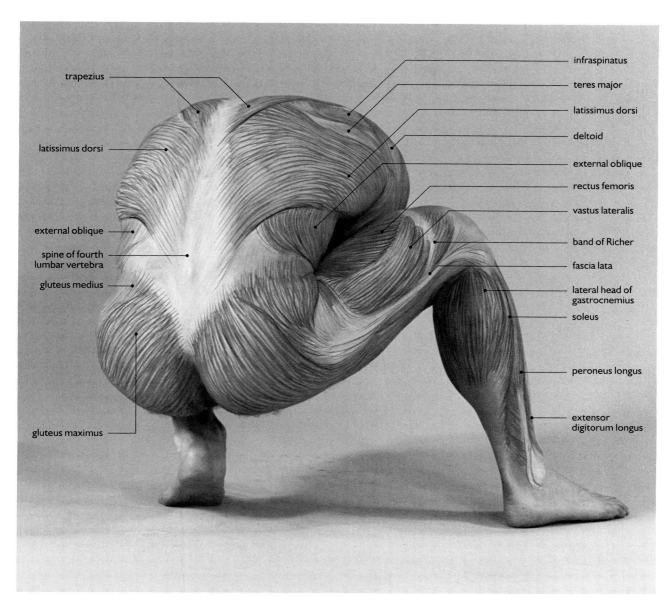

trapezius

latissimus dorsi

external oblique

spine of fourth
lumbar vertebra

gluteus medius

gluteus maximus

infraspinatus

teres major

latissimus dorsi

deltoid

external oblique

rectus femoris

vastus lateralis

band of Richer

fascia lata

lateral head of
gastrocnemius

soleus

peroneus longus

extensor
digitorum longus

Figure 203.

The rhythmic flow of the musculature is remarkable and reveals great elegance ordinarily hidden from view. That preeminent scientific artist Max Brödel once observed that there was nothing about the human body that was not beautiful.

220

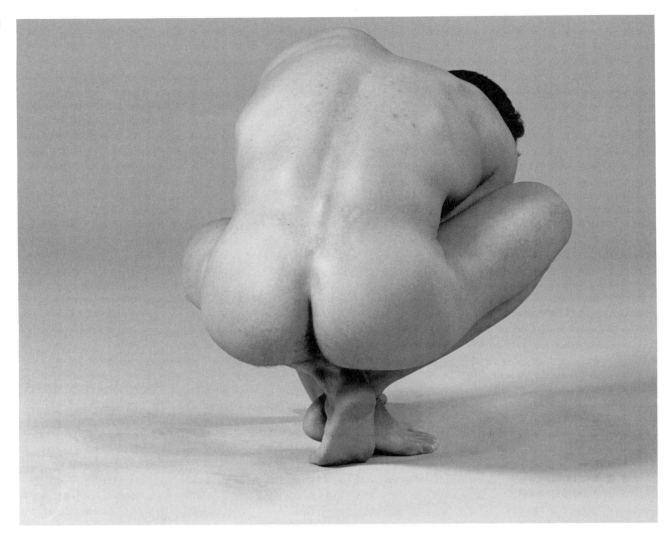

Figure 204.
The depression just above the gluteal cleft in this position corresponds to the space between the two horns of the sacrum and the hiatus between them, at the apex of the sacrum. Below the apex is the coccyx or tailbone.

220

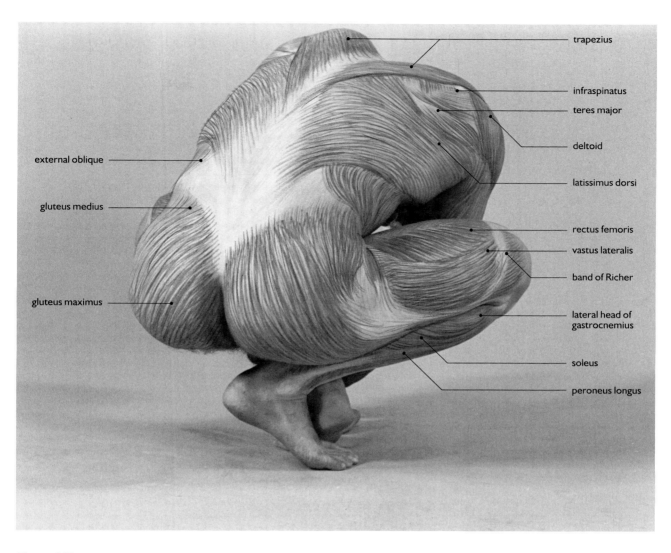

external oblique

gluteus medius

gluteus maximus

trapezius

infraspinatus

teres major

deltoid

latissimus dorsi

rectus femoris

vastus lateralis

band of Richer

lateral head of gastrocnemius

soleus

peroneus longus

Figure 205.

This pose is similar to the ones in Figs. 202 and 203. Despite its smaller base, it is probably as stable as those. Rodin sculpted a caryatid in this position.

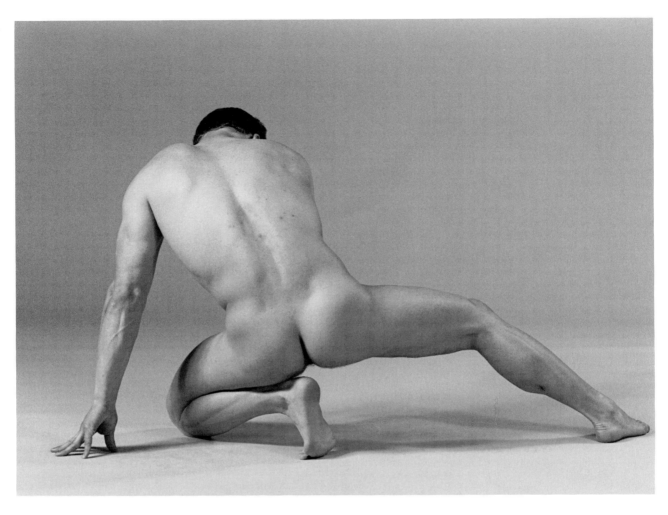

Figure 206.
It is easy to imagine this figure done in marble and to see how suitable marble is for representing flesh. It seems cause for wonder, however, that the Greeks ever thought of using bronze for the purpose and then painting it flesh color.

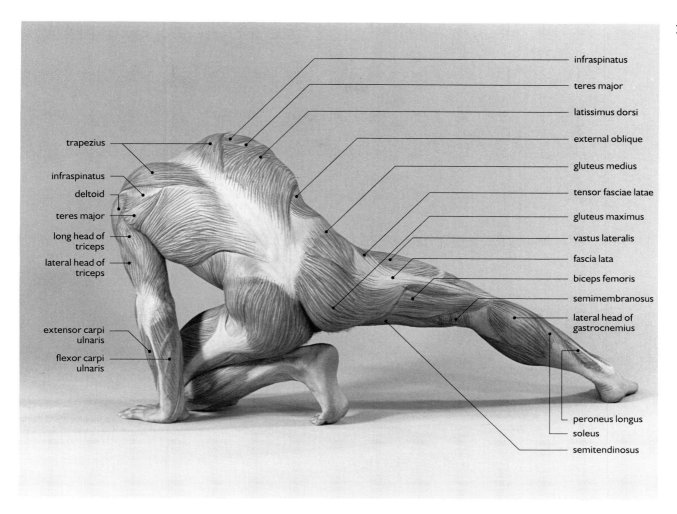

infraspinatus

teres major

latissimus dorsi

external oblique

gluteus medius

tensor fasciae latae

gluteus maximus

vastus lateralis

fascia lata

biceps femoris

semimembranosus

lateral head of gastrocnemius

peroneus longus

soleus

semitendinosus

trapezius

infraspinatus

deltoid

teres major

long head of triceps

lateral head of triceps

extensor carpi ulnaris

flexor carpi ulnaris

Figure 207.

The "fallen warrior" pose was used by Greek sculptors at the acute angles of their pediments, as in the temple of Aphaia on Aegina. They needed a figure that would fit plausibly into the narrowing space. Bent and reclining figures such as this suited admirably.

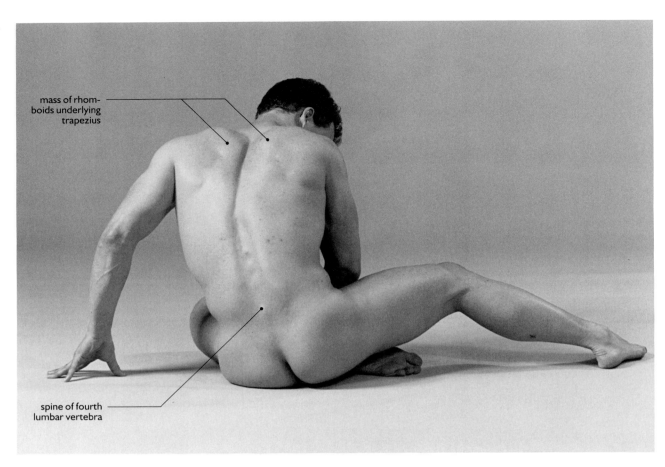

mass of rhom-
boids underlying
trapezius

spine of fourth
lumbar vertebra

Figure 208.

This photograph shows an "acute angle" pose. Although the upper thoracic spine is as flexed as the lower and lumbar, the upper vertebral spines are hidden by the surrounding bulky musculature. The lower thoracic and lumbar spines are clearly visible, especially the fourth lumbar.

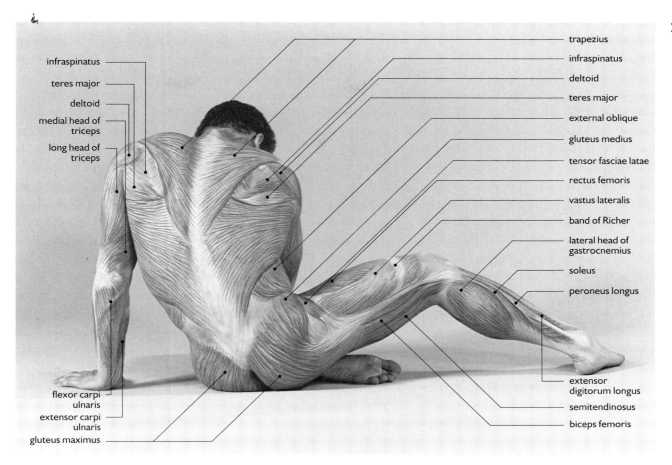

infraspinatus
teres major
deltoid
medial head of
triceps
long head of
triceps

trapezius
infraspinatus
deltoid
teres major
external oblique
gluteus medius
tensor fasciae latae
rectus femoris
vastus lateralis
band of Richer
lateral head of
gastrocnemius
soleus
peroneus longus

flexor carpi
ulnaris
extensor carpi
ulnaris
gluteus maximus

extensor
digitorum longus
semitendinosus
biceps femoris

Figure 209.

Both *trapezius* and *latissimus dorsi* cover the trunk like shawls or cloaks. *Latissimus dorsi* actually narrows toward its insertion and appears to narrow even more when the trunk is inclined to one side. Here its left side appears twice the width of the right.

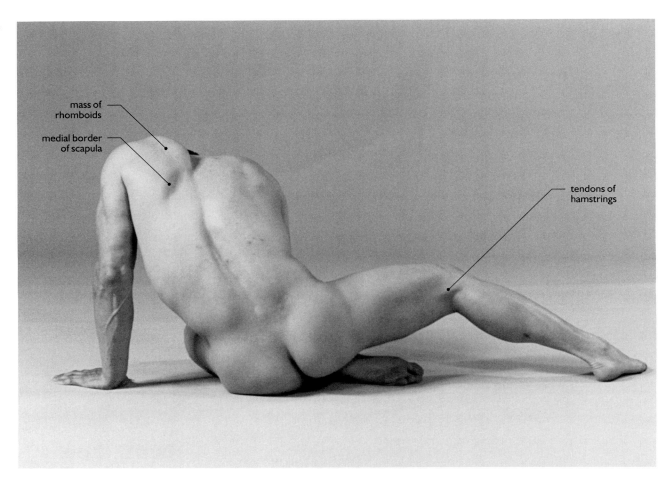

mass of
rhomboids

medial border
of scapula

tendons of
hamstrings

Figure 210.

The model assumes another "acute angle" pose. The left clavicle and scapula are braced and elevated to support the arm on which the weight of that side of the trunk rests. Medial to the scapula is the humped mass of the *rhomboids* covered by the relatively thin *trapezius*.

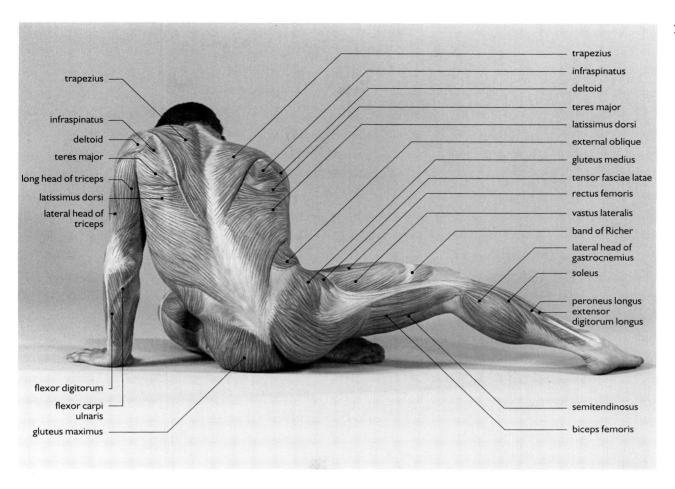

Figure 211.

The model may appear to be sitting on his left *gluteus maximus,* but he is not; in fact, the muscle has moved out of the way posteriorly, and it is his left ischial tuberosity, with its tough fascial and fatty pad, that bears his weight.

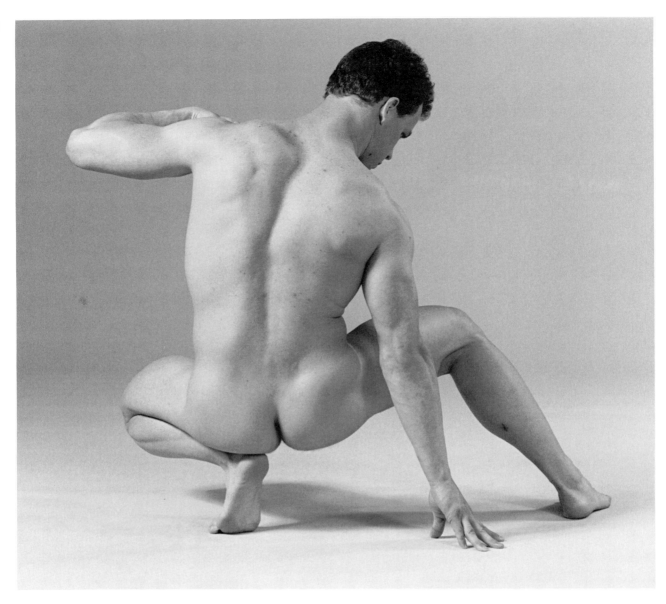

Figure 212.

Because of a reflected light on the thigh, the swelling right *gluteus medius* is shown in high relief. As the *maximus* on that side is also working, bracing the pelvis against the flexed thigh, the hollow over the great trochanter is sharply circumscribed.

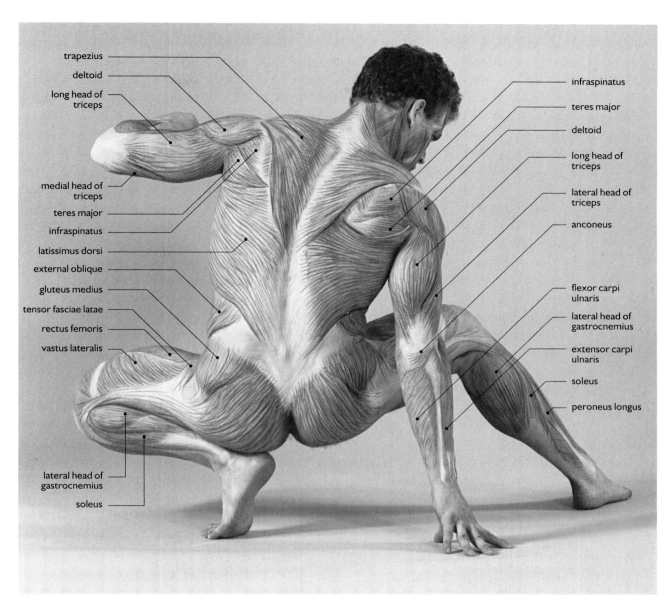

trapezius
deltoid
long head of triceps
medial head of triceps
teres major
infraspinatus
latissimus dorsi
external oblique
gluteus medius
tensor fasciae latae
rectus femoris
vastus lateralis
lateral head of gastrocnemius
soleus

infraspinatus
teres major
deltoid
long head of triceps
lateral head of triceps
anconeus
flexor carpi ulnaris
lateral head of gastrocnemius
extensor carpi ulnaris
soleus
peroneus longus

Figure 213.

Gluteus medius on both sides is prominent here as both thighs are abducted. The right one is especially tensed as the buttock does not have the support of the foot that the left one has.

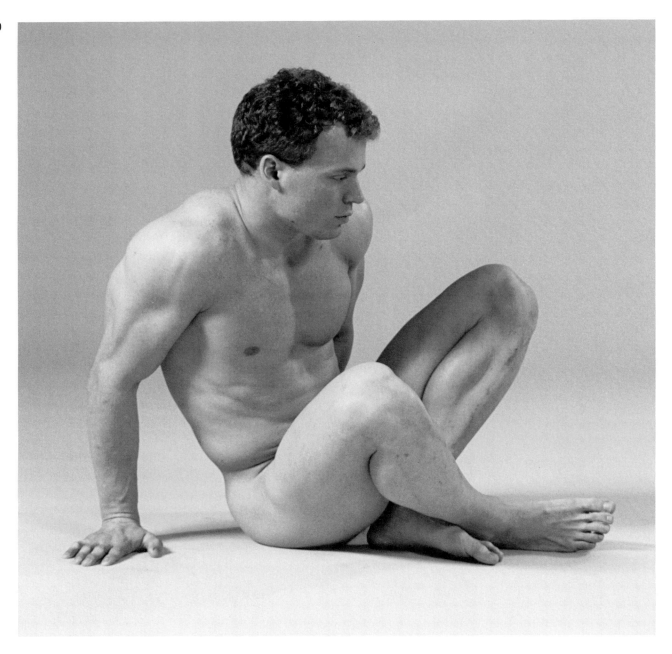

Figure 214.
Note the degree of flexion of the left leg on the thigh. The idea that large muscles limit a joint's range of motion ("muscle-bound") is surely a canard of the scrawny. Muscles in relaxation are supple and pliable and accommodate to each other. They are not like armor.

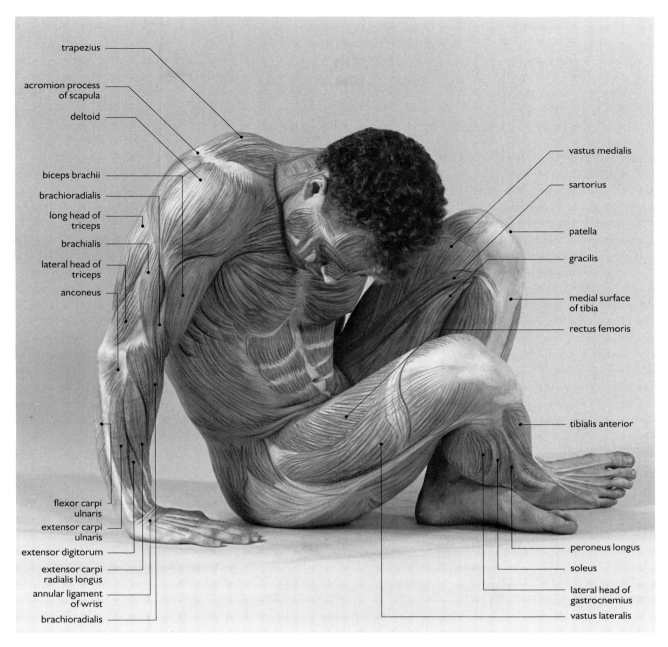

Figure 215.

It is remarkable how muscles, when flaccid, can accommodate themselves to small spaces, as with *rectus abdominis* here. When contracted maximally, the fibers in a muscle are only half their resting length but are thick and noncompressible.